ROMANCE FILM

Passion Strategies in Film and Life

Norman Kagan

D1414594

Hamilton Books
An Imprint of
Rowman & Littlefield
Lanham • Boulder • New York • Toronto • Plymouth, UK

Copyright © 2015 by
Hamilton Books
4501 Forbes Boulevard
Suite 200
Lanham, Maryland 20706
Hamilton Books Acquisitions Department (301) 459-3366

Unit A, Whitacre Mews, 26-34 Stannary Street,
London SE11 4AB, United Kingdom

Library of Congress Control Number: 2015948117
ISBN: 978-0-7618-6661-9 (paperback : alk. paper)

♾™ The paper used in this publication meets the minimum
requirements of American National Standard for Information
Sciences—Permanence of Paper for Printed Library Materials,
ANSI Z39.48-1992

"Romantic love stories are our best guide to life. We reinvent ourselves with each relationship, matching ourselves to the desired individual…Human history is a million-year version of *Bringing Up Baby, Pretty Woman,* and so on. Our minds have been shaped over millions of years to provide ideological entertainment in the endless process of sexual selection."

—Geoffrey F. Miller, *The Mating Mind*

"[Romance is able]….to convert a creature who is cool, dry, calm, articulate, independent, and purposeful into a creature that is the opposite of these; to demonstrate to an animal which is pretending not to be an animal that it is an animal."

—Kingsley Amis, *The Life of Kingsley Amis*

To Janis Siegel
and Christine Stanowski—
two passionate romantics

Contents

Acknowledgements

I would like to thank the following people for their help and inspiration:

Gloria Avery, Anna Besedina, Brian Camp, Carol Cartaino, Dianna Collier, Joan Feinberg-Kagan, Judy Trojan, and William Vassilopoulos

Introduction
Courtship and Seduction: Understanding Hollywood Romance

An estimated four out of five Hollywood films have a romance as their main plot, and if we include secondary romance plots, it's an estimated nineteen out of twenty—tens of thousands of movies seen for the delightful, overwhelming experience of winning, holding, and enjoying a passionate love or lover. What more central way to study and understand such films than by analyzing their tactics and strategies of courtship and seduction?

This volume accomplishes this by categorizing, analyzing, and comparing the skills and techniques of romance in films. The most critically acclaimed, the best known, the innovative, and the typical are all considered here, in chronological order by types, providing new and deeper pleasures and understandings, including the following.

- **Love seeking's delights**: Films that portray couples uniting through thrilling language, images, and stories—Garbo's smoldering charisma in *Camille*, Brando's manliness in *A Streetcar Named Desire*, Nicholson's cheerful debauchery in *The Witches of Eastwick*, and many others.

- **Lover character types explored:** The development of romance films' archetypal lovers down through the years, rendered by our finest actors—sirens from Theda Bara to Sharon Stone, rakes from Erich von Stroheim to Michael Douglas, coquettes from Clara Bow to Vivien Leigh, and others as they each evolved to win the desired one with their gestures, expressions, attitudes, and beliefs.

- **The psychology of film lovers:** How the lovers in films intensify, exaggerate, and transcend the experiences of "the whirlwind, the delirium of eros, " as described in love poetry, is discussed in terms of current scientific findings and theories about the love experience. Film

lovers and real ones are shown in different ways to be slaves of their biochemistry and brilliant reinventors of themselves to win the desired one.

- **Film lovers' disappointments**: Film lovers' breakups are analyzed, often as self-sabotage—generalized anxiety disorder in *Annie Hall*, avoidant personality disorder in *Four Weddings and a Funeral*, situational "hit-and-run" lovers in *Closer*, and so on.

- **Insights into avant garde romance films**: Today's film artists find new and changing meanings in modern relationships. Some examples here are *The Girlfriend Experience*'s detached siren, *The Shape of Things*'s lover as art object, *Intimacy*'s stillborn first love, *Secretary*'s perversity as normality, and *Romance* as settling of feminism's accounts.

Certainly almost everyone wishes to experience, if only vicariously, the overwhelming physical, emotional, and spiritual feelings of winning love and falling in love. This study details and illuminates the romance film's treatment of this experience by exploring and enriching it. May readers and viewers learn from it and enjoy it.

Norman Kagan

Chapter One
The Siren

The siren is the ultimate male sexual-romantic fantasy—she promises a world of pure pleasure, release, and freedom. She also promises danger along with the excitement, risk with the ecstasy, perhaps even destruction or slavery—various ultimate temptations. It's been argued that sirens' power lies not in beauty or sexuality, but in providing man's most secret needs and pleasures—danger, thrills, innocence, and the desire to aid the apparently weak or needy.

The siren may cast her spell with a sexual aura, or a touch of risk and danger, reaching out to a man's secret irrational impulses. Like Marilyn Monroe, she may herself have a streak of madness, her secret qualities communicated by scent, clothing, tones of voice, and movements.

The siren may be seen as the answer to men's worst romantic fear—fear of rejection. The siren wants all men, if only for her own reasons. She also expresses the demon lover impulse that we struggle to suppress—using sex to express hate and selfishness, or to be or submit to a passionate, insane temptress or to sexual addiction.

Psychoanalytic theory proposes that promiscuity in real-life women may be due to any of a spectrum of causes from severely narcissistic character disorder at one extreme to masochistically or hysterically inspired pathology at the other. The film siren often does not reveal the reasons for her passionate nature. Research has also found women often deliberately or inadvertently indicate their greater sexual willingness during their fertile periods, which some males can detect—a real if mild counterpart of the siren persona. It is also true that some female primates show no sense of sexual commitment to a particular male. If a better male comes along, and a female is not too afraid of a beating from a jealous mate (this often happens with chimpanzees), she will switch partners.

Finally, the siren is noted for finding ways to overcome the implicit problems of her way of life—jealousy, unwanted overtures, and her inevitable eventual transition to emotional maturity. The first sirens in silent films took the idea to its extremes by portraying inhuman sexual monsters seeking to destroy their prey.

A Fool There Was (1915*)*, the most famous silent siren film, starts with a Kipling line: "*He called her the woman who did not care, but the fool called her his lady fair.*" Theda Bara played the inhuman siren. A Charles Dana Gibson study commented: "*In her dark eyes lurked the lure of the vamp, in her every sinuous movement there was a panther-like suggestion that was wonderfully evil.*" Bara's temptress has raven hair, dark skin, and darkly painted eyes. She inhales the perfume of a rose and then tears it off its stem with sadistic joy. The titles say "Devil" and "Hell Cat." Like Ulysses' sirens, she will make her victims give up everything for total pleasure and pain.

At the start she has already claimed two victims, a homeless tramp who babbles of her power, and a terrified alcoholic who tries to shoot her down but by mistake lets her look into his eyes. "*Kill me, my fool!*" she cries, and he shoots himself.

Aboard an ocean liner, a diplomat falls under her spell when he picks up her dropped flower, catching a glimpse of her foot and ankle. On a beachfront, she curls up like a cat and he falls at her feet. She caresses her love slave, even as she destroys a letter from his wife and child. The diplomat gives up all for her, attending parties where he is treated contemptuously, ignoring friends' warnings, giving up his career. She is all he cares about. When his daughter begs him to go back to his wife, he drops to his knees, and starts kissing his mistress's dress (title: "*Fool Was Stripped to His Foolish Hide*"). Matched against other men, he burns with sexual jealousy. Penniless and drinking heavily, he swiftly declines into old age. At the end he lies at her feet, and she sprinkles flower petals over him as if he was already dead.

In an interview, Theda Bara reflected: "*I have never loved and if I ever fall under the spell of a man, I know that my power over men will be gone. Every woman must choose to love or be loved. She cannot hope for both.*"

Over the next decade siren films much resembled *A Fool There Was*, with its ruthless temptress. In each, the male lives out a fantasy of uncontrolled ecstasy, the siren a feelingless outsider.

The Eternal Temptress (1917) features opera star Linda Cavalieri, who uses her erotic powers on a U.S. diplomat to obtain U.S. secrets, realizing she loves him only at the close.

Carmen (1918*)* has Pola Negri as the fascinating gypsy who puts soldier Don José under her spell, so he cries "*Lower and lower! I am no longer a soldier to be trusted!*" Carmen replies: "*Care not! Tomorrow I'll bring a sweet reward.*"

Blood and Sand (1922) has great matador Rudolph Valentino become obsessed with seductress Nita Naldi. Her lovemaking is as violent as his attacks on bulls; she bites and slaps him. Tiring of him, she quickly finds another.

Salome (1922) tells the bible story with Alla Nazimova as a passionate adolescent whose father King Herod, like every other man at court, cannot resist her. Everyone, that is except the prophet Jokaanan. She demands his head, displays it, and the king orders her death.

The Temptress (1926) stars sophisticate Greta Garbo, who seduces and then drops many men who give all for her. The one man she loves she gives up, accepting her nature as a beauty who inevitably destroys any man who encounters her or seeks her out.

Films like *Salome* and *The Temptress* hint that the siren's nature is forced on her, a proud beauty's unsanctioned drives and needs. In the twenties and thirties, this idea was explored in *Flesh and the Devil*, *Sunrise*, and *Pandora's Box*.

In *Flesh and the Devil* (1926) army recruit John Gilbert glimpses the stunningly beautiful countess Greta Garbo, and is smitten. Finding her at a ball, he ignores friends and family. In a garden bower, they begin sexual foreplay. She rides atop him, giving him open-mouthed kisses, and rubbing faces. Next he's at her feet as she reclines, both clearly experiencing post-sexual delight. Her husband shows up, demands a duel, and is killed. Garbo is indifferent. Gilbert gets five years duty abroad. Gilbert: "Forget you? Not while I live! Not if I die!" Finally, he returns and learns Garbo has married his friend, who arranged his return. She immediately seeks to seduce Gilbert again, placing her lips on the communion cup where his rested. She tells Gilbert they can remain lovers. When the two men agree to duel for her, she runs towards them, breaks through the ice, and drowns. Her mad romantic passion proves her undoing.

Sunrise (1927) has Margaret Livingston, the siren from the city, entice a simple farmer with her cigarettes, lipstick, and lingerie. When he speaks of his wife, she comments: *"Couldn't she get drowned?"* He begins to strangle her, but it becomes a passionate embrace. In a delirious double exposure, the siren seems to take command of his home life. In the end, the siren goes on to new adventures in the city again.

Man, Woman, and Sin (1927) stars John Gilbert as a naïve momma's boy infatuated with his boss's kept woman—steamy, unwholesome gardenia Jeanne Eagels, a disillusioned sophisticate who radiates sexuality, a ruined woman who knows too much.

Sadie Thompson (1928) features Gloria Swanson as a flashy tramp. An army sergeant falls for her, as does a fierce reformer played by Lionel Barrymore. She approaches him, but he's driven to rape her, then to suicide—a limited man unable to deal with the siren who must be free. In the end, she sails off with the sergeant. Later remakes of this movie were shot with Joan Crawford and Rita Hayworth.

Mantrap (1926) has sexpot Clara Bow marry a woodsman. Out of boredom she makes advances to a city man on vacation, tossing her curls, pulling up her stockings, and flashing her gleaming smile, so he runs off with her, declaring her right to live her own life. Later, she returns to her husband on the same terms.

Their Hour (1928) has free-living socialite Dorothy Sebastian pick up a low-class party crasher and fly him in her plane to her country inn, where the two spend a night together. When his fiancée arrives, Sebastian casually gives the boy toy back.

Pandora's Box (1929, Germany), an extremely erotic siren film, stars Louise Brooks as a paradoxically innocent, yet sexually driven and irresistible siren in Weimar Germany, whose search for love brings only destruction. As mistress to a powerful newsman, Brooks manipulates him into marriage. At the wedding he sees her as too sexually free, even coming on to his son, and demands she commit suicide. But when they struggle he is shot. At her murder trial, she is likened to the goddess Pandora, who unleashed ruin. Helped by a newsman's son and a lesbian countess, both in thrall to her, she escapes the courtroom. On the run, she is offered sleazy deals by various blackmailing con artists aboard a gambling ship, eager to enslave the amoral beauty. But instead she runs off with the newsman's son and an old mentor, to the London slums where she prostitutes herself. Her first client is the equally perverse Jack the Ripper. Despite everything, Brooks' siren is less ruthless and manipulative than those around her.

The Blue Angel (1930, Germany) tells how cabaret singer siren Marlene Dietrich, a skilled seductress, conquers high school teacher Emil Jannings, which leads to his destruction. Jannings first visits the Blue Angel cabaret to understand his visiting students, and finds it a rowdy counterpart of his classroom, dominated by Dietrich's singer in high heels, corset, and garter belt, her songs mocking his bourgeois values.

Dietrich: *Falling in love again/never wanted to. What am I doing? I cannot help it.*

Dietrich courts Jannings by admiring and teasing him, dropping her panties and tossing them to him. He soon is sacked from teaching and marries Dietrich, reduced to being a clown in her act, selling lewd pictures of her, and putting on her stockings. Siren Dietrich soon begins to have flings with other men she encounters. In her show business world this is normal. Finally Jannings loses control and attacks one of her lovers. He is beaten, straitjacketed, and returned to his empty classroom where he dies.

Like the sirens of *Flesh and the Devil, Sunrise,* and *Pandora's Box, The Blue Angel*'s siren accepts her nature even as she realizes it may bring destruction to those around her, and even herself.

The growth of feminism, notably the acceptance of the idea that a woman is capable of if not perhaps entitled to the full range of emotions of a man, appears in the Hollywood siren films of the thirties.

In *A Free Soul* (1931), M.G.M's superstar Norma Shearer plays a "liberated" socialite with carnal cravings. When her alcoholic lawyer dad befriends gangster Clark Gable, the upper-class siren/flapper drops a "swell" lover and takes off with the devilish mobster for his place. She spends the night with him, becoming his mistress in a revealing, slinky nightgown, then going home but soon returning. Next they're living together.

Shearer: *You're a swine working with swine.*
Gable: *You're talking to the man you love.*

When he shoves her around, her earlier lover Leslie Howard shoots him down. Shearer announces she will leave for New York to start life anew, or just continue her wild ways. Howard will follow.

Inspiration (1931) stars Greta Garbo as a beautiful Parisian model who is impassioned when she picks up young diplomat Robert Montgomery and heads home telling him: "*Just a nice young woman, not too young and not too nice! I hope!*" Her next affair begins, but Montgomery turns out to be a prig.

> Montgomery: *Don't use the word love. It sounds vile coming from*
> *you...I want to forget that I ever knew you!*

She suffers the rejection and is swept up again into her free spirit life and then he takes her back. But when he falls asleep one day, she writes him a note, and returns to her siren's life in Paris. The protagonists of both films, it is implied, live in a sophisticated world where the siren is accepted, even if some men can't deal with that.

Blonde Venus (1932), a film that echoes *Blue Angel*, stars Marlene Dietrich as an irresistible showgirl wed to a scientist-intellectual so overwhelmed he must abuse her. Leaving him, she goes back to her "Blonde Venus" nightclub act, an erotic song and dance that implies a siren in any and all women:

> *Hot voodoo—black as mud.*
> *Hot voodoo—in my blood.*
> *That African tempo has made me a slave!*
> *Hot voodoo—dance of sin!*
> *Hot voodoo—worse than gin!*
> *I'd follow a caveman right into his cave!*

Next, gangster boss Cary Grant makes her his lover and streetwalker, Dietrich controlling every man she encounters. She soon works a Paris club where Grant falls for her and proposes, but her husband forgives her, and she goes back to him (for now).

Another group of films showed lower-class women becoming sirens out of economic necessity, but also finding that it was their nature.

Red Headed Woman (1932) stars sexy stenographer Jean Harlow, who ruthlessly seduces her married boss. Harlow tells her girl pal the siren's credo: "*A girl is a fool if she doesn't get ahead. It's as easy to get a rich man as a poor man!*" When his wife finds out, the siren is unrepentant Harlow: "*If she wants to keep the barn door open, what is to keep a girl from going in?!*" When the boss slaps her, she cries out: "*Do it again—I like it, do it again,*" suggesting darker motives. Next, she takes up with an elderly tycoon, until he is warned off. In Paris two years later Harlow is the toast of France with a wealthy French aristocrat lover, and the old tycoon's chauffeur driving them, apparently her secret second lover.

Baby Face (1933) was promoted with an ad: "She played the love games with everything she had, and made 'it' pay!" Barbara Stanwyck starts out as a slinky, street-smart beauty in a steel town. Abused by her dad, she runs off to New York. Seeing the Gotham Trust skyscraper, she resolves to scale it her own way, inviting the personnel director to "be friendly," then climbing the executive

ladder with flirtations and affairs. Near the top, simultaneous affairs lead to a murder and suicide. Her response: "*I was the victim of circumstance!*" The new president of the company has her put in the Paris office. Still a beauty, she tells him: "*I'd like to have a Mrs. on my tombstone.*" But there is a crisis, and he needs to borrow all her savings. She refuses, but finally comes through, and the couple run away back to the steel town, where she is never punished for her "sins."

The Beast of the City (1932) is a gangster movie with a strong subplot of Harlow as a sexy gang moll/siren who seduces crime fighter Walter Huston's weakling brother, so he changes sides and participates in various crimes. The beautiful siren Harlow knows how to appeal to a man's irrational needs:

Wallace Ford: *Do you like getting hurt?*

Harlow: *Oh, I dunno, it can be fun if it is done in the right spirit.*

I'm No Angel (1933) features Mae West as a cool siren who likes hustling men. Cary Grant is a rich society type to whom she makes clear her nature:

Grant: *If I could really trust you…*

West: *A hundred have.*

West makes fun of her own siren's promise of hundreds of pleasures:

West: *I like sophisticated men to take me out.*

Grant: *I'm not really sophisticated.*

West: *You're not really out yet either.*

In the end, they're a sort of comic siren/victim act:

Grant: *I could be your slave.*

West: *That could be arranged.*

Algiers (1938) is a notable variation on the siren theme with Hedy Lamarr as a steamy young Parisian beauty who visits French Algiers and fascinates the otherwise shrewd gang leader Charles Boyer, until now easily evading the Kasbah police. Soon she is meeting him again and again in passionate love scenes. She has become his obsession.

Boyer: *You know what you are to me? Paris, that's you…a spring morning in Paris.*

Lamarr believes Boyer has been killed, and books passage for Paris. Boyer, madly in love, leaves his hiding place and tries to board the liner. He is arrested, sees her and runs for the ship, and is shot down. Lamarr sails away alone for France. An earlier French version, *Pépé le Moko* (1937), has Jean Gabin dying for love. It was also shot as *The Casbah* (1948) with Yvonne De Carlo.

The film sirens of the forties are often throwbacks to the perverse, uncaring sirens of the twenties and thirties. In particular, postwar sirens often enthralled the films' protagonists, offering erotic and wealth-filled new lives. In some cases, there is a fantastic nightmare marriage to come, even as they destroy their current spouses.

In its remake *Blood and Sand* (1941) the evil but overwhelmingly desirable siren Rita Hayworth quickly steals matador Tyrone Power from his true love, strumming her guitar with her blood-red fingernails. The price of his adultery is death.

White Cargo (1942) stars Hedy Lamarr as sensuous tropical siren Tondelayo, who has already seduced and destroyed many at a British Empire outpost. She comes out of the trees like a jungle cat and fascinates new recruit Richard Carlson At first she is happy with bangles and silks, then is slyly trying to poison him.

In Double Indemnity (1944), his first vision of beautiful siren Barbara Stanwyck, a sexually masterful goddess in towel and anklet, stuns insurance man Fred MacMurray. Stanwyck soon provides fantasies of sex, wealth, and adventure following their killing of her husband. As MacMurray's boss puts it: "They're riders on a trolley car and one can't get off without the other."

The Postman Always Rings Twice (1946) has Lana Turner as a stunning siren, irresistible in white pumps, a two-piece white outfit, and platinum hair, who offers John Garfield a new life. From the first moment, she totally controls him, in crime, sex, or housework.

> Turner: *I know men. Somehow they always seem to be more interested in the problems of young wives with older husbands.*

Gilda (1946) stars Rita Hayworth as Gilda, a beautiful, sensuous, but vengeful siren. Her husband hires Glenn Ford to work in his posh casino. Ford and Hayworth pretend they've just met, but they once had a torrid affair—"*She was the air I breathed and the food I ate!*" Now she is indifferent: "*Johnny—a hard name to remember and easy to forget.*" Her husband makes Ford her bodyguard, noting the attraction. (Gilda: "*If I'd been a ranch they'd have called me the bar nothing!*") She provokes Ford with a sexy striptease, "*Put the Blame on Mame!*" The club's patrons become so excited they almost assault the siren. Hayworth keeps trying to start an affair with Ford, without success:

> Hayworth: *You hate me, don't you, Johnny? Hate is a very exciting emotion. I hate you too, Johnny. I hate you so much I think I'm going to die from it!*

Her husband finds Ford struggling with her, drunk and wanting to run off. He is lost at sea. Hayworth declares her love for Ford, but he feels she is a betrayer (of her husband). Her husband shows up to kill the couple, but is shot first. Ford and Hayworth decide to start over ("*Nobody has to apologize because we both are such stinkers!*"). Can the siren settle down? It seems unlikely.

Out of the Past (1947) like *Gilda*, is a dark romantic triangle with an irresistible siren spinning a web of destruction for all. It starts with former detective Robert Mitchum explaining how he was hired by mobster Kirk Douglas to track down a lover.

> Douglas: *I just want her back. When you see her, you'll understand.*

Mitchum traces the siren to Mexico City and falls for her at once. The by now passionate lovers flee to San Francisco. Douglas sends a second detective and Jane Greer kills him. Mitchum and Greer separate, then he finds her with Douglas, blackmailed into it through the killing. Soon she kills Douglas, explaining herself to Mitchum.

> Greer: *I never told you I was anything but what I am. You just wanted to imagine what I was, that's why I left you.*

The siren talks him into leaving the U.S. with her, but he also informs the police. As they make their getaway they speak passionately:

Greer: *You're no good for anyone but me. You're no good and neither am I.*

Mitchum: *We deserve each other.*

When they reach a police roadblock Greer turns on Mitchum, shoots him, and they hit the roadblock, and both die.

Out of the Past was remade as *Against All Odds*, a good title for any siren film.

The Lady From Shanghai (1947) much resembles the last two films. Young sailor Orson Welles meets stunning blonde siren Rita Hayworth, who hires him to sail with her and her husband. (*"Would you like to work for me? I'll make it worth your while!"*) Dressed provocatively, she stands on the deck while the crew stares lasciviously and her crippled husband looks on suspiciously. She schemes with Welles to run off, but in the end Welles, Hayworth, and her husband are trapped in a mirror maze that suggests their destructive fascination with surface attraction. They shoot it out in what seems an endless kaleidoscope, shouting and screaming. Only Welles escapes alive, but remains forever under her spell (Welles: *"Maybe if I live long enough I'll forget her. Maybe I'll die trying."*) In fact, he married her in real life.

Gilda, Out of the Past, and *The Lady from Shanghai* all emphasize the siren's irresistible nature, and her power to overcome even strong men's attempts to have some sort of conventional love relationship with her. Some later films also take this approach, seemingly exhausting it, all ending in ruin.

The Loves of Carmen (1948), remaking the 1927 silent, has Rita Hayworth as the fiery gypsy who teases and taunts any man who approaches. Soldier Glenn Ford, her husband, and a matador are swept into her smuggling scheme. In the end Ford tries to kill her, but cannot.

Pandora and the Flying Dutchman (1951) casts Ava Gardner as Pandora, a stunning nightclub singer, seemingly hypnotizing all. A racecar driver destroys his car to excite her; another man commits suicide while she sings; a matador parallels their affair with a bullfight. When a schooner docks, its captain claims she is the reincarnation of his wife, killed out of jealousy. Fearing a repetition, he rejects the siren, but she swims to him in a storm, and their bodies wash ashore in each other's arms.

Miss Sadie Thompson (1953), remaking the 1928 film, has Rita Hayworth as the irresistible prostitute courted by marine Aldo Ray and missionary José Ferrer, whose attempts to reform the siren end tragically for him.

Salome (1953), re-making the 1922 silent, has Rita Hayworth doing the dance of the seven veils. In this version, the siren tries to stop the beheading of John the Baptist. Though she fascinates every man at court, in the end she runs off with the man she wants, soldier Stewart Granger.

In *The Egyptian* (1954), set in ancient Egypt, exotic Bella Darvi, beautiful and sadistic, totally dominates a noble, who gives up his wealth and

independence even as she has affairs with others. When they meet later, he devotes himself to treating an illness she develops, becoming her total slave.

In *The Prodigal* (1955), Lana Turner is a New Testament siren who quickly seduces Edmund Purdom, a rich Hebrew youth. Soon Turner, whose religion calls for human sacrifices, takes the boy's wealth and sells him into slavery, which leads to Turner's destruction, the temptress crying out: *"I never belonged to any one man. I belong to all men!"*

The early fifties saw a new version of the film siren—the beautiful, passionate, playful, ambitious, manipulative American golden girl, who wanted a man and knew how to wrap him around her finger.

Gentlemen Prefer Blondes (1953), *The Seven Year Itch* (1955), and *North by Northwest* (1959) have variations of this new fabulous fifties adorable, ruthless siren, sweetly determined to do anything to get the guy and the goods.

Gentlemen Prefer Blondes (1953) stars Marilyn Monroe and Jane Russell as two gorgeous American showgirls on a luxury liner, Monroe a gold-digger, Russell looking for fun. Monroe has a rich boyfriend lined up to marry her in France, but meanwhile goes after an old diamond mine owner. (She fantasizes his head as a giant diamond!) Meanwhile Russell seduces a whole Olympic team. Monroe exemplifies the new playful siren, ready to justify her outrageous double-dealing with men:

> *"I won't let myself fall in love with a man who won't trust me, no matter what I do...I can be smart when it's important, but men don't like it. A man being rich is like a girl being pretty. You might not marry her because she's pretty, but my goodness, does it help. I'm not marrying your son for his money; I'm marrying him for your money!"*

In the conclusion, Monroe and Russell use double crosses, swapped impersonations, and false arrests to get the guys they really want, Russell whispering to the judge: *"You're so much more intelligent than poor little me. Won't you tell me what I ought to say?"* Soon she is singing "Diamonds Are a Girl's Best Friend," while stripping to win her case.

In the *Seven Year Itch* (1955) husband Tom Ewell, alone for the summer, finds himself befriending playful single model-actress Marilyn Monroe, who is innocently tempting him with a siren's weapons; stunning face and body, delightful manner, and total availability. She tells him nothing can beat a married man—*"No matter what happens, he can't ask you to marry him."* At the end she makes a declaration of total commitment that would wreck his marriage.

> Ewell: *Let's face it...no pretty girl in her right mind wants me. She wants Gregory Peck.*
>
> Monroe: *Is that so? How do you know what a pretty girl wants? You think every girl's a dope? You think a girl goes to a party and there's some guy in a fancy striped vest strutting around like a tiger, giving you that "I'm so handsome you can't resist me" look and for this she's supposed to fall flat on her face? Maybe there's another guy in the room, way over in the corner. Maybe he's kind of nervous and perspiring a little. First you look past him, but then you sort of sense*

he's gentle and kind and worried and would be tender with you. Nice and sweet. That's what's really exciting (touches him*). I'd be very jealous of you* (kisses him*)—I think you're just elegant.*

In Hitchcock's *North by Northwest* (1959*)*, Eva Marie Saint plays a beautiful, ruthless, yet playful siren, the mistress of an enemy agent, who is also a double agent, but at heart a siren with no loyalties, as suggested in an early exchange with playboy Cary Grant.

Grant: *The moment I meet an attractive girl, I have to start pretending that I've no desire to make love to her.*

Saint: *What makes you think you have to conceal it?*

Grant: *She might find the idea objectionable.*

Saint (provocatively): *And then again she might not. I tipped the steward five dollars to seat you here if you should come in.*

Grant: *Is that a proposition?*

Saint: *I'm Eve Kendall. Twenty-six and unmarried. Now you know everything.*

Grant: *What else do you do besides lure men to their doom on the New York Central?*

A little later, Saint is even more direct:

Saint: *It's going to be a long night...and I don't particularly like the book I've started...know what I mean?*

Later dialogue suggests they've quickly become very intimate

Saint: *You've got taste in clothes, taste in food.*

Grant: *Taste in women...I like your flavor.*

Yet shortly afterwards, she sends her newest lover to his death (attacked by a cropduster plane). Grant survives and sizes her up as the basic beautiful siren, fifties version.

Grant: *Ever kill anyone? I bet you could tease a man to death without even trying. So stop trying, hmmm?*

She later explains falling in love with spies and killers as her obsessive sex drive in action:

Saint: *I met Phillip Vandamm at a party one night, and saw only his charm. I had nothing to do that weekend, so I decided to fall in love.*

The C.I.A. contacts Grant and explains that Saint is a uniquely valuable double agent. Grant saves her from the spy's killer, and they speak of marriage. But there is a grim earlier exchange:

Grant: *How did a girl like you get to be a girl like you?*

Saint: *Just lucky, I guess.*

Grant: *Not lucky...wicked...naughty...up to no good.*

Their future together is clearly highly problematical.

A darker treatment of the new free spirit film siren is *Jules and Jim* (1962, France), set in 1907-1927, about the love relationships of Austrian Jules (Oskar Werner), Frenchman Jim (Henri Serre), and young willful siren Catherine (Jeanne Moreau). The new intellectual modern woman, Moreau claims full equality with men, but has unique powers to enchant and manipulate. At first

they have playful times, but soon Werner falls for her, and proposes. But when Werner makes chauvinistic comments, Moreau leaps into the Seine, winning Serre's love. After, Serre visits the now unhappy couple. In café scenes she lists all her other lovers, but Serre still wants her. After Catherine runs off with another friend of Werner's, the couple reunites, but she miscarries Serre's love child. When Serre visits again and Moreau tries to seduce him, he refuses, and Moreau tries to shoot him, but fails. Later they dine together, and Moreau takes Serre for a brief ride, and drives off a bridge, the two drowning. Moreau is a modernistic siren endlessly conquering men, finding her fulfillment in these victories. Despite her strange, unexplained, and destructive nature, this siren is always an eerily powerful sympathetic figure.

Several other films of the sixties take up this vision of the siren as beautiful, delightful, and irresistible, a mystery to herself.

In *The Testament of Dr. Antonio* (1962, Italy), a giant, voluptuous billboard image of Anita Eckberg fascinates a middle-aged censor who cries, "A pleasure as great as death...stay with me forever!" She replies she cannot be with one man—the next day he is found half mad.

Lilith (1964) features Jean Seberg as a mentally disturbed siren, stunning but treacherous. Warren Beatty falls for her, and she has a lesbian affair, and makes another patient commit suicide: "*I show my love for all of you, and you despise me!*" She finally retreats into total madness.

I, a Woman (Denmark, Sweden, 1965) stars Essy Persson as a nurse recalling her sexual experiences. She is awakened sexually by a wealthy older patient; a sailor and a physician follow, who both want to marry her. Her new date arrives, and their philosophies match up—indulging in sex for its own sake.

Darling (1965, England) presents Julie Christie as a beautiful, petulant young woman adrift in "swinging" England of the sixties. First working as a model, then an actress, she charms newsman Dirk Bogarde, so he drops his family. Christie then runs off with ruthless B.B.C. publicity man Laurence Harvey. Bogarde comments: "*Your idea of fidelity is not having more than one man in your bed at a time!*" She has an abortion to preserve her lifestyle: "*Never did like sex anyway!*" She bounces between the two men, goes on to other lovers, is part of showbiz orgies, and lives for a while with a gay photographer. After a religious conversion, she marries a rich prince with whom she has nothing in common. None of these episodes seem to matter much ("*If I could just feel complete...*").

Julie Christie's siren in *Darling* recalls Jeanne Moreau's in *Jules and Jim*. Both seek meaning in chaotic societies, start with intense relationships with two men, are not fulfilled, then use their beauty and magnetism in ever briefer, less satisfying relationships, ultimately turning to destructive emptiness.

The late sixties and seventies saw a new sort of siren—beautiful, sexually adept, but fully able to carry on despite a lack of meaningful fulfillment.

The Graduate (1967), the topical hit of the sixties, is a love triangle: confused new college grad Dustin Hoffman, inexperienced coed Katharine Ross,

and her sexy siren adulterous mom, Anne Bancroft. When graduate Hoffman comes home, Bancroft immediately seduces him.

> Bancroft: *I want you to know I'm available to you. If you won't sleep with me this time, Benjamin, I want you to know you can call me up anytime you want, and we'll make some arrangement.*

After a first awkward encounter at a hotel ("Would it be easier for you in the dark?"), they continue to meet at regular intervals. Bancroft makes it clear that fornication is their only purpose.

> Bancroft: *I don't think we have much to say to each other.*

Meanwhile, Hoffman starts seeing Ross and falls in love with her. But when he speaks of marrying her, Bancroft becomes totally hostile and threatening. Hoffman tries to talk Ross into marrying him, but she becomes engaged to a college friend to escape her mother's animosity. In the end, Hoffman gets Ross to leave the wedding and run off with him. Bancroft will also presumably continue to follow her impulses. The graduate clearly doesn't care.

Far From the Madding Crowd (1967, England), based on the Thomas Hardy novel, stars Julie Christie as the strong, restless beauty superior to her several lovers. Terence Stamp is a soldier who becomes obsessed ("*A woman like you does more damage than she can conceivably imagine*"); Peter Finch is a rich farmer whose fascination with her becomes madness *("I ask only the privilege of looking after you"*); Alan Bates is a herdsman who stands by the siren through her various affairs ("*Whenever you look up, there I shall be*").

Mississippi Mermaid (1969, France) has beautiful, passionate siren Catherine Deneuve marry a lonely plantation owner, Jean-Paul Belmondo, but she is a thief and imposter, who soon runs off. Yet when an investigator arrives, Belmondo murders him, and the reunited couple now flee together. In the end the siren kills her lover and he accepts this, saying he is not sorry he loved her. She replies: "*You are all I want. Is love always too powerful?*"

Manhattan (1979) is Woody Allen's take on the siren theme. Allen is a New York TV writer having an affair with high school girl Mariel Hemingway, until he meets the high-strung, neurotic journalist siren, Diane Keaton. At first he finds her false, superficial, and arty, a social climber with ridiculous intellectual pretensions.

> Keaton: *My problem is I'm both attracted and repelled by the male organ.*

But Allen is gradually fascinated by Keaton, even though this causes great pain to his teenage lover. In particular, Keaton can display a sense of humor and inferiority much like his own.

> Keaton: *I finally had an orgasm, and my doctor said it was the wrong kind.*

In addition, Keaton wins Allen's sympathy as an ordinary person trying to put on an intellectual show to be accepted by the sophisticates, such as her "Academy of the Overrated" (e.g., Norman Mailer) and the work she does turning out novelizations of worthless movies. She is also having an affair with

his best friend, Michael Murphy. When they break up, Keaton starts an affair with Allen, and he drops Hemingway. A great sequence shows the couple visiting the Planetarium—walking on the moon, Saturn, and the Milky Way, suggesting romantic rapture as they talk about love. Allen gets excited about making her a New York intellectual, but this of course fails.

> Keaton: *Could you just hold me? Your love for me always has to express itself sexually? What about other values, like love and spiritual contact? A hotel, right? Jesus, I'm a* [laughing] *pushover anyway!*

She drops Allen for Murphy, who has left his wife. Finally Allen tries to get back with the sweet Hemingway, but it is likely she'll move on.

The siren films of the eighties and nineties saw a return to the beautiful, brilliant, ruthless, and manipulative early siren character types, reflecting the period's own competitive, unforgiving zeitgeist. *Body Heat* (1981) was a clear effort to recreate the film noir siren in films like *The Postman Always Rings Twice*. Its protagonist, William Hurt, is a not very bright Florida lawyer who is picked up one hot summer night by the stunning young wife and siren Kathleen Turner in a bar:

> Hurt: *I need tending. Someone to take care of me. Someone to rub my tired muscles, soothe my...*
> Turner: *Get married?*
> Hurt: *I only need it for tonight.*
> Turner: *My temperature runs a couple of degrees higher than normal. About a hundred degrees. I don't mind. I guess it's the engine or something.*
> Hurt: *Maybe you need a tuneup.*
> Turner: *Don't tell me. You've got just the right tool.*

Eventually, she pressures (or pleasures) Hurt into murdering her rich husband.

> Turner: *You think I'm bad. I am, and I know it, but I need you and I love you.*

She'll inherit her husband's money, and in time the two of them can run away. The film is shot to arouse the audience. After the two have sex, Hurt stands up to look out the window, and she apparently grabs him playfully off screen to lead him around the room.

> Turner: *I could never do anything to hurt you. I love you, you've got to believe that!*
> Hurt: *Keep talking, Mattie. Experience shows I can be convinced of anything.*

Hurt commits the murder for the siren, but once she has the money he is made to take the fall. The siren has gotten rid of two lovers and moved on.

The remake of *The Postman Always Rings Twice* in 1981 shifts the storyline so that siren Jessica Lange and her lover Jack Nicholson are driven less by greed and hatred than by sexual obsession for each other. Lange is a lower-class wife in a loveless marriage, Nicholson a combative ex-con. Their sex is compulsive, outdoors or on a kitchen table,

Lange: *I've got to have you; I'm tired of what is right or wrong!*

Choose Me (1984) is a sort of surreal love comedy with several sirens running wild. Lesley Ann Warren, a bar owner, is extremely self-confident and can attract any man. She has several affairs going in the film but won't marry because *"I've ruined too many marriages to have one of my own."* Geneviéve Bujold is a radio "psyche jockey" ("Dr. Love"), whose advice is usually to run wild. She is always changing her looks and moods, sailing under false flags as she searches for the right man.

She's Gotta Have It (1986) centers on Tracy Camilla Johns, a young black siren in Brooklyn who has mesmerized three very different black males. Overstreet is a conventional marriage-minded guy who seeks her love with offers of matrimony; John Canada Terrell is a fashion model who claims she was only "a lump of clay" before they met; Spike Lee is a fast-talking street punk babbling jokes and wit. At the end she tells them: *"...it is about control. My body. My mind. I'm not a one-man woman!"*

Children of a Lesser God (1986) tells how a beautiful young deaf woman's disability has shaped her into a vindictive siren. Marlee Matlin, working at a school for the deaf, encounters William Hurt, a teacher there. As a disabled child she was mocked, while her great beauty in high school led her to become promiscuous (she was also sexually abused), and thus a highly skilled and challenging siren. Matlin and Hurt become lovers, Hurt struggling to win the siren's love in a passionate relationship.

The film sirens of the nineties and beyond explore the extremes—the ultimate ways sirens master their victims, how society's limits shape this, the types and depths of the victims' vulnerabilities, and the siren transcending her own nature. In brief, society tears itself apart, sex the metaphor for this.

Basic Instinct (1992) stars beautiful, brilliant, psychopathic siren Sharon Stone, who delights in her powers to seduce and outwit man or woman. At the start she is suspected of tying a rock star lover to a bed naked for sex, then ice picking him to death. She admits a relationship (*"I wasn't dating him, I was fucking him!"*) to detective Michael Douglas, fascinates him, and ties him up like the rock star after they have sex.

Douglas: *I'll nail you.*
Stone: *You'll fall in love with me.*
Douglas: *I'm already in love with you, but I'll nail you anyway.*

At a disco, she lets him watch her have sex with her lesbian lover, which arouses him. In a notable scene, she appears for interrogation at police headquarters, encircled by a dozen fascinated cops, admitting the sex killer thrillers she writes delight her. Meanwhile she apparently seduces and kills Douglas's partner and a policewoman psychologist lover. At the end, Douglas seeks to get the ruthless siren beauty to settle down!

Douglas: *The fuck of the century.*
Stone: *I won't tell you all my secrets, just because I had an orgasm!*

The two are in bed, but there is an ice pick on the floor ready for use. The sequel, *Basic Instinct II*, has a similar thriller siren plot, with Stone manipulating a London psychiatrist.

Body of Evidence (1993) has Madonna searching out men to sexually control: *"That's what I do. I fuck!"* She is first shown on trial for "Using her body as a lethal weapon," inducing a lover's heart attack. She tells her lawyer that he has the same tastes as she does, but doesn't know it yet. In extreme sex play, they fornicate atop a car roof covered with broken glass, while he gives her oral sex. He is obsessed, wins her case, but can't save her from a rejected lover who drowns her.

In *Body of Influence* (1993), a Beverly Hills therapist for sexually dissatisfied women has a new patient—Laura (played by Shannon Whirry)—frightened, childlike, with a history of rape and abuse. She disappears, then shows up as alter ego Lana—aggressive and challenging (*"You just want what's between my legs, that's why you've been fucking with my mind!"*) He gradually becomes sexually submissive, shows her tapes of him having sex with his patients, scenarios such as breaking into a woman's home so she handcuffs and mounts him for sex. His therapy practice falls apart. Her control is total, such as when she starts to strangle him. (*"I trust you with my life!"*) The siren's final command is that he will kill for her. But will he do it?

Return of the Native (1994), based on the classic novel by Thomas Hardy, stars Catherine Zeta-Jones as a haughty village siren thought a witch for her power to beguile any man. She is shown climbing a tall hill:

Jones: *Deliver my heart from this fearful lonely place. Send me a great love from somewhere, or else I shall die.*

One lover fears her too much to marry her, but asks her what she seeks:

Jones: *To be loved to madness.*

She releases him and a second villager is smitten, whom she hopes will take her out of the small-minded village. When the second is blinded, she takes back the first. When they try to flee, they're stopped at a bridge in a raging storm, and she jumps to her death in the river below.

The Last Seduction (1994) stars Linda Fiorentino as a crafty criminal siren who drops her drug dealer husband, steals his cash, and flees. In a small town she seduces a new man in a bar with sadistic patter (*"Who do I have to suck off to get a drink around here?"*). Soon, the new man, Peter Berg, submits.

Berg: *I'm trying to figure out if you are a total fucking bitch or not.*

Fiorentino: *I am a total fucking bitch.*

Her husband sends a killer after her, but she seduces and kills him. She insists on "unconditional love" from the new man, including killing her husband. The husband is killed, the new man arrested, and Fiorentino triumphs, the men accepting or even taking pleasure in being destroyed.

The Color of Night (1994) stars Jane March as a beautiful siren suffering multiple personality disorder—she functions as your sex fantasy, until she turns on you ("a charming chameleon with a scorpion's sting"). For her psychotic brother, she is their long-dead sibling, for members of her therapy group she

becomes each one's sexual fantasy—for a painter a dominatrix in fetish gear, for a tormented cop who lost his family, his child; for a promiscuous woman a serious lesbian lover. Her most elaborate persona, Rose, is created for psychiatrist Bruce Willis, who is guilt-ridden over causing a patient's suicide. She appears from nowhere as various stunning seductresses—a sexy intimate wife, a teen eager for intercourse—flash! flash! flash! Meanwhile, Willis investigates killings linked to his therapy group, which lead to a loft where her insane brother has trapped "Rose"—his fantasy. Willis saves Rose, and she murders her brother to stop him from killing Willis. Rose prepares to commit suicide, but Willis stops her by threatening to jump too—instead they embrace.

Sirens (1993, Australia, England) is a return to the lighthearted siren films, but more explicit and candid. A cabinet minister and his wife visit an Australian painter noted for paintings of wanton, voluptuous female nudes. While the men argue over such a painting for a London show, the stunning, uninhibited live-in models (Elle Macpherson, Kate Fischer, and Portia de Rossi) lead the wife to fantasize being ravished by the handyman. The chosen painting hints the fantasies were realized. Headed home in a passenger-filled railroad car, the wife commences her husband's sexual liberation by turning into one more siren.

Romance (1999) begins with a young beauty, Catherine Ducey, rejected by her live-in lover. Wanting to feel desirable, she lets herself be picked up at a bar and makes out in the man's car, hungry for "the miracle of the stranger...pure childish desire." In bed, in various positions, she speaks plainly: "*I'm just a hole to stuff.*" She returns to her lover, then beds the middle-aged headmaster she works for, accepting rope bondage. Then she is picked up and raped, and has more S&M trysts with the headmaster. Her relationship with her original lover meanwhile goes on until he dies. The film's director, Catherine Breillat, argues the protagonist is a siren in a modern feminist sense: "There is a power shift in a relationship over time...the man starts out being the predator and the strong one and ends up being the one who is possessed by the woman."

Intimacy (2001) depicts the weekly meetings between an anonymous man and woman in a hotel. They undress quickly and have passionate sex without even exchanging names. The man is a divorced head barman, the woman a married woman and actress who needs more than one man. The early scenes emphasize physical sex, struggling for better positions, and the like. In time the man falls into the siren's victim pattern—shadowing her, attending her plays, befriending her husband and son, obsessed. When he pleads with her to marry him and she refuses, they have sex a last time, and he leaves forever.

Rape Me (*Baise-Moi*, 2000, France), a shock comedy about sirens, has two streetwise French women, Karen Lancaume, a cold-hearted blonde, and Raffaëla Anderson, a comic hysteric, become tired of being victimized by the men of their low-class milieu, so they go on a wild sex and murder spree across Europe. As one explains; "*The more you fuck, the less you think, the better you sleep.*" Sometimes after they have sex they choose to let the men go, other times they decide to kill them.

Original Sin (2001), a remake of *Mississippi Mermaid,* stars Angelina Jolie as a siren who ruins businessman Antonio Banderas via rough sex, bloody cuts, and her pursuit of other men. Banderas' life is gradually destroyed—he is cuckolded, wrecks his business, breaks the law, and seems to turn killer. In time, he has the siren poison him, telling her: "Don't you see I can't live without you?!" Afterwards Jolie goes on to a new life in a casino, circling the tables, signaling the players' cards to a cardsharp who will be her next victim—a beautiful, erotic angel of ruin.

The Girlfriend Experience (2009) has Sasha Grey providing rich New Yorkers simulated intimacies at $2000 per hour as she performs as each one's ideal girlfriend—exchanging sex, financial advice, or personal secrets in an emotional mirror maze. She is shown in several such interludes, including one client sadly claiming they have extraordinary rapport, and a meeting with an internet expert, the Erotic Connoisseur, about ways to compete with other such escorts. She is also shown to have a real relationship with a personal trainer that greatly resembles those with her clients. Grey is not totally detached—she is shown jealous at an old client's choosing a different escort, and appears moved when a new client is sympathetic. But her personality reduces to her power to smoothly blend the skills and paradoxes of the siren—at once predator and prey, empowered and submissive, sexual conqueror and sexual conquest—in each persona providing the sought-after dream needs.

The People I've Slept With (2009) stars Karin Anna Cheung, who proclaims *"A slut is just a woman with the morals of a man."* She sleeps with any man who appeals to her, then photographs him—*"to remind me of where I've been."* When she gets morning sickness, she decides to track down the five likely daddies and collect DNA samples. This involves such comic moments as visiting a funeral at which the mourners all pregnant executives, and the need to stalk a stalker. She has proved herself a true siren, if a free-spirited one. And in the end, at her wedding, she still has a siren's creed—*"The most important thing is: you do what you want!"*

The film siren remains a figure of great fascination, with the power to control others through their erotic longings to the point of destroying themselves, or reaching ultimate fulfillment. In both she reminds us of our physical, mental, and spiritual fragility and vulnerability to our passions.

Chapter Two
The Rake

The film rake represents the ultimate wish fulfillment for some women—a man who will do anything to fulfill her. He may be disloyal, dishonest, amoral, or all of these, but such lack of restraint can even add to his attraction. The rake is a wild combination of danger and rapture women can't resist. Because he will do anything for a woman he is irresistible, inflaming her to the point that nothing else matters. He can even make her stop thinking.

The rake uses several tools to overwhelm. His words and language aim to excite his present target. His dark past proves his irresistible nature. He creates the illusion he lives only for her, which is often her most secret desire. He may even create obstacles—dangers, broken taboos, cruelty, or a "savage nature," all of which can be thrilling to a repressed female.

In terms of psychology the rake represents the answer to one of both sexes' greatest fears: the fear of rejection. The rake also embodies males' fear of becoming the demon lover—ruthless, seductive, and frequently brutal and beastlike. (Most male primates never miss an opportunity to copulate with any available female.) Finally, the rake symbolizes the taming of another male concern—sexual addiction. For women, psychologically, the rake represents her impulse to find a more desirable mate. As the saying goes, men are like tires—some get better mileage, but eventually they all wear out. He doesn't.

The rake also balances geniality against patriarchy—he is driven towards a mother/lover figure, identifying with his father, but never has a full adult sexual relationship. Rakes are found along a personality spectrum from promiscuous, narcissistic personalities to opposite extremes—infantile, dependent, rebellious, but effeminate. Finally, as noted, behavioral research suggests women during periods of fertility deliberately or inadvertently give off indications of sexual availability, suggesting rakes may be those males sensitive to these events and choosing to act on them.

Early silent films were notable for rake characters and moral lessons that employed them.

The Secret Orchard (1915) stars Blanche Sweet, who is seduced by an English nobleman, then falls in love with an American naval officer who excuses her indiscretions, then kills the nobleman in a duel before he marries Sweet.

Blind Husbands (1919) features cruel Austrian officer Erich von Stroheim, who gives a neglected American doctor's wife gifts, attention, and romantic talk:

> Von Stroheim: *You were created for nothing else but love, love with its longings, its ecstasies.*

The passive, sentimental wife is moved, flirting but honorable.

The Affairs of Anatol (1921) stars Wallace Reid, unfaithful to his wife with young beauties, including Bebe Daniels.

Foolish Wives (1922) uses Erich von Stroheim as a European rake, in a dress uniform or dressing gown, with monocle, elegant boots, and flickering tongue, quickly seducing an American millionaire's wife.

The Eternal Three (1923) has Raymond Griffith, a longtime rake, ply his female victims with alcohol before seducing them. He seduces and abandons Bessie Love. But while stalking his next victim, he is hit by a truck, and his surgeon is her dad.

Don Juan (1926) stars John Barrymore as a cavalier who seduces every pretty wife available. At one point he juggles the affection of three women at once, a husband pounding on the door. At the end, he is murdered by a jealous mistress.

Marks of the Devil (1928) stars John Gilbert as a rake who drops one conquest to seduce an innocent student and take her on a trip abroad. At times he looks at his face in the mirror, where he sees images of Satan.

The coming of sound films made possible a more complex and subtle treatment of the rake, suggesting the roots of his sexual compulsion and magnetism, and the reasons for women's vulnerability to him.

In *The Public Enemy* (1931), James Cagney's crime underworld is also a brutal sexual jungle in which he thrives. As a youth he plays cruel tricks on local girls, and is soon a criminal. After a night partying with Mae Clarke, they quarrel. When Clarke asks: *"Maybe you found somebody you like better?,"* he jams a half grapefruit in her face. Later, out driving, Cagney spots call girl Jean Harlow and gets her number. Soon he becomes a killer and is visiting Harlow, telling her *"How long can I wait...I'll go screwy."* In response, she sits in his lap, presses his head to her chest.

> Harlow: *The men I know...and I've known dozens of them...oh, they're so nice, so polished, so considerate...most women like them, Tommy. I guess they're afraid of the other kind. I thought I was too. But you're so strong, you don't give, you take. Oh, Tommy, I could love you to death.*

When a gang war breaks out, their leader has Cagney and the rest stay in an apartment he provided with cards, booze, and women. Cagney wakes up drunk and a prostitute explains she seduced him the night before. Furious, he runs outside and is gunned down.

The Road to Singapore (1931) stars William Powell as a nasty longtime seducer living in a British colony. He wants Doris Kenyon, the new wife of a workaholic. The tropics make Kenyon vulnerable; she is shown abed, fanning herself, legs spread. Later she sits on her porch, listening to the erotic energy of the tribal drums. The camera tracks across the village to Powell, also listening—suggesting physical attraction makes its own rules, and to follow it is to be in tune with nature.

Ladies' Man (1931) stars William Powell as a womanizer who lives off the gifts of rich women, meeting their emotional and physical needs. Olive Tell and daughter Carole Lombard both fall for him, but the jealous husband/father murders Powell, who actually loves a different one of his "clients," Kay Francis.

Tonight or Never (1931) features opera star Gloria Swanson, who sizes up admirer Melvyn Douglas as a gigolo. She gets into his apartment, and he chooses to act the archetypical rake, kissing her passionately and throwing her down. He then tenderly kisses her bruises, and confused, she cries: "*I don't want to love a man—that is, I do!*" He responds: "*Tonight, or never!*"

Downstairs (1932) tells how chauffeur John Gilbert seduces and swindles an entire family. Afterwards, the young wife is unrepentant, worshipping the rake's technique.

> Wife: *There's a kind of love that drives you mad and crazy. Are you going to throw me out in the street because I didn't know this before? If I can't have you, then I thank heaven I found something else. Something that makes you so dizzy you don't know what's happening to you, and don't care!*

One Hour With You (1932) stars Maurice Chevalier as a happy husband pursued by his wife's best friend. Provocatively, he tells her: "*Any man who lets a woman like you take up on a night like this with a man like me—deserves it!*" With the choice of a night with his wife or the friend he faces the camera and says: "*But this I know—we can't have all three be satisfied!*" Later he tells a detective: "*Now I ask you, what would you do?*" (The man shrugs.) "*That's what I did too.*"

A different group of early sound rake films emphasized the women's longtime suffering and wasted life, and the rake's exploitiveness, hypocrisy, and ridiculousness.

Back Street (1932, also 1941, 1961), set in 1901, has John Boles meet and fascinate Irene Dunne. Five years later they meet and though he is married, he sets her up as his secret mistress—otherwise his social position would be ruined. Her life consists of their brief meetings, but when she gets a marriage offer he swears undying love, retaining his selfish control.

The Mind Reader (1933) features a clearly phony psychic medium, Chandra the Great (Warren William), who specializes in seducing credulous young females. On a park bench, with an eerie smile, chattering psychic nonsense, he puts one hand on a shoulder, another on a thigh, and then smiling, nodding, he closes in.

The Private Life of Don Juan (1934) features aging rake Douglas Fairbanks, who stops womanizing, then starts again with gorgeous Merle Oberon, against advice from his wife and doctor. Soon he finds women no longer show any interest, and his wife declares him a sexual imposter.

The Affairs of Cellini (1934) has Fredric March as the hell-raising rake and talented artist, who pursues his lovely model Fay Wray, then chases beautiful Constance Bennett, the Duchess of Florence.

Anna Karenina is a movie made in 1935 (also 1948, 1997, 2000, and 2013). The 1935 version stars Greta Garbo as the wife, who falls in joyfully in love with dashing officer Fredric March, his magnetism clear in her fierce denouncement of her husband:

> Garbo: *You don't love me! You love only position and appearance...*
> *Your honor! Your selfishness, your hypocrisy, your egotism, your social position! All these must be maintained. You've never considered me as a human being.*

The two lovers run off, but March soon grows restless, and they quarrel and separate. Garbo learns he is posted elsewhere and rushes to the train station, sees his passionate goodbye to another woman, and steps before an oncoming train. The 1935 film emphasizes the power of the rake to torment a love-seeking woman.

The 1948 British remake starring Vivien Leigh also has the vulnerable Leigh driven to self-destruction.

Later rake films of the thirties portray the character type as having a more complex nature, perhaps a reflection of the difficult economic times.

Dangerous Secrets, aka *Brief Ecstasy* (1937, England), features Hugh Williams as a cheating playboy who seduces "good girl" Linden Travers, before going abroad. Soon after she marries her university professor. Years later he is a houseguest, and seeks to rekindle the affair. A violent storm suggests her apparent dissatisfaction with her marriage as he pounds on her room's door while she lies rigid on the bed.

Stage Door (1937) features Adolphe Menjou as Anthony Powell, a blundering, aging rake. At a dance studio he asks: "*Who's that blonde over there?*" as she murmurs: "*He makes me feel I should go home and put on a tin overcoat.*" He gets a part for Ginger Rogers, then takes her to his penthouse and points at a picture of a woman he says is his wife.

> Menjou: *Lots of men who are separated from their wives let it be understood they're not married. I believe in this day and age a man can have his home on the one hand and lead his own life. I know at the office I'm called a theatrical producer. That's a pose. Here I'm just a tired little boy with a dream. I'll be the sculptor; you'll be the clay. I'll be Pygmalion; you'll be Galatea.*

She responds by asking if Pygmalion and Galatea marry. Later he entertains another showgirl, who points out that his "wife" is an often-photographed model.

> Menjou: *My dear, you've just ended a very convenient marriage.*

The coming of World War II is reflected in the treatment of rakes as ruthless, pitiless, and obsessed with their own selfish needs and survival— perhaps reflecting wartime's harsher morality, and/or the view that unfaithful (soldiers') wives were contemptible.

The Maltese Falcon (1941) stars detective Humphrey Bogart, a cold-hearted rake who sleeps with his partner's wife, showing no regard for the couple. He soon meets, sleeps with, and falls for beautiful Mary Astor, a killer. In the climax the rake won't help Astor avoid justice, remaining a manipulator, going against his feelings since they would let her win against him. Bogart seems willing to oppose any romantic feelings, quite likely the rake's creed.

> Bogart: *Maybe I do* [love you]—*well, I'll have some rotten nights after I've sent you over, but that will pass...We'll make it just this: I won't because all of me wants to regardless of consequences, and because you counted on that with me, the same as you counted on that with all the others...I don't care who loves who, I won't play the sap for you. You killed Miles and you're going over for it.*

Less well known movie versions of the novel were made in 1931, and in 1936 as *Satan Met a Lady.*

Johnny Eager (1941) has Robert Taylor as an ex-con secretly running a town's rackets. Prim college student Lana Turner meets and falls for him and his smooth line, as he immediately admits he is an adventurous rake.

> Taylor: *Don't turn ordinary on me. I get tired of ordinary dames, and I don't want to ever get tired of you.*

The devious Taylor takes Turner home, where there is a staged attack on him, so Turner grabs a gun and kills the attacker. She believes Taylor can now blackmail her dad, a judge—"Keep my crooked dog track open, or your daughter will pay for what she did." Though Turner becomes sick to death, she can't stop throwing herself at Taylor.

Dr. Jekyll and Mr. Hyde (1941) is a fantasy treatment of the rake theme set in Victorian England. Dr. Jekyll (Spencer Tracy) must delay his marriage to gentlewoman Lana Turner despite his great passion for her. Enormously frustrated, he devises a potion that changes him into a subhuman, lust-driven beast, who finds satisfaction by ruthlessly seducing an immoral street woman, Ingrid Bergman. The rake side of his personality becomes ever more dominant and brutal, culminating in the passion murder of Bergman.

> March (as Dr. Hyde): *"I'm no beauty. But under this exterior you'll find the flower of a man!"*

Interestingly, postwar rake films often treated the rake as an upward mobile libertine, a counterpart of the forward-looking nation starting to make up for lost time.

Monsieur Verdoux (1947), written, directed by, and starring Charlie Chaplin, what is now called shock comedy, is based on the real serial killer Henri Landru, who seduced and murdered rich spinsters, advertising for them in newspaper lonely hearts columns. Comedy arises when one widow, Martha Raye, proves almost impossible to kill.

Ruthless (1948) has Zachary Scott getting ahead by seducing rich women. First he proposes to the daughter of the richest man in town. To be worthy, he attends Harvard, the father paying. Next, he conquers the daughter of a super-wealthy banker, then seduces the wife of a corporate C.E.O., getting her stock shares. Then it is on to an even richer woman.

The Adventures of Don Juan (1948) features Errol Flynn stringing along numerous women with rakish sweet talk, as below:

> Flynn: *I have loved you since the beginning of time.*
> Mary Stuart (as the character Catherine): *But you only met me yesterday!*
> Flynn: *But that was when time began.*
> Stuart: *But you made love to so many women!*
> Flynn: *Catherine, an artist paints a thousand canvases before achieving a work of art. Would you deny a lover the same practice?*

The fifties saw the flowering of American cinema, extraordinary films treating the rake theme. Several significant foreign films also dealt with the subject.

A Streetcar Named Desire (1951), set in New Orleans, is about the crisis created when crude, highly sexed rake husband Marlon Brando and his wife Kim Hunter are joined by her sexually tormented sister Vivien Leigh. Brando sees himself as a rake, taking pride in it:

> Brando to Hunter: *Listen, baby, when we first met—you and me—you thought I was common. Well, how right you was! I was common as dirt. You showed me a snapshot of the place with the columns, and I pulled you down off them columns, and you loved it! We were having them colored lights going, and wasn't we happy? Wasn't it okay until she showed up here?*

Leigh's unhappy life has already included her husband's suicide and casual affairs. Brando makes clear he is strongly attracted to the disturbed, passionate woman, but she has only contempt for the rake.

> Leigh: *He's like an animal. He has an animal's habits. There's even something subhuman about him. Thousands of years have passed him right by and there he is, Stanley Kowalski, survivor of the Stone Age.*

Meanwhile his conversations with his friends imply he is casually unfaithful, and his wife accepts it. Brando and Leigh at last confront each other (Brando: "*We've had this date from the beginning!*"). He brutally rapes her and engineers her commitment to an asylum, his wife finally leaving him.

A Place in the Sun (1951) stars Montgomery Clift as a success-driven youth who'll do anything to get "his place in the sun." As a supervisor in his uncle's factory, he secretly starts an affair with lower-class Shelley Winters. Clift is a likable, handsome devil, and soon meets a beautiful, wealthy, loving upper-class girl, Elizabeth Taylor, who could provide his place in the sun. He tells her, with some cynicism:

> Clift: *I love you. I loved you from the first moment I saw you. I guess maybe I even loved you before I saw you.*

But Winters becomes pregnant, and threatens to expose Clift to his new upper-class pals. He vows to kill her, and although she dies in an accident, he is convicted of her murder. In prison he is visited by Taylor, who reaffirms her love. The rake tells her to stop.

Clift: *Love me for the...time I have left...Then forget me.*

From Here to Eternity (1953) opens just before the outbreak of World War II. A major plotline is about a tough sergeant and casual rake Burt Lancaster, who begins an affair with Deborah Kerr, an unhappy wife in a loveless marriage to a mean, unfaithful officer. Noticing her womanizing mate leads Lancaster to the beautiful Kerr. Their early lust becomes true love, climaxing in a passionate embrace on a deserted Hawaiian beach, the foaming, rushing waves suggesting their intense feelings.

Lovers, Happy Lovers (1954, England), a prototype of many rake comedies, stars Gérard Philipe as a Frenchman who seduces a series of women, living off them until they try to catch him, then moving on. His first affair is with his female employer, mostly as job insurance, then he lives with a shop girl until she starts pricing bedroom furniture and speaking of matrimony. Next a French prostitute shelters him, then he marries, and next romances his wife's best friend, finally dying when he tries to fake a suicide to win affection, an ultimate comic womanizer—shiftless, tawdry, deceitful, and finally pitiful.

Confessions of Felix Krull (1957, Germany) stars Horst Buchholz as a young imposter carrying out gay and straight liaisons, including affairs in Germany, Paris, and Lisbon. At one point a society woman tears off her clothes and forces him to steal from her, crying out: "*How delightfully you debase me!*"

Written on the Wind (1956) is about rich, insecure Texas oilman and rake Robert Stack, a compulsive womanizer never sure if he is loved. When he is introduced to beautiful ad executive Lauren Bacall, he offers to buy her the ad agency and gives her a hotel suite of expensive gifts, trying to win her affections. They quickly marry, he mistakenly decides she is unfaithful and threatens to murder her, but is accidently killed.

Room at the Top (1959, England) stars Laurence Harvey as a slum-born Englishman who becomes a rake to go after class, money, and power. He works as an accountant, but feeling this is a dead end, he seduces the naïve daughter of the richest man in town. Though he feels no love, he decides to marry her to advance his fortunes. Later he meets Simone Signoret, ten years older than him and unhappily married. Strong love scenes suggest the depth of their feelings for each other. But he chooses to give up this love for his ambitions. He makes the rich man's daughter pregnant and Signoret kills herself. Harvey realizes he now has wealth but an empty life, having allowed the one woman who loved him to die. The sequel, *Life at the Top*, was made in 1965.

The Long, Hot Summer (1958) stars Paul Newman as an apparent rake, a troublemaker who arrives in the town Frenchman's Creek. There is soon a powerful mutual attraction between Newman and Joanne Woodward, a schoolteacher and daughter of the town "boss." Newman, however, comes on to her as the uncommitted rake:

Newman: *I'm going to show you how simple lovemaking is: you please me and I'll please you. I'll tell you one thing. You're going to wake up in the morning smiling.*

Woodward, however, has worked out her own response to such an offer from a rake.

Woodward: *I've got quite a lot to give. I've got things I've been saving up my whole life, things like love, understanding, and jokes and good times and good cooking. I'm prepared to be the Queen of Sheba for some lucky man and the best wife any man could hope for.*

Newman eventually apologizes, and the two plan to wed.

Rake films of the sixties and seventies stand out for more boldly and harshly probing the rake's ways of thinking, and how society deals with him (see also *Room at the Top* and *The Long Hot Summer*).

Saturday Night and Sunday Morning (1960, England) concerns rakish British machinist Albert Finney, who uses his self-control to have his own way, as he explains how he wins a drinking contest. Afterwards he visits Brenda, played by Rachel Roberts, a fellow workman's wife, the visit ending in the bedroom and then a quick exit. But when Brenda becomes pregnant, she rejects his offer of marriage or money: "*Nothing much you can do.*" She'll have the child and take what comes. Finney next meets Doreen, played by Shirley Anne Field, a careful beauty who sets out the terms of their relationship (and ignores her mom's disapproval). She fakes his leaving the house to satisfy her mom upstairs, then the lovemaking commences. Finney decides to marry Doreen. Going fishing, he tells a workmate "*Never bite unless the bait's good,*" presumably referring to sex. He'll leave living with his family for living with her and her mom. ("*Every boy's gotta get married sometime.*") In the end, the longtime rake stands on a hill with Doreen and hurls a stone away. ("*It won't be the last thing I'll throw!*")

The Roman Spring of Mrs. Stone (1961) features Warren Beatty as an Italian youth who provides "love for hire" through a procuress. She arranges a meeting with Vivien Leigh, and he is soon making love to the aging actress, who provides gifts and cash.

Leigh: *The beautiful make their own laws!*

When he leaves and she tries to win him back, he tells her cruelly that she was the subject of Rome's derision for accepting him. Later she tosses her keys down to a sinister stalker who has followed her, Beatty's dark counterpart.

All Fall Down (1962) stars young Warren Beatty as a self-absorbed rake, callous and indifferent. He is shown lounging on a big yacht, providing sex for an older woman. When his family takes in the beautiful, disturbed young Eva Marie Saint, he quickly seduces her, makes her pregnant, then abandons her so she commits suicide. When his younger brother confronts Beatty over the death, Beatty begins crying like a child.

Hud (1963) starts Paul Newman as an amoral, crude, sexually arrogant rancher who sums himself up thusly: "*The only question I ever ask a woman is, what time is your husband coming home?*" Hud crudely charms weary,

attractive Patricia Neal, then, drunk, he enters her cabin and tries to force himself on her. Neal leaves, and Hud's father tells him *"You're an immoral man, Hud. You don't give a damn."*

Marnie (1964) features Sean Connery as a wealthy businessman and womanizer boasting of his skill at taming wild animals. Tippi Hedren (Marnie), his beautiful employee, tries to steal from him but is trapped.

Connery: *I caught something really wild this time!*

He tries to "condition" her psychologically, threatening a horse she loves, keeping her on his estate, persuading her to marry him, but raping her on their honeymoon cruise. They visit her childhood home to relive a youthful trauma (her killing her prostitute-mom's client). In the end she embraces him lovingly.

What's New Pussycat? (1965, U.S., France), a sex farce, has Peter O'Toole, Paris fashion magazine editor and rake, endlessly chasing beautiful women, but unwilling to marry. Hosts of women pursue O'Toole, including Romy Schneider, who loves him and would marry him if he'd stop being a rake. Lovely Capucine also wants him, as does stripper Paula Prentiss. O'Toole finally decides to marry Schneider just as stunning Ursula Andress shows up. There is a final wild game of sexual musical chairs at the close, with all of the women trying to capture O'Toole. He marries, and a new beauty pops up, paralyzing him with lust.

Alfie (1966, England), a thoughtful treatment of a rake's character and life, stars young Michael Caine as a cockney rake who uses women ruthlessly: *"You got to look out for yourself in this life."* He realizes trouble is inevitable. (*"If they ain't got you one way, they got you another."*) Caine tries to protect himself by refusing serious involvements. (*"It don't do to get attached to nothing, 'cause sooner or later it's gonna bring you some pain."*) Early on, when his steady "bird" Gilda insists on having his child, he gives up interest in the boy. (*"My understanding of women goes only as far as the pleasures."*) Later, he seduces a friend's wife, which makes it necessary to arrange her abortion: *"You don't get anything free in this life...when it comes to pain in love, like any other bloke, I didn't want to know."* Caine then picks up a girl, Annie, who he turns into his housekeeper, though he insists she stay attractive. (*"Nothin' gets me off so much as a bird getting 'old of me with hard, 'orny mitts!'"*) He encounters a variety of other women: a hedonist, an egomaniac, and a rich woman who uses men. At the end, he is alone yet again.

Caine expresses remorse over an ultimately empty life. *"I don't want a bird's respect—I wouldn't how what to do with it."* The words of the film's theme song spell out the rake's awareness of his shallow exploitation of others' hopes and needs: "What's it all about, Alfie? Is it right to take more than you give?" A sequel, *Alfie Darling* (1975), has Alan Price meet the love of his life, she dies, and he continues on behaving as before. In a remake, *Alfie* (2004), Jude Law gains no insights into his life.

Tristana (1970) stars Fernando Rey as Luis Buñuel's idea of "a womanizer and a blowhard" in 1930's Toledo, Spain...a Don Juan in decay. Rey has a reputation as a rake, with many sexual successes. For the last six years, he's had

a relationship with a childlike young woman he is the guardian of, Tristana—Catherine Deneuve. His attraction to her appears to be a combination of his need for her young companionship and his dissatisfaction with older, worldly women. At one point he tells her: *"I'm your father and your husband, I can be whichever one suits me at the time."* She comments that when he is not spruced up, *"he is a different person, a cock who has lost his feathers and can't sing."* She leaves him to pursue a romance with an artist, but is stricken with illness and returns, still in love with Rey. His family insists they marry, offering an estate as an incentive. On the wedding night he is dismissed by his bride, and huddles alone over a fire. Much of *Tristana* is meant to mock the intelligentsia of Buñuel's generation. In the end, Buñuel's rake tries to make a home for himself.

In *The Heartbreak Kid* (1972), goofy protagonist Charles Grodin only begins to realize his rakishness on his honeymoon. His new bride is a childish young woman, barely pretty, insisting she must be told how wonderful they are together sexually. Soon after, however, he meets Cybill Shepherd, a long-legged, blonde, American dream girl, and immediately begins a series of crafty maneuvers to separate from his new bride and capture Shepherd, telling his new interest as much.

Grodin: *The marriage is off. I had my doubts in Virginia; I was pretty sure in Georgia. But you settled things for me in Florida. I've been waiting for a girl like you all my life.*

After sex, she tells him breathlessly, *"I knew it could be like this."*

Soon he leaves his bride and is moving towards his second marriage. Yet he is already half aware his new wife may well be as empty and share as little with him as his first as she murmurs: *"You're so positive about everything. Daddy's the same way."* A somewhat inadequate character analysis of a suitor who is a sneak and a cad.

Many rake films of the seventies, like these two, variously interpret the rake's compulsive need to manipulate the male-female relationship. *Last Tango in Paris* is an extreme case, seeking to illuminate the nature of sexual relations in partners who for the moment have no social or personal existence.

In *Last Tango in Paris* (1972, France), Marlon Brando, a tormented recent widower, encounters young Frenchwoman Maria Schneider as they are both looking over an empty apartment. Without speaking, they immediately have violent, animal-like sex. His wife a recent suicide, Brando wishes a purely physical affair (a rake's dream?).

Brando: *We don't need names here. Don't you see? We're going to forget everything we knew—everything—all the people, all that we do, wherever we live. We're going to forget that, everything—everything.*

The two retreat to a wordless state and wordless couplings. Schneider becomes a willing prisoner to the man's lust, a working out of the rake's control obsession. Gradually the rake's anger at women leaks out, then floods out. He attacks his family's tyranny, his nightmare childhood, mocks the church and society as he anally rapes her. Fascinated, she says he is the man she loves; as he seeks to humiliate her totally. Next he attacks all women: *"Either they pretend to*

know who I am, or they pretend that I don't know who they are!" It is the nightmare version of his dream life—ecstatic existence outside of normal everyday life. Still, he has touched her real self, totally arousing her into wild frenzy, glorying in his brutal and savage prowess. Nonetheless, after he buries his wife, he seeks to continue his conventional social life by marrying Schneider. Yet outside in the social world, she sees him as just another middle-aged failure and has-been chasing a good-looking, middle-class girl. When he pursues her into her family's bourgeois home, she shoots him. Brando is both a selfish, unloving brute, and a tragic rake figure, suffering and honest and real.

The Man Who Loved Women (1977), a charming, distant counterpart to *Last Tango in Paris*, stars Charles Denner as a man who falls in love with every woman he meets, and each of them with him. For him, seduction is a passion. When he notices a beauty in black silk stockings, he becomes fascinated, and must track her down, no matter the difficulty, yet he stays sweet and innocent, and all the woman readily enjoy him as well. He explains it thusly:

> Denner: *If their hearts are fate, then their bodies are for the taking, and it seems to me I haven't the right to pass up the chance.* For him, *"women's legs measure the world like a compass, giving it balance and harmony."*

In the end, chasing another beautiful pair of legs, he is run over. In the hospital, trying to embrace a nurse, he accidently disconnects his life support system. At the funeral, dozens of beauties appear to mourn his passing. A remake in 1983, starring Burt Reynolds, was unsuccessful.

In *Swept Away* (1974), a frustrated, foul-mouthed sailor, Giancarlo Giannini, is cast away on a lovely island with an arrogant, upper-class babbling beauty, Mariangela Melato. His animalistic sex quickly brings her down to his level (*"You are a man as he must have been in nature!"*), so she eagerly fulfills all his sexual dreams. But when they are rescued, the relationship dissolves.

Fellini's *Casanova* (1976) inverts the rake plot, with Donald Sutherland as a haughty Lothario who seeks to sleep with various beauties across Europe, but can take little pleasure in his activities. One stunning girl vows to meet him but never appears, another proves to be a cleverly operated mannequin, but he is so overcome with lust he makes love to it anyway.

Dona Flor and Her Two Husbands (1976, Brazil) stars Sonia Braga as a beautiful, sensuous widow whose second spouse is aged, boring, and repressed. As she lies in bed, her first husband's nude ghost appears—a whoring rake, but also a fiery womanizer. After his blandishments, she lets him take her to bed (he is invisible to everyone else). This is followed by more sexual encounters. In the last scene, all three go off to church, Braga smiling lasciviously.

All That Jazz (1979) stars Roy Scheider as Bob Fosse, a Broadway dance choreographer surrounded by beautiful women that he casually controls and seldom resists. He is always promiscuous and always unrepentant—to the edge of death, as he confesses in a hospital scene:

Scheider: (to his wife) *If I die, I'm sorry for all the bad things I did to you.* (To his mistress) *If I live, I'm sorry for all the bad things I'm going to do to you.*

The rake films of the eighties are different, not focusing on the rake's sexual obsessions, but rather accepting seduction as central to his nature, and dealing with how it fits into an increasingly amoral world.

American Gigolo (1980) centers on narcissistic, handsome, bisexual rake Richard Gere, an assertive male prostitute (self-described "guide and interpreter") to wealthy women. At one point, he tells how he spent hours bringing a mature woman to orgasm for the first time.

Gere: *It took me three hours to get her off. When it was over, I thought I'd done something worthwhile—who else would have taken the time?*

Early on Gere meets Lauren Hutton, a sophisticated, lovely Frenchwoman who has few illusions about him. Next a pimp friend sets up a kinky ménage à trois with a Las Vegas couple. Later, Hutton and Gere make love. The Las Vegas woman is murdered. Fearing arrest, Gere pleads with the pimp to help him, but it is soon clear the pimp framed him deliberately. Hutton, however, alibis Gere.

Bad Timing (1980) concerns rake/psychoanalyst/spy Art Garfunkel, who claims to be a ruthless seeker of truths—"a Freud, a Stalin, a J. Edgar Hoover." When the stunning Theresa Russell meets him, he decides to investigate her beauty, personality, and activities. They date, and he tries to convince her that she loves him.

Garfunkel: *You tell the truth about a lie so beautifully.*

His controlling efforts so depress her she turns to drugs, wears children's clothing and chains, and begs him to "fuck off." When she overdoses, he repeatedly has sex with her, chanting: "*You don't need anyone else.*" When he lets her almost die from a drug overdose, she leaves him. Her older husband explains: "*You must love her tremendously, more than one's own dignity.*"

An Officer and a Gentleman (1982) stars Richard Gere, made insensitive to women by a childhood with a lecherous, alcoholic dad. Rake Gere attends naval pilot school, where his sergeant spots him as a selfish hustler. Gere meets Debra Winger, a strong-willed, low-class mill worker determined to become some pilot's wife. Gere and Winger are soon together, making out on the beach, and then going to a motel where he acts badly. She tells him she is not "some whore" he picked up, and they become affectionate. She says she only wants to have a good time until he leaves. He pulls her close, saying, "Last night was incredible." She agrees. A nude love scene shows them kissing, staring at each other, talking intimately, and snuggling happily, so the rake has won her. Later they break up. (Gere: "*I don't need you, I don't need anyone!*") But he recognizes their oneness, and they reunite.

Tales of Ordinary Madness (1981) stars Ben Gazzara as an aging beat poet (modeled on Charles Bukowski's stories) who is either reading his works, drinking to excess, or seducing disturbed women, "seeking to find himself." The women make it easy to be rakish: self-destructive floozy Ornella Muti cries out:

"*Now give it to me! Take my soul with your cock!*" Susan Tyrrell, in black underwear, announces: "*I want you to be mean to me! Next time I want you to use the belt!*"

Choose Me (1984) features Keith Carradine as a devilishly handsome master rake and/or psychopath—he claims careers as jet pilot, Yale professor, and C.I.A. spy—who drifts into dark, clubby L.A. and goes on a romantic rampage with its beautiful neurotic women with their shifting, multiple personas, zeroing in on their most secret needs ("*I only kiss women that I'd marry*"). A typical come-on is with Lesley Ann Warren.

> Carradine: *You have perfection about you...your eyes have music...your heart is the best part of your body. And when you move, every man, woman, and child is forced to watch.*

Nine ½ Weeks (1986) has Mickey Rourke, a high-powered stockbroker, attracted to beautiful art dealer Kim Basinger. He stalks her, then charms her with fancy gifts. The two sophisticates turn to sexual games in her apartment. A fantasy of erotic play and control is set up.

> Roarke: *I want to feed you, dress you, bathe you.*

Basinger begins to fear he has taken over her personality:

> Basinger (to pal): *I think I've been hypnotized.*

Soon the games include blindfolds, riding crops, cross-dressing, and money pasted over nakedness. Next it goes too far: she is crawling to him, and watching his sex acts with another girl. Desperate, he begins telling her his true life story, but Basinger leaves as Roarke cries out: "*I love you!*"

A sequel, *Another Nine & a Half Weeks* (aka *Love in Paris*, 1997) has Rourke search for his love, but he meets her confident, act-alike friend who falls for him and plays his games for her own pleasure, without understanding. Meanwhile his love has died, and Rourke is finally left alone.

The Witches of Eastwick (1987) is a fantasy of three man-hungry modern women who conjure up the ultimate rake, the devil (Jack Nicholson), who seduces each in turn. A well done scene has Nicholson carrying out a successful seduction with Alex, an intelligent, sophisticated, dissatisfied modern woman played by Cher.

> Cher: *I have to...*
>
> Nicholson: *You've done your best, Alex. You've done the motherhood bit, the garden club, the car pools, the cocktail parties, coffee in the morning with the cleaning lady, a couple of drinks, a couple of pills, a little psychoanalysis—where are you now?*
>
> Cher: *I don't know.*
>
> Nicholson: *Pretending to be somebody else. Pretending to be half of what you are. How long can you last like that? The world keeps growing, you feed it, but it doesn't feed you anymore, does it? It washes through you, wasted, down the drain. A woman is a hole, isn't that what they say? All the futility of the world pouring into her. How much can you take, Alex? How much before you snap?*
>
> Cher (dizzy): *Don't—*

Nicholson: *Lying on a bed, staring at the ceiling, waiting for something to happen, and knowing all the time that you were meant for something better. Feeling it, wanting it, having so much power. Use it, Alex. Use me. Use me. I'll be your hole. Fill me up. I want your magic. No. Don't wait. Time is a killer. Make it happen. Do it, Alex. Do it now!*

Later in the town church, Nicholson gives a vicious and furious sermon against women, summing up the rake's impossible needs and demands.

Nicholson: *You think God doesn't make mistakes? But when he does—they call it nature!*

Moonstruck (1987) stars Cher as a widow proposed to by her dullish fiancé, who then meets his volatile brother, Nicolas Cage. Cage is a furious sensualist who lost a hand in a work accident, and is filled with grief and self-pity. Drinking, Cage and Cher admit they don't think either will find true love, but he wants her.

Cage: *The storybooks are bullshit! Now I want you to come upstairs with me and get in my bed! Come on...come on...come on.*

Later he claims his rake's wildness is what she has always been looking for, right or wrong.

Cage: *I'm a wolf? You run to the wolf in me, that don't make you no lamb! You're gonna marry my brother? Why you gonna sell your life short? Playing it safe is just about the most dangerous thing a woman like you could do! We aren't here to make things perfect, we're here to ruin ourselves, break our hearts, and love the wrong people!*

The two spend the night together and soon decide to marry. The film's first title was *The Bride and the Wolf.*

The Pick-up Artist (1987) stars Robert Downey, Jr. as a young pickup artist who practices facing a mirror: "Hey, my name is Jack Jericho. Did anyone ever tell you that you have the face of a Botticelli, and the body of a Degas?" He comes on to every good looker in New York—they walk off, are flattered, or even give him their numbers. His goal—perfecting his technique. Then he meets Molly Ringwald.

Downey: *Did anyone ever tell you you're too good to be true?*
Ringwald: *Only that I'm too truthful to be good.*

When he tries to seduce her, she complies, and they make love in his car. She disappears, but he tracks her down. They're both obsessive gamblers, so Ringwald says they must part. Downey replies their love is not a gamble but preordained fact, and they walk off together.

Barfly (1987) tells the story of alcoholic poet Mickey Rourke, powerfully drawn to beautiful young women he finds in low dives. A fast conquest is Faye Dunaway (Rourke: "Some kind of distressed goddess!"). Deciding they're soulmates, the two spend endless days and nights drinking and talking. They're soon living in her trashy furnished apartment, the alcoholic rake drawing her to him in soft, soothing tones, though Dunaway has violent episodes:

Dunaway: *We're all living in some kind of hell and the madhouses are the only places where people know they are in hell!*

Soon they meet Alice Krige, a literary magazine publisher, and Rourke works his magic on her. In bed with the wealthy beauty, he is still the rebel:

Rourke: *I belong on the streets. I don't feel right here. I can't breathe!*

The two gorgeous women are soon fighting over him on a barroom floor, biting and scratching over the free spirit artist-rake that lady rebel aristocrats seem unable to resist. *Barfly* has been highly praised as a beautiful, sincere film that shows how the other half thinks and feels, all of its naked emotions and romantic vulnerabilities.

The Unbearable Lightness of Being (1988) starts in Prague in 1968, where Daniel Day-Lewis is a brilliant surgeon and rake, handsome and youthful with a crooked, seductive smile. Immediately after a brain operation, he playfully asks his nurse to undress for him. His longtime independent sex partner is Lena Olin, partial to black lingerie. He won't, however, spend a whole night with her, or any of his women. He meets shy Juliette Binoche, makes his intentions plain, but has to hurry off. She follows him home, and wild lovemaking follows. They marry, but he keeps seeing Olin—sex and love are not the same thing, he explains. When the Soviets invade, they all go to Switzerland. Lewis and Binoche return to Prague, where he works as a window washer, still chasing agreeable women. *"Take off your clothes,"* he says, adding, *"don't worry, I'm a doctor."*

The rake films of the nineties tend to playfulness or tragedy: the rake is accepted as part of a decaying society, amusing or destructive depending on the circumstances.

Don Juan DeMarco (1994) stars Johnny Depp as a mental case who has taken the identify of Byron's Don Juan, complete with medieval swordsman costume, manic libertine manner, and an obsession with women, as when he asks his therapist Marlon Brando.

Depp: *Haven't you known a woman who inspires you to love until your every sense is filled with her? You inhale her; you taste her. You see your unborn child in her eyes and know that you have at last found a home. Your life begins with her, and without her it must surely end.*

The rake wants to commit suicide because after a thousand women, his true love has turned him down. Flashbacks show his fantasy romance: an adulterous affair, education in a harem by 1500 women, and the island of Eros where he wins and loses his true love, Géraldine Pailhas. Eventually he is released, and Brando takes him to Eros, where Depp's true love awaits.

The Mask (1994) stars Jim Carrey as a repressed, submissive bank clerk who meets sexy dancer Cameron Diaz, who has a gangster boyfriend. Carrey finds a pre-Columbian ceremonial mask that loosens up his personality so he can impress the girl. The mask dissolves all inhibitions, and his hungers for sex and aggression go wild. He eagerly chases Diaz, saying: "Our love is like a red, red rose, and I am a little thorny!" The newly born rake is soon dancing with her at

the nightclub where she performs, arranging a later rendezvous. Soon Diaz is chasing Carrey.

The English Patient (1996) features Ralph Fiennes, first seen as a victim of serious burns during World War II, then earlier as a handsome rake and cartographer who charts Africa's deserts. He meets married Englishwoman Kristin Scott Thomas, the two matched in passionate conversations and otherwise, so separation is a torment: "*Every night I cut out my heart, but in the morning it was full again.*" When she resists, he insults all at a party, including her and her husband. When the husband learns of the affair, he crashes his plane, killing himself and crippling her. Fiennes promises to save her, but must sell British secrets to the Germans to get a plane and supplies. By the time he returns, she is dead. He puts her shrouded body in the plane, and then flies it into enemy fire so it crashes and burns, explaining how we first see him.

Anna Karenina (1997) revises the Tolstoy novel, dashing Russian officer and rake Sean Bean meeting young wife Sophie Marceau and becoming fascinated with her. They soon start a torrid affair. She becomes pregnant, confesses to her husband, and demands a divorce. The lovers go to Italy and then come back, and are shunned by society. Anna turns to opium, and despondent, commits suicide when she suspects the rake is having a new affair.

The rake films of the twenty-first century continue the tendency of the previous decade to accept the rake as a conventional part of society, focusing on how his rakish nature shapes his character, and impacts society as a whole. There is little moralizing; rather the rake is just more evidence of society's slide into hypocrisy, indifference, and decay.

Autumn in New York (2000) centers on Richard Gere as a middle-aged Manhattan restaurateur and charming lecher. He spots Winona Ryder, beautiful daughter of a deceased old flame. They sleep together, and he explains that he can't offer her any future, just a glamorous superficial present. She replies she has a terminal heart condition. A warning from a friend whose daughter suffered at Gere's hands is disregarded. Soon Gere is sneaking off for sex with another woman. When Ryder finds out and asks about love, he says she is "a kid." They separate, but then Gere meets a girl he fathered, but ignored. He returns to Ryder telling her: "*You ruined me for other women.*" Ryder dies, but Gere perhaps has learned his lesson. Or perhaps not.

The Tao of Steve (2000) features Donal Logue as a charming, knowing, aging college graduate, a former campus Yoda who scored with many coeds. Using Kant and Schopenhauer-based pickup lines he still perseveres, winning over a lady bartender by analyzing a Long Island iced tea. ("*Add vodka and Everclear, the sweet twins of Judaism and Christianity, and the West's only contribution—Coca-Cola.*") The Tao of Steve is his seduction formula— "*Eliminate desire, be excellent in her presence, and then retreat!*") Thus the rake outlines how to avoid commitment. A local girl drummer, Greer Goodman, tests the Tao, his elaborate excuses to avoid real love.

The Invention of Love (2000, Quebec, original title *L'Invention de l'Amour*) deals with rake David La Haye engaging in a ménage à trois with a married

woman and a young prostitute. Trying to deal with the pain of a breakup with lover Irene Stamou, he visits a hypnotist's office. But on the way to reconcile with Stamou he is struck by the car of Pascale Montpetit, a married woman. They soon become passionate lovers, but because she still cares about her husband, her life begins to fall apart. Meanwhile, the free-spirited prostitute, Delphine Brodeur, is now sexually involved with them. One night after heavy drinking the three form a ménage à trois. The intense intimacy is too much to sustain. La Haye leaves Montreal not knowing Brodeur is pregnant with his child, while Montpetit goes back to try to deal with her marriage.

Two Ninas (1999) has Ron Livingston, a writer and ordinary guy, meeting Cara Buono (Nina), then also dating Amanda Peet (a second Nina). The first holds out sexually; the second quickly gives in. But he likes both and continues seeing both after three months, despite many close calls. He begins losing track of date nights, phone numbers, and confessions. The two women already know each other, and when the right message gets on the wrong phone, the inevitable unwinds.

Pipe Dream (2002) concerns a plumber, Martin Donovan, who decides to impersonate a Hollywood film director to attract women, though he is already sleeping with neighbor Toni Edelman, who is a screenwriter. Donovan gets a friend, a Hollywood pro, to set up a fake casting call and soon beautiful actresses are showing up eager to win the new film director's adoration any way they can, particularly by doing romantic scenes from Toni's script. Edelman and Donovan work together to get her film made, but then the plumber becomes "obligated" to a new actress for the lead role. After more romantic complications, the movie moves ahead toward production.

Solitary Man (2009) starts with Michael Douglas as a bigtime car dealer and loyal husband who is told that he may have a heart problem. Flash forward six years, and he is a convicted swindler and compulsive rake. (Sixtyish, meeting his grandson at a park where there is a twentyish blonde, he tells the kid not to call him Grandpa—it might hurt his chance with the blonde!) Bedding a woman with powerful connections, he can't resist sleeping with her creepily beautiful daughter, ruining his chance to start over. Penniless, he comes on to college girls, through it is clear they loathe the beefy, sixtyish cad. In the last scene, he sits on a bench, and his kind ex-wife offers to help him, just as a cute coed strolls by—he rises, face opaque, and it's left to viewers to guess which woman he'll pay attention to!

Heartbreaker (2010, France, original title *L'arnacoeur*) has rakish French charmer Romain Duris putting romantic moves on a rich haughty beauty, Vanessa Paradis. Duris devotes his life to breaking up mismatched couples by making a play for the female partner, giving her the impression she is missing out on something better. (Duris: *"They deserve the best."*). His efforts are paid for by the girls' parents or friends, who believe the girl has made a mistake, at least from their point of view. His "rules" include not going after couples that are really in love, and not sleeping with the women. (He is really a pseudo-rake, but a rake for all practical purposes.) His operations are quite elaborate,

including exhaustively researched targets and using a group of talented associates to play roles in his often masterfully orchestrated seduction scenarios. In an early scene, in North Africa, Duris poses as a humanitarian doctor to charm a young woman away from her prosaic boyfriend. The seduction dramas can include his eyes filling with tears at a memory of childhood abuse, as well as making the woman believe the two are mystically in tune in their food, entertainment, and dancing choices.

Society changes over the years and decades, but the rake always finds ways to be irresistible.

Chapter Three
Love Intrigue

Love intrigue seems a good general term for films and, for that matter, real relationships, in which additional and/or contradictory motives play as significant a role for the lovers as passion, love, and romance. In these relationships a lover or lovers employ various forms of intrigue thus creating illusions, shaping false expectations, hiding true facts, values, or goals, or using still other kinds of manipulations or trickery.

Of course most passion, love, and romance involves some imperfect communications, accidental or exaggerated or playful, but in love intrigue the miscommunication is coldly or even meanly calculated, even directly opposed to romantic appearances. Reasons for this cover a wide spectrum: it may be the only if dishonest way to attract or hold a lover, meant to hide or deny one's flaws, or to achieve some other end at great risk or great harm. Popular culture often speaks of dissembling in romance. As one witticism says, "love is a little sighing, a little crying, a little dying, and a great deal of lying."

Psychologically, films that feature love intrigue often deal with emotionally wounded characters that use each other sexually or otherwise to deal with their own emotional emptiness caused by not being able to live out true romance. All the complications and maneuverings are an elaborate maze created to provide diversion from real feelings that hold too awful possibilities or memories. Many viewers may relate to this on an unconscious or even conscious level.

Many early silent film dramas are love intrigue movies, often playful and innocent. But most make the point that lovers often choose subterfuge and indirection to win their beloved.

Reggie Mixes In (1916) has millionaire Douglas Fairbanks masquerade as a saloon bouncer, and fall for Bessie Love, a dancer. Fairbanks whips a bully and then a gang leader, arranges for Love to inherit $100,000, proposes, and reveals the truth about himself.

The Eagle (1925) has Valentino, a Czarist officer, turn vigilante when a tyrant seizes his family's holdings. But when he falls for the tyrant's daughter, he drops the fight for justice, disguising himself as a handsome fop to win her love.

Battling Butler (1926) stars Buster Keaton as a wealthy fop who disguises himself as a boxer to win a girl, then is forced to fight in the ring for real.

Midnight Madness (1928) has a millionaire marry a tough fortune hunter, who takes her on a safari to Africa where the phony hardships he arranges convince her of his love.

The Virginian (1929) has cowboy Gary Cooper courting a schoolmarm, and acting like a mischievous boy: *"Would book learnin' do cowpoke any good?"* He embraces, kisses, and quickly marries her— *"Bein' a schoolteacher ain't a real woman's job in life!"* But the boyish cowpoke has his own pitiless view of justice. When his best friend turns cattle rustler, Cooper quickly hangs him. (*"There ain't no room for weaklings, men or women!"*)

The coming of sound made possible more complex love intrigue romances, often with roguish or criminal lovers whose dishonesty could be forgiven.

One Way Passage (1932) stars William Powell and Kay Francis, who start a romance on an ocean liner bound for San Francisco. Both conceal grim secrets: Francis has a terminal illness; Powell is a murderer being delivered for trial (a kind cop lets him move about without handcuffs). Neither confides the truth. Powell escapes but comes back when he learns her story, and she learns his secret. They agree to meet for drinks at a club, and so at the end, at the club, two glasses click and break. This film was remade in 1940 as *'Til We Meet Again.*

No Man of Her Own (1932) stars Clark Gable as a tough con man: *"What gets me is the way women can't laugh when it's over."* Small-town girl Carole Lombard chases him using a phony tough façade, and a two-headed coin. (Lombard: *"The girl who lands him will have to say no, but isn't it tough when all you can think of is 'yes'!"*) He's outsmarted, they marry, and he gets a nine to five job, but stays tough. (*"C'mere, you!"* he says at the end.)

Twentieth Century (1934) stars Carole Lombard as a Broadway star and John Barrymore as a bigtime producer, formerly lovers. He is willing to use every trick and con he can think of to get her to appear in his upcoming show, and presumably renew their relationship. It gradually becomes clear that they should be together again as lovers since both are passionate and ruthless toward each other in the same way. When he threatens to slash his throat if she doesn't rejoin him, she says it's all a con.

Lombard: *If you did, greasepaint would run out of it.*

As the Great Depression came to dominate society, love intrigue films often emphasized the characters' need to use duplicity and other scheming ways in love as their last chance to find acceptance and affection in hard times.

Alice Adams (1935) stars Katharine Hepburn as a small-town girl from a modest background who wants to join the social elite, in particular to attract upper-class bachelor Fred MacMurray. But when he attends her family dinner, all her faked "sophistication" fails, ending in a financial crisis. But when she works a way out, he embraces her, so she cries: *"Gee whiz!"*

Theodora Goes Wild (1936) has Irene Dunne as a country girl who writes a titillating romance novel under a pseudonym. When the cover artist tries to enact the novel's seduction scene, she cries: *"Don't you dare!"* and fights him off. He promises *"to give her the world...break loose, be yourself!"* She reveals her true self at last. *"You've scolded me and frightened me all I'll stand for!"* In New York she crusades for female freedom, and gets the artist to divorce his wife and chase her.

Libeled Lady (1936) starts with heiress Myrna Loy plotting a libel suit against a local paper for an untrue story about her. To stop her, editor Spencer Tracy hires lawyer William Powell to set Loy up as a "husband stealer." First, Powell is married "in name only" to his frustrated lover Jean Harlow, then he fakes a romance with Loy—until they really fall for each other. After a big fight, the truly loving couples match up. Loy cries out: *"You can't build love on hate or marriage on spite!"* But you can on a little intrigue, apparently.

Desire (1936) stars Marlene Dietrich as a beautiful, crafty jewel thief who flees Paris with a priceless string of pearls. At the border she tricks customs, dropping the necklace into young Gary Cooper's pocket. She ends up in his car, and Cooper is soon in love with her, and she with him. Shamed by her past, she tells him she's already married, and a thief. Cooper learns she's single, has her return the pearls, and the two marry and take off for the U.S.

Love Before Breakfast (1936) has lovers manipulate each other to get the right matchups. Millionaire Preston Foster and assistant Cesar Romero both desire Carole Lombard, who prefers Romero. Foster sends Romero to Japan on a ship with Betty Lawford, an irresistible love opportunity. Foster then chases Lombard with no success until Romero telegraphs he's marrying Lawford. Lombard gives in, but also begs Romero to return. Catching on to Foster's scheming, she breaks the engagement, but then realizes he did it because he loves her, so they wed.

The late thirties saw a number of more subtle and complex treatments of the love intrigue theme. *The Plainsman* (1936) stars Gary Cooper as Wild Bill Hickok, pioneering America's West, while Jean Arthur is Calamity Jane, always telling him she loves him though he replies, *"she isn't woman enough."* He wipes off her kisses, staying cold and sexually indifferent. He holds her love by denying it. When he's killed, she kisses him, concluding, *"For once he won't wipe this kiss off!"*

Angel (1937) stars Marlene Dietrich as the neglected wife of diplomat Herbert Marshall. Earlier she had a secret affair with Melvyn Douglas, who knew her as Angel, and still madly wants her. Douglas learns Angel is the diplomat's wife, but she won't admit her past with him. Her husband also learns about Angel, and seeks the truth. When the old lover and couple meet at a bordello the husband tells her she's Angel, and unfaithful. She again denies it. Angel is supposedly in the next room, but "If you go into that room, our marriage is over!" That is, to keep her love, he must go along with her intrigue.

Dietrich: *You won't be sure of yourself...or of me. And that could be wonderful.*

He goes in, and Dietrich prepares to go off with her old lover. The husband returns and says: *"She looks exactly like you!"* He asks Dietrich to go off with him, and she does. Participating in her love intrigue, he saves his love.

The coming of World War II was reflected in a new crop of love intrigue comedies, relieving war's tension.

The Shop Around the Corner (1940) is set in a Budapest gift shop. James Stewart and Margaret Sullavan star as employees who dislike each other, although without realizing it they also have a relationship via the newspaper "personals." In a sense the film is a love intrigue among four people. Eventually Stewart realizes the truth, and at last admits he's her letter-writing lover. Sullavan embraces him and cries: *"Take me out of my envelope and kiss me!"*

My Favorite Wife (1940) has Cary Grant marrying svelte Gail Patrick, believing first wife Irene Dunne was lost at sea. Then she reappears, ready to go on with the marriage, if not to speak of her desert island days with Randolph Scott. Grant must decide what to say and what to conceal—a real love intrigue.

>Dunne: *Are you sure you don't love her?*
>Grant: *The moment I saw you I knew.*
>Dunne: *Oh, go on! I bet you say that to all your wives!*

Too Many Husbands (1940) has Jean Arthur, just married to her missing husband's pal Melvyn Douglas, faced with the return of late husband Fred MacMurray, who still wants her. Each must maneuver as best he can to win her, dealing with his competitor. Douglas paws her in a closet, and MacMurray leaps chairs. Both masquerade as Hollywood macho men, and they try to both dance with her at the same time! In the end she decides she likes having two suitors endlessly intriguing to win her.

The return of peace led to more melodramatic love intrigue stories, some perhaps inspired by the real-life stresses of war-separated couples and their efforts to reunite, or the shifting of identities the war led to.

Spellbound (1945) has psychiatrist Gregory Peck becoming head of a mental institution, though he himself acts unstable. Psychotherapist Ingrid Bergman falls in love with him, and also seeks to help him, the feelings in a passionate kiss implied by endless opening doors suggesting her ecstasy and submission. Peck soon thinks he's not a psychiatrist, may even be a murderer. He flees, and Bergman joins his intrigue, with the police in pursuit as she continues therapy on an intriguer who may kill again.

Madame Bovary (1949), based on Flaubert's novel, is another character's futile love masquerade, with intrigue leading to ruin. Jennifer Jones is the tempestuous Frenchwoman who marries a conventional doctor she soon finds dull. She hides her feelings and, taking on a passionate persona, has an affair with a rich man, Rodolphe Boulanger (played by Louis Jourdan), whom she finds is even more tedious, though he's a deft seducer.

>Jourdan: *This fact that haunts me, drugs me...those hands that were designed for a thousand pleasures. These lips—were they meant to speak of love or grocery lists?*

Love intrigue films of the fifties took the theme in a new direction. Instead of leading to torment, the lover's tricks and subterfuge often lead to happiness and fulfillment, though things get rough for those who get in the way. The fifties was a highly conformist decade, so making the idea of a love ruse work was especially fascinating to audiences.

No Man of Her Own (1950) starts with single Barbara Stanwyck pregnant by lover Lyle Bettger, so he puts her on a train out of town. She befriends a young married couple, and when they die in a train wreck, Stanwyck takes the wife's identity. Now daughter-in-law to the dead husband's rich parents, she has the dead man's older brother fall for her. Then her old bad boyfriend shows up asking for a payoff for his silence, so the couple kills him, their love stronger than ever. The film was remade in 1983 as *I Married a Shadow*.

In *Invitation* (1952), rich man's daughter Dorothy McGuire, who has never known love, is dying of a heart problem. Rich dad Louis Calhern hires ladies' man Van Johnson to fake his affections to give her "the ultimate happiness." Maguire finds out the truth, but by then Van Johnson is really in love with her, a love that gives her the strength to go through an operation which will extend her life.

The Quiet Man (1952) has ex-fighter John Wayne returning to his Irish homeland. Wayne soon spots the beautiful red-headed local Maureen O'Hara. But O'Hara is "defended" by her tough brother Victor McLaglen. Nevertheless, Wayne is soon at her doorstep, asking her brother for her hand. Victor demands to fight Wayne, but he refuses (he killed a man in the ring). The villagers, who like Wayne, form a conspiracy—if Victor okays the Wayne-O'Hara match, his own wedding to a village girl he loves can go ahead. But it's really a ruse—the village girl says she will never marry him. Wayne's wedding takes place, Wayne and Victor unite, and Victor wins the heart of the village girl.

Dream Wife (1953) has Cary Grant trying to decide who to marry: Betta St. John, supposedly a submissive Middle Eastern princess, or Deborah Kerr, an independent state department career woman, both deceivers. Grant woos Kerr with candlelight dinners and soft music, but she keeps postponing the nuptials. Finally he gives up and marries the Middle Eastern princess, who then becomes a nightmare American homemaker—opening up charge accounts and becoming intimate with anyone she meets. Each is out to get her own version of the American dream.

The Captain's Paradise (1953, England) stars sea ferry steamer captain Alec Guinness, who leads a double life to gain the most romantic pleasures: in the port of Gibraltar he has housewifely wife Celia Johnson in a middle-class cottage, and in Morocco he enjoys passionate, volatile wife Yvonne De Carlo. Both women are tricked but innocent of the situation, the perfect intrigue. Then the deception gradually breaks down—Johnson seeking liberation, and De Carlo wanting to be a hausfrau. By the end Guinness is facing a firing squad!

Sabrina (1954) features Humphrey Bogart as a workaholic businessman and William Holden as his playboy brother, both very rich. Audrey Hepburn is their chauffeur's beautiful young daughter, who's crazy about Holden. She's sent to

France to learn to be a chef, but instead meets an old baron who teaches her the devices of love—clothes, wines, conversation. Bogart is trying to marry Holden off to a rich baroness to multiply the family fortunes, but when Hepburn returns, she grabs Holden. To save the money match, Bogart pretends to fall for Hepburn, his second intrigue. To divert Hepburn, Bogart takes her on an ocean liner, then Holden reveals that Bogart really wants Hepburn and the two are soon united. Bogart falls victim to his own intrigues. This film was remade as *Sabrina* in 1995.

Vertigo (1958), praised as one of the greatest love films, is shaped from multiple love intrigues that lead its characters to multiple destructions. Ex-San Francisco detective James Stewart, who has serious vertigo (fear of heights), is asked by an old college friend, Tom Helmore, to shadow his wife Kim Novak, who he fears is going insane. Stewart is strongly attracted to Novak since both share feelings of emptiness and meaninglessness, and he falls deeply in love with her. But when they visit a Spanish mission, Novak is driven to climb the tower and leap to her death—Stewart's vertigo keeps him from saving her. "*It wasn't supposed to happen this way,*" she says, an admission that will change in meaning. Stewart has a total breakdown that lasts a year. Released from the hospital, he starts an affair with a new girl he's strangely attracted to, who is Kim Novak "made over," her real low-class self. This Novak character reveals the intrigue to the audience—she impersonated Helmore's wife. On the death day she climbed the tower and then Helmore threw his real wife's murdered corpse off it. Stewart's limited viewpoint made it look like a suicide. Later Novak and Helmore fled. But Novak still loves Stewart, so lets him make her over to look like Helmore's wife as she portrayed her, the woman Stewart still madly loves. Novak realizes this is madness, but loves him too much to resist. Then Novak wears an old necklace, part of the conspiracy. Stewart realizes at least part of the truth, drives them to the mission, and forces her to climb the tower with him, raving that she can't bring his first love back—although she is that woman. Novak, hysterical, pleads for his love—then they hear a woman's voice, just a nun, but the tormented Novak leaps to her death. Stewart is left standing on the tower, his face a mask of agony.

Vertigo goes to the heart of the love intrigue film and the human needs and dreams it's rooted in. Stewart's character appears rational and good-humored, but conceals a deep need for his sort of love, passion, and romance, which Novak's first disturbed, suicidal, dependent, beautiful woman fulfills, so he falls hopelessly in love with her. (He appears to be one of the emotionally wounded, fascinated by the love intrigue of the needy, helpless, mysterious beauty.) By contrast, note his independent, charming old girlfriend can't interest him romantically at all. Yet Stewart's relationships with "both" Novaks are increasingly manipulative, perverse, all-controlling fantasies. At the end, when lover Novak begs to just go on with their love, he only wants the mad, passive, manipulative woman who fits into his love intrigue, no other will do.

Two other love intrigue films followed *Vertigo*, neither as powerful, but both clever variations, one playful, the other pitiless.

Gigi (1958) centers on Leslie Caron, an illegitimate child in nineteenth-century Paris, who lives with grandmother Hermione Gingold. The grandmother schemes to make her a courtesan, and the mistress of rich Louis Jourdan. Jourdan accepts the mistress scheme, falls for Caron, and wants her to be his wife. Gingold becomes hysterical—the family tradition is to be kept women—but agrees to have the innocent Caron marry. Intrigue upon intrigue.

In *Breathless* (1960, France), Jean-Paul Belmondo is a young Parisian thief and killer, and Jean Seberg an attractive, bitchy woman having an affair with him without commitment. In her apartment they flirt, discuss books and philosophy, and go to bed, while he continues to rob and mug people. A policeman visits Seberg at work, shows her a clipping of her boyfriend, and tells her she'd better cooperate or else she'll have passport problems. She soon calls the police to tell them where Belmondo is. When he's shot down, betrayed, Seberg stands on a sidewalk with an innocent expression watching him die. A remake, *Breathless* (1983), starred Richard Gere.

Several love intrigue films of the sixties, seventies, and beyond clearly show *Vertigo's* influence, efforts to respond to the upsetting questions it raises. (Are we aware of, or can we deal with our passions? How much can we let others control us to win love?)

Tender Is the Night (1962) is set in post-World War I, decadent Europe, where an ambitious psychiatrist is unable to deal with its corruption. On the French Riviera, therapist Jason Robards and his rich wife Jennifer Jones party. Guests include a stunning starlet. Robards's attraction to the starlet causes his wife to have a mental breakdown. A flashback shows Robards treating Jones, her crackup due to her father's sexual assaults—this erotic pattern causing her to fall in love with Robards, who likewise loves her. Robards marries Jones and falsely keeps playing the role of the father figure for her in the high society whirl of endless empty, wild parties. The death of a talented friend makes Robards decide to return to honest therapy work. But by this time the extended rich, decadent lifestyle his wife seduced him into has destroyed his therapeutic skills. When he tries to return to her, she asks for a divorce so she can marry a new lover. An outcast from both ways of life, Robards returns to his hometown in the U.S. As with *Vertigo's* protagonist, Robards' faith in his intelligence makes him peculiarly vulnerable to unstable and wounded women.

The Legend of Lylah Clare (1968) is one of two "rewrite" films commenting on *Vertigo*. Kim Novak (Lylah) is intimate with her director Peter Finch and assistant Rosella Park, but can't be controlled. Her death, struggling with a mysterious assailant, is shown repeatedly. Her director, in an obsessional fugue, surrounds himself with pictures of her. Then he meets a new starlet (also played by Novak). He chooses her to play Lylah in a film biography. As she learns the role she "becomes" Lylah, taking lovers, including again Rosella. But she only sleeps with Finch once, and is furious with his obsession with the dead woman. Finally, as Lylah's murder is to be filmed, Novak insists she will do the scene. Finch, from several contradictory motives, gives in, and Novak actually dies during the murder sequence. The film ends

with Finch in mental collapse (again), and the suggestion that Novak's lesbian lover will soon kill him.

Bob & Carol & Ted & Alice (1969) is technically a love intrigue film, if an absurd one. The four main characters, hip Californians, try to fool themselves and each other into participating in group sex because it's so stylish. Married cool couple Robert Culp and Natalie Wood visit an Esalen-Institute style spiritual resort of the sixties, returning to babble endlessly of sexual freedom. Pals Elliott Gould and Dyan Cannon get roped in, and the four plan a sex orgy, but chicken out. The theme music points out the problem: "One relationship is difficult enough!"

Obsession (1976) begins with millionaire Cliff Robertson and wife Geneviève Bujold deeply in love. Then the wife and his daughter are kidnapped, and apparently die in a car chase explosion, which sends Robertson into a two-decades-long extreme mental collapse. He's obsessed by his loss, making their bedroom a shrine and building a gigantic tomb-monument to his wife. Then, visiting Florence, he meets a new woman—also played by Bujold—who resembles his late wife. Robinson becomes obsessed, making her walk, talk, dress, and act like the dead woman. The truth is shown in flashback—the Florentine woman is his real daughter, who escaped the kidnapping, and now wants revenge for her dad's decision not to pay the kidnapping ransom, which led to her mom's death. Her surface love hides a vengeance intrigue. But the girl, made unstable by the crisis, attempts suicide. When she arrives on a plane from Florence, she's in a wheelchair. Her father, equally crazy, runs towards her with a briefcase. The daughter, hysterical, imagines this time he's brought the ransom money. "*Daddy, Daddy!*" she screams. They fall into an erotic embrace. (This film is another "rewrite" that seems to be homage to *Vertigo.*)

10 (1979), a comic love intrigue, stars Dudley Moore as a very successful Hollywood songwriter. He becomes fascinated by a beautiful young bride-to-be, Bo Derek, whom he decides is his ideal sexual partner—a "10." Moore can't keep from learning all he can about her, then following the newly married couple to a Mexican honeymoon resort, scheming to get close to Derek. His intrigues pay off when he fortuitously saves her husband in a surfing accident, so Derek decides to go to bed with him. The joke is that Derek explains she has always and continues to sleep around on her whims. All the intrigue was unnecessary. Moore tries to criticize her way of thinking, but she has an answer for that too.

> Derek: *I know what your problem is, but I don't think you're going to solve it by solving mine.*
> Moore: *That's your problem!*

Moore goes back to Hollywood and his knowing middle-aged lover.

The love intrigue films of the eighties reflect the era's prosperity and sophistication. A well-off lover without values can follow his or her obsession as far as they dare.

Thief of Hearts (1984) features John Getz and Barbara Williams as a rich married couple whose home is broken into by thief Steven Bauer, who steals

Williams' diaries, which include her erotic fantasies. The thief uses this information to flirt and win her interest. Bauer pretends to be a rich man who wants his home decorated, one of her careers. He and Williams visit a site she's decorated and a museum exhibition of her work, and make a lunch date where they go for a sail (one of her fantasies). He hires her, but her husband senses something's going on. Meanwhile, Bauer seduces Williams as he teaches her to shoot at his firing range. He eerily reveals more and more of her secrets, while revealing nothing about him. She starts to pull away, even as she becomes his obsession, and he decides take further steps; he can't stop himself.

Bolero (1984), set in 1920, has stunning heiress Bo Derek fascinated by Valentino, having liaisons with poor look-alikes, and explaining to a pal that she'll try any devious scheme to lose her virginity in an ideal "exstasy" (her spelling) to a perfect man. She hunts him in Morocco and Spain, one prospect exciting her by covering her with honey as he babbles erotic nonsense (*"Nectar of the gods from the belly of a goddess..."*), but overdosing on his hookah makes him pass out. In Spain, she beguiles a matador, bullfighting him nude in bed, directing her defloration orgasm after orgasm.

> Derek: *You say that we never found ecstasy—that it was like quicksilver, always promised next time! Angel, I want ecstasy—let's find it!*

When her matador is gored and made impotent, Derek takes the male's role in hat, cape, and cigar, mounting her perfect man, her face ecstatic. They marry, and she grins exultantly. Was this her most secret intrigue?

Fatal Attraction (1987) stars Glenn Close as an attractive, mentally unstable editor who has a brief weekend affair with married lawyer Michael Douglas, and obsessively decides she won't give him up, trying every stratagem as she gradually goes mad, from threatening phone calls to killing family pets and kidnapping his child.

> Close: *I won't let you treat me like some slut you can bang a couple of times and then toss away like a piece of garbage.*

Love intrigue films of the nineties fall into a number of categories: adaptations of classic novels and biographies; earnest treatment of social problems; daring artistic statements, and playful romantic comedies. Love intrigue is accepted as human nature, familiar artistic raw material.

Henry & June (1990) is a fictionalized treatment of episodes in the life of writer Anaïs Nin, set in 1931. The young writer, Maria de Medeiros, meets the struggling Fred Ward (modeled after Henry Miller), and dreams of an affair with him.

> De Medeiros: *I want to know what you know; I want my life to match your life!*

Ward tells her writing about "fucking" is actually "about self-liberation." Sexual adventures are intriguing ways to reach a higher level of life. She acts on her desire for him, and later writes in her diary she feels "innocent." When they make love, he associates sex with higher values and ideas, carnality with spirituality,

Ward: *I want to fuck you, teach you things.*
De Medeiros: *I feel so pure, so strong, so new.*
Ward: *Maybe I should get down on my knees and worship you, I'm going to undress you, vulgarize you a bit.*

In other sequences, she discovers multiple groups of men and women having sex. The writer and the young writer visit a brothel. The young writer wants to have sex with the writer's wife (June), but when she reveals she had sex with her husband, the wife says no. In time the young writer goes back to her husband, and this relationship based on intellectual ambition fades away.

Jungle Fever (1991) stars Wesley Snipes as a young, black, upward mobile New York architect, and Annabella Sciorra as an office temp. They begin spending a great deal of time together, including late-night dinners, then spontaneously they make love. Talking with a friend, Snipes says their adulterous affair was motivated by curiosity and physical attraction.

Snipes: *I've got to admit I've always been curious about Caucasian women.*

After his wife throws him out and her family turns on her, the two find a love nest to spend time together. But the affair is soon over.

Snipes: *I give up. It's not worth it. It's over. I don't love you, and I doubt seriously if you've ever loved me.*

Their scenes together hint they never really had satisfactory sex. The affair fits the Freudian pattern, in which the adulterous male seeks a debased sexual object—inferior socially, economically, and professionally. "Jungle fever" is a slang term for temporary sexual fascination between whites and blacks, which does not last. Afterward she's left on her own,

The Piano (1993, New Zealand) stars Holly Hunter as a nineteenth-century Scot who has not spoken since childhood, and is sent by her family to New Zealand's outback to marry Sam Neill, a grim farmer. When she arrives with her daughter from an earlier marriage, who speaks for her, her husband-to-be won't haul her piano to his house. Local Harvey Keitel buys the piano, and has her give him lessons. For sexual intimacies, she may earn back the piano, piece by piece. Meanwhile the marriage goes unconsummated. When Keitel says he loves her, she sleeps with him. Hunter shows Neill affection, but when she writes Keitel a note, Neill cuts off one of her fingers. Hunter departs with Keitel, her daughter, and the piano. At the end she plays again with a new silver finger, and starts to speak. The film depicts outcasts at civilization's edge, for whom the piano's art stands in for confused longings, the woman playing for what she can get.

While You Were Sleeping (1995) stars Sandra Bullock as a lonely ticket collector, who rescues a mugged lawyer she's attracted to. His family assumes her to be his fiancée and warily accepts her, except her suspicious brother Bill Pullman. As the lawyer lies comatose and Pullman questions her, Bullock intrigues to win the family over and so the lawyer's love. For her, it's at least a respite from loneliness. Meanwhile, she and Pullman get to know each other, and she learns of his decency and career frustrations, so she falls for him. When

the lawyer wakes up and doesn't recognize Bullock, the family assumes it's amnesia. Meanwhile, Pullman proposes.

A Walk in the Clouds (1995) is another clever love-intrigue variation. Keanu Reeves is a married salesman whose wife is an adulteress. He meets Aitana Sánchez-Gijón, a vineyard heiress seduced and abandoned at college. As a kindness, Reeves plays her suitor for her family, then plans to run, so she'll be pitied, not scorned. But instead he falls for her family and her, so is soon pretending to be what he'd like to be, but can't! He goes back to his wife, learns she's unfaithful, and returns to the vineyard. A wedding follows.

The Truth About Cats and Dogs (1996) has young man Ben Chaplin fall in love with radio pet advice show hostess Janeane Garofalo before he meets her. Garofalo, self-conscious about her looks, gets stunning blonde neighbor Uma Thurman to take her place. In the end the love intrigue disappears and the couple unites.

The Wings of the Dove (1997), based on a Henry James novel, is set in 1916 England. Helena Bonham Carter, a young Englishwoman, loves a young journalist without money, Linus Roache, so her guardian aunt seeks to prevent the marriage, threatening to stop supporting her. Bonham Carter then befriends Alison Elliott, known as "The World's Richest Orphan." When Elliott sees Roache, she tells Bonham Carter she's attracted. Since Elliott is dying of a rare blood disease, Bonham Carter devises a scheme to win Roache. If Elliott falls in love with him, dying, she'd leave him enough money for Roache and Carter to solve all their problems. Despite competition from another suitor, the intrigue works. They marry, then Elliott dies. Carter and Roache meet, and he tells her he will marry her, but without Elliott's money, which he will refuse. What they will do next is uncertain, although their passions for each other remain strong.

You've Got Mail (1998), an update of *Shop Around the Corner* (1940), stars Meg Ryan as the owner-operator of a small children's bookshop, Tom Hanks as C.E.O. of his family's enormous bookstore chain. They don't get along in person (his chain is driving her shop out of business), but they also meet unknowingly online, then gradually fall in love as they exchange personal and professional intimacies (still not knowing the truth). Each has a live-in lover not really suitable for them, both of whom in time depart. Hanks uses a computer trick to learn his internet lover is Ryan, even as he manipulates to put her out of business, while exchanging business smarts. Finally they arrange a live meeting in a park full of flowers and sunshine, Ryan somehow forgetting her dislike of the schemer who put the family bookstore and her friendly staff out of business, and seeing only the funny, kind, charming e-mail writer. (Ryan: "*I wanted it to be you...I wanted it to be you so badly.*")

Cruel Intentions (1999) features Sarah Michelle Gellar as a treacherous, wealthy beauty, and Ryan Phillippe as her ruthless, manipulative, handsome brother. He pursues Reese Witherspoon, another blueblood, not out of passion as he claims, but as part of his and his sister's perverse games and bitter love

intrigues. Then he falls for Witherspoon, is killed, and the love treachery traced back to his sister (recalling *Dangerous Liaisons,* on which this film is based).

In *Message in a Bottle* (1999), Robin Wright visits a beach and finds a passionate love message in a bottle. Fascinated, she tracks down the writer, sailboat builder Kevin Costner, who seeks to remain intimate with his drowned wife even as he lives on, a mad love intrigue. Wright and Costner begin an affair, but he remains torn between his dead wife and new love, tormented by her using the letter to find him, and having it printed in the newspaper. When Robin runs off, Costner sails into the sea, dying in a storm. A note he leaves says he was ready to give up his relationship with his dead wife, and devote himself to the new love.

The love intrigue films of the new century continue to be diverse in mood and design, though mostly paralleling those of the previous decade.

Happy Accidents (2000) has single Marisa Tomei fall for sweet, offbeat Vincent D'Onofrio, who claims to be a time traveler from 2470 A.D.—clearly an absurd love intrigue. Tomei is always finding the wrong sort of guy and trying to "fix" him, which her therapist says is her problem. At first D'Onofrio seems normal, so she sleeps with him and takes him in. But he goes into fugues, doesn't know how to date, and finally explains he's a rebel time traveler who found her picture "up ahead." She decides it's a role game (*"He sure tells a good story"*), but the truth lies elsewhere.

In the Mood for Love (2000, Japan) has Tony Chiu Wai Leung start a passionate affair with Maggie Cheung after their mates run off together. The two couples lived next door, and soon Leung and Cheung, realizing the truth, began exchanging both suspicions and intimacies they no longer wish to share with their mates. The intrigue grows, with temptations to go further, suggested by slow motion sequences of them passing in the hallways, intensely aware of each other. Abruptly the almost-affair ends.

Maid in Manhattan (2002) stars Jennifer Lopez as a beautiful, lower-class housekeeper at a high-class hotel, with upwardly mobile aspirations. She meets ambitious Ralph Fiennes, who is seeking his dad's U.S. senate seat. When she accidently takes on the identity of an upper-class hotel guest, the love intrigue is on. Her friends help her dress for a benefit where she charms Fiennes into spending the night, but a vicious guest tells her superiors. Happily, over time the two stay together.

The Shape of Things (2003) starts with sexy fine arts grad student Rachel Weisz taking pictures of a museum statue past the ropes, as guard/graduate student Paul Rudd stops her, and gets her number. Soon they're flirting, but he's too shy.

> Rudd: *Public display of affection, I'm not used to that.*
> Weisz: *No? I don't mind.*
> Rudd: *Really?*
> Weisz: *Nah, whose business is it? Ours, right? Kiss if we want to, make out in the bathroom stall. Who cares?*

Soon he lets her videotape their lovemaking, help him lose weight and get a nose job, and dress sharper. She also touches up his morals and values. Then he gives her an engagement ring. The end is a shock. Weisz's real goal was to have Rudd be her graduate thesis, a human sculpture she shaped for eighteen weeks, systematically making over his face, body, clothing, and behavior. It was not out of love, but to create the illusion of interest and desire (an ultimate love intrigue). Weisz justifies what she did by the fact that she is an artist. She has created the sort of man she wants, although she is morally unable to marry him.

The Shape of Things (in a sense, *Vertigo* inverted) asks if anyone has the right to manipulate someone else for hidden goals, whatever they might be.

How to Lose a Guy in Ten Days (2003) has two bright sophisticates carrying out love intrigues with each other. Kate Hudson, a magazine columnist, decides to fake a romance, then drive the guy away with fake needs to have the basis for a lively column. Meanwhile, ad exec Matthew McConaughey has to show his boss he can run an all-woman creative team, and decides proof will be making a suitable woman fall for him in a ten-day "selling" of himself. He'll stop at nothing to get her. She'll stop at nothing to drive him away! At first Hudson seems a perfect lover—amorous, relaxed, with no hang-ups, a sportswoman. But she crowds his apartment with her toys, wrecks his poker night, and gives cute names to his sex organ. Meanwhile, he struggles to hang on to her to win his promotion.

Hudson: *Our love is finished. You let it die!*

McConaughey: *No, honey, it's just sleeping.*

Eventually each learns the truth, but the relationship goes on.

The Door in the Floor (2004) stars Jeff Bridges as a writer of children's books and an adulterous alcoholic, Kim Basinger as his unhappy wife, and Jon Foster as the writer's assistant during a trial separation. The two bitter adults each use Foster as a tool in intrigues to hurt each other. (The husband picked him to resemble their dead son, knowing it would lead to a romance between his wife and the teen.) But the ongoing conflicts allow the youth to grow up and behave in a more adult way than the husband.

P.S. (2004) deals with Laura Linney, a Columbia University admissions coordinator who at thirty-nine apparently thinks love has passed her by. An arts program applicant, F. Scott Feinstadt, however, makes her think obsessively of her high school boyfriend, Scott Feinstadt, an aspiring artist who died young. The guy, played by Topher Grace, totally resembles her memories, leading to her bringing him to her apartment for a sofa romp. Reliving the great lost opportunity of her life without revealing it, up to now trapped in a permanent adolescence, she finally grows up and rebuilds her previously immature relationships with lover, mother, brother, friends and ex-husband, becoming an adult at long last.

Hitch (2005) tells how Alex Hitchens—Will Smith—a New York "date doctor," coaches the inept in how to win their "dream girl"—that is, puts love intrigue on a boutique basis. The movie shows a series of such educations, one a goofy accountant who wants a beautiful Hitch client, and is advised to act nice

and stand up straight. Meanwhile, Hitch, who sees himself as an ace love intriguer, runs into a beautiful workaholic gossip columnist, Eva Mendes, who starts talking pickup techniques with him in a bar—soon they're off. Hitch makes comic, amateurish errors, but in the end things work out for both couples.

Failure to Launch (2006) stars Matthew McConaughey as a thirtyish man still living at home. His parents hire a "transition consultant," Sara Jessica Parker, to romance him so he gets his own place, then plan to have her dump him, since by then he should be confident enough that he won't care— more boutique love intrigue. But then Parker falls for him, and the complications commence.

My Best Friend's Girl (2008) has nice guy Jason Biggs and swaggering lout Dane Cook both chasing classy beauty Kate Hudson. Cook has a sleazy side job, being set up as a date for women who've jilted their boyfriends, but providing such a lousy experience (filthy talk, dirty restaurants, etc.) they run back to their old boyfriends (who arranged this "date")—more boutique love intrigue. When Biggs is rejected by Hudson, he too hires Cook as a "date." Then Hudson turns out to be a wild card looking for a dirty fling! Now loving Hudson, but loyal to friend Biggs, Cook fakes a "nice" date, so Hudson complains about the lack of sexy sex. But soon they're in a relationship that includes casual sex too. At the end Cook stays with Hudson, and Biggs gets Hudson's roommate.

The increasing number and types of love intrigue film suggest that duplicity and manipulation are more than ever a usual, tolerated part of people's love lives, even in some ways a necessity. As a saying goes, some people don't mind the lies told about them, what worries them is the truth. Or perhaps more and more the pure and simple truth is rarely pure and never simple. It's *Vertigo* for everyone.

Chapter Four
The Dandy

The dandy, male but also female, or vice versa, is fluid, ambiguous, and can create various personas as he or she chooses. The dandy has the freedom almost everyone wishes for at least at times—to be more or less one sex or the other, able to shift from one persona to another. The dandy is startling, mysterious, and elusive. Womanly, manly, woman, man, the dandy entices and seduces by appealing to those trapped in their gender, yet aware of their other repressed sexual identities. Fluid, super aware, exciting, he/she tempts the strait-jacketed personality. A dandy, when he needs a haircut, gets a hairdo instead.

Film dandies include Valentino's sheiks, Cary Grant's male war bride, Jack Lemmon and Tony Curtis's female musicians who like it hot, Garbo's Queen Christina, and Julie Andrews' Victor and Victoria. The feminine dandy attracts with pleasing intimacy, charm, and presence—which may transition to masculine force, "pleasing women by displeasing them." The masculine dandy attracts with fetching beauty, independence, and a masculine way of thinking which men often find irresistible.

Some psychologists theorize that dandies are fulfillments of women's sexual tendencies—passionate while ovulating, cooler at other times. Fertile women gravitate towards more masculine men—lean and domineering, with low-pitched voices. At other times they prefer men who are soft-featured and loose-bodied, with higher voices. The feminine dandy can provide either sort of maleness, and the masculine dandy allows the expression of both sorts of needs—lust for passion, and the cooler calculation of which man would best serve as husband and father.

Psychoanalytic theory implies the dandy's special nature makes a conventional love relationship almost impossible. It would end the unconscious fantasy life which underlies both their own erotic excitement and their special fascination for normal lovers—slutty transvestite one moment, raging bull rake or vampire siren the next. Numerous silent dandy films were made, though the dandy's sexual nature was usually underplayed or played for laughs.

The Clever Mrs. Carfax (1917) stars period female impersonator Julian Eltinge, as a man who attends a luncheon and is attracted to a girl with a

gangster boyfriend. Pursuing her, he joins them (in drag) on an ocean cruise, where he saves the day and wins her.

Eyes of Youth (1919) stars Rudolph Valentino playing a graceful and sensitive seducer, with smooth skin and a pretty face. Women in the audience were fascinated by the dandy's delicacy and feminine attention to detail.

Oh, What a Nurse! (1926) stars Sydney Chaplin, Charlie's brother, working as an advice to the lovelorn columnist. In drag, he stops a lovelorn young girl from marrying a fortune hunter, and wins her for himself.

The Four Horsemen of the Apocalypse (1921) has Valentino playing a feminine playboy. In a tango seduction scene, his smooth and fluid dancing has cruel and menacing elements.

The Sheik (1921) features Valentino rescuing a proud English lady, and later conquering her. She wears trousers, while the desert dandy wears flowing robes and eye makeup.

> English lady: *Why have you brought me here?*
> Valentino: *Are you not woman enough to know?*

Leering, he stalks her about his tent, and soon she is his romantic victim. Soon after, he/she has enslaved her.

The Thief of Bagdad (1924) has Douglas Fairbanks displaying ballet-like movements, a bare chest, ballooning pantaloons, and a carefree manner—a dandy of masculine beauty.

Beau Brummel (1924) is the life story of the English dandy, played by John Barrymore. Witty and elegant, he has many delicate love scenes, but dies friendless in an insane asylum.

Irene (1926) is the story of an Irish girl's work at Madame Lucy's hair salon, but George K. Arthur's performance in drag as the comic proprietress steals the film.

Son of the Sheik (1926) has Valentino kidnap his dancing girl lover. The romance proceeds through many stages, gentle ("*Love such as mine can do no harm*"), as well as cruel and brutal violence (when Valentino wrongly believes she has betrayed him), culminating in rape. But the rape starts with Valentino doing a very feminine sort of striptease of his silks.

The coming of sound allowed for a more subtle, complex treatment of the dandy persona.

Morocco (1930) stars Marlene Dietrich as the dandy Amy Jolly. Dietrich is a nightclub singer en route by ship to Morocco. In Morocco, Dietrich becomes the tuxedoed headline singer at the best club, one frequented by French Foreign Legionnaires. She shocks the audience by going to a woman alone at a table, stroking her hair, and kissing her mouth. But when she meets Legionnaire Gary Cooper, she hands him the key to her apartment. He later shows up, but seems uninterested in her advances, and returns her key. In several scenes, Cooper behaves like a dandy himself, putting a rose behind his ear, using a fan to hide a kiss he gives Dietrich, and smoking cigarettes with a noticeably limp wrist. At the film's end, dandy Cooper marches off into the desert, dandy Dietrich pursuing him in high heels.

The Guardsman (1931) stars Alfred Lunt and Lynn Fontanne as actor and actress who marry, though the husband fears his wife wants a more masculine mate. He therefore disguises himself as a Russian guardsman and seduces her. When he appears as his effete self and confronts her, she laughs and says that she knew the truth all the time (*"You boy...you silly child!"*). The film ends with his face hidden and her smiling delightedly—she was fooling all along.

Queen Christina (1933) is based on the life of the real Queen Vesta of Sweden, who was bisexual. The opening sequence stresses the masculine tendencies of Greta Garbo as queen—in long shots she is shown on horseback galloping cross country, riding into the palace, dismounting, and striding through the entrance and up the stairs to her private quarters, only at the end revealing herself as a woman. At one point Garbo greets her lady in waiting, Elizabeth Young, with a full kiss on the lips, the queen dressed like a cavalier, Young in very feminine attire. But in the midst of a war, she asks her cabinet for peace, a feminine gesture:

> Garbo: *Spoils, glory, flags, trumpets, what is behind these words? Cripples, dead men! I want for my people security and happiness! I want peace, and peace I will have!*

She meets handsome Spanish ambassador John Gilbert, and learns his nature by disguising herself as a male youth, telling the woman who dresses her: *"I shall die a bachelor!"* In disguise, she meets Gilbert, and they spend the night together and fall in love. They continue to meet. It becomes a scandal and she abdicates.

> Garbo: (abdicating) *I am tired of being a symbol, I long to be a human being...This longing I cannot suppress. One must live a life for oneself. After all, one's life is all one has.*

She sails to meet him to live together, but he is killed in a duel, and she goes on to a loveless future.

I Was a Male War Bride (1949) stars Cary Grant as a French officer who meets and falls in love with W.A.C. Lieutenant Ann Sheridan just after World War II. Though in love, they don't really get along, yet still want to marry.

> Grant: *Why do you say I run after everything in skirts?*
> Sheridan: *I don't.*
> Grant: *You did.*
> Sheridan: *I said "anything."*
> Grant: *Oh, that is different, then.*

However, because of legalisms, the only way Grant can enter the U.S. is as a "war bride." To get away with it, he puts on feminine undergarments, a black wig, and a feminine manner as he understands it. Coming back to the U.S. on a troop ship, Grant's mockingly seductive masquerade, combined with his real actor's charm, yields a fascinating treatment of the dandy in extremis.

Some Like It Hot (1959) a classic dandyish sex comedy, features Jack Lemmon and Tony Curtis, who must masquerade as women, with Lemmon starting to see himself as one, and both pursuing romantic relationships. The story starts in 1929, when the two out-of-work, penniless musicians must flee

Chicago after witnessing the St. Valentine's Day massacre. Their only hope is disguising themselves as female musicians, and joining an all-girl band. Even before they join, Lemmon begins to identify with women:

Lemmon (pulls down skirt): *And it is so drafty! They must be catching cold all the time.*

Curtis: *Quit stalling, we'll miss the train.*

Lemmon: *I feel so naked. Like everybody is staring at me.*

Curtis: *With those legs? Are you crazy!*

One of the band members is Marilyn Monroe, so both go after her. But she wants a millionaire. In Florida they meet Joe E. Brown, an effete millionaire, who falls for Jack Lemmon's female impersonation. Meanwhile, Curtis impersonates a sexually troubled plutocrat to win Monroe, who "cures" him and falls in love. In the two guys' hotel room, Lemmon tells Curtis that Brown has proposed, and he is thinking of adopting his sexual masquerade for keeps.

Curtis: *You're a guy. Why should a guy want to marry a guy?*

Lemmon: *Security.*

Dandyism has its points. Lemmon will tell him the truth—right after the ceremony. Then the massacre gangsters show up, and Lemmon and Curtis flee, after Curtis as a woman kisses Monroe who realizes he/she is who she loves. The three escape with Brown in his speedboat and the film concludes with Lemmon attempting to reveal the truth even as Brown makes a good case for dandy marriage:

Lemmon: *For three years I lived with a saxophone player.*

Brown: *I forgive you.*

Lemmon: *I'm not a natural blonde.*

Brown: *It doesn't matter.*

Lemmon: *I smoke, I smoke all the time.*

Brown: *I don't care.*

Lemmon: *We can't have children.*

Brown: *We can adopt some.*

Lemmon: *You don't understand, I'm a man.*

Brown: *Well, nobody's perfect.*

Goodbye Charlie (1964) is a clever dandy comedy in which a Hollywood writer is murdered by producer Walter Matthau when he finds him with his wife. However, the womanizing writer somehow is reborn as the stunning young beauty Debbie Reynolds. While still having the writer's original masculine mind, he/she moves in with his old friend Tony Curtis, another ladies' man, who doesn't really know what has happened. Reynolds, a beautiful woman, cannot keep from thinking like a Hollywood romeo (Reynolds: "*It is like being a gourmet all my life, and now I'm a lamb chop!*") She/he uses her old self's knowledge of his past affairs to carry out a new series of affairs, while also taking revenge on Matthau.

Performance (1970), with James Fox as a sadistic thug and Mick Jagger as a pansexual rock star, lets each explore their dandyish tendencies. Fox is first shown as an underworld specialist in terrorism, extortion, and violent

lovemaking. Fleeing gang revenge, he takes refuge in the home of spiritually and sexually ambivalent rock star Mick Jagger. Jagger has "lost his demon" and retreated to a sumptuous abode with two young sympathetic beauties, where he participates in sex adventures with partners of many backgrounds. He sees his demon in Fox, as the gangster has parallel insights about Jagger. With the help of drugs and Jagger's companions, they are soon "getting into each other's heads" (at one point their faces melt together on the screen). Jagger explores his feminine side with lip rouge and pouty male drag, while Fox becomes hyper-masculine in his aggression. Eventually Fox shoots Jagger and then "becomes" him.

Performance has been both highly praised and deeply condemned. One critic called it "the ultimate metaphysical comic strip."

Shampoo (1975) stars Warren Beatty as a fashionable Hollywood hair stylist who frequently has sexual relationships with his rich women clients, but his playful, feminine nature—self-absorbed, trying to please, impulsive—makes him more of a dandy than a rake or lover, always role-playing.

> Beatty: *I'm always trying to fuck them. They know it and they like it... and they don't like it. That is the way it is.*

The story starts with him having casual intimacies with Lee Grant, as well as her daughter. He next spends the night with his dissatisfied lover Goldie Hawn.

> Hawn: *You never stop moving, you never get anywhere. Grow up!*

He tries to get a bank loan to open his own salon, but has no business plan, shouting: *"I've got the heads!"* Jack Warden, a power in L.A., is convinced that the hair stylist, his mistress Julie Christie's old lover, is gay. At a party Beatty and Christie have sex and are discovered by Warden and Hawn, who both are furious. The next day Beatty visits Christie and asks her to marry him, and tries to justify his dandy nature:

> Beatty: *You dumb cunt, everybody fucks everybody, grow up, for Christ's sake. You're an antique, you know that? Look around you! All of them, all these chicks, they're getting their hair done so they can go and fuck! That's what it's all about. Come in to the shop tomorrow and I'll show you—I fucked her, and her and her, and her and her—I fucked them all. That is what I do. I fuck. That is why I went to beauty school, to fuck. I can't help it, they're there and I do their hair and sometimes I fuck them. I stick it in and I pull it out and that is a fuck, it is not a crime.*

Christie, however, has decided to marry Warden, who has money and apparent stability, unlike Beatty, who pleads: *"Please, please, I don't trust anybody but you."* Beatty's dandy is fascinating, in some ways a sexual aesthete. As he says at one point, *"There's a beautiful girl—I mean, that's it, it makes my day, I feel like I'm gonna live forever."* But as the film's conclusion suggests, with Warden and Christie driving off and Beatty alone, it has its drawbacks as well.

Victor Victoria (1982) begins with Julie Andrews and Robert Preston as out of luck performers in Paris of the thirties. Preston is an aging gay and Andrews is a British singer. To get work, Preston devises a scheme and has Andrews masquerade as a male singer-dancer who dresses as a women. They are an immediate hit at a gay club. Preston has taught her well—she has a voice just low enough to be a touch masculine and stylized dancing ("broader, with just a touch of shoulders"). When James Garner, a tough U.S. gangster, visits the club, he is immediately attracted to Andrews' performer, but also bewildered by his feelings toward a "man." At an opening night party, Garner confronts Andrews:

> Garner: *Well, I—I just find it hard to believe you're a man.*
> Andrews: *Because you found me attractive as a woman?*
> Garner: *Yes, as a matter of fact.*
> Andrews: *It happens frequently.*

Andrews, as the masculine dandy, has fetching beauty, independence, and an analytical mind that makes her irresistible to many men. But Garner's mind is too conventional and not analytical enough to understand what is going on, although Andrew's mind is.

> Garner: *If you were a man I'd knock your block off.*
> Andrews: *And prove you're a man.*
> Garner: *That is a woman's argument.*
> Andrews: *Your problem, Mr. Marchand, is that you're preoccupied with stereotypes. I think it is as simple as you're one kind of man, I'm another.*
> Garner: *And what are you?*
> Andrews: *One who doesn't have to prove it—to myself or anyone.*

Eventually, Garner learns that Andrews is really a woman, and begins a secret romance with her. Unlike him, she is clearly aware of the benefits of dandyhood.

> Andrews: *I find it all really fascinating. There are things available to me as a man that I could never have as a woman. I'm emancipated!*

Tootsie (1982) stars Dustin Hoffman as a talented but hard to work with actor who secretly gets work as a female character on a TV show, and also at times plays the actress off camera as a masculine dandy, a bit like Julie Andrews's Victoria character. His problems multiply as he is attracted to actress Jessica Lange but must hide it, as well as hide the masquerade from old girlfriend Teri Garr. Meanwhile, a male actor in the show and Lange's father are both sexually attracted to Hoffman's actress masquerade, males captured by the masculine dandy's charms. In addition his dandy character is an enormous hit with female viewers across the country. Unable to sustain the situation, Hoffman has his character go off script, revealing her as a man, so he is dropped from the show. But playing a masculine dandy has taught Hoffman a lesson about how to be less of a macho male chauvinist (his old persona) and a better person. He puts it wittily:

Hoffman: *I was a better man for you as a woman than I ever was for a woman as a man. The hard part is over, we're good friends. I'll just have to learn to do it without the dress.*

But he hasn't lost all of the masculine dandy persona:

Lange: *Can I try on your yellow dress?*

Hoffman: *What are you going to use it for?*

Switch (1991), a sex farce that plays with the dandy idea, starts when womanizing adman Perry King is murdered by three angry former lovers, but then is allowed by Satan to return to earth as a woman (and so a masculine dandy). He/she will be allowed to go to heaven if he/she can find a woman who really likes him/her. Ellen Barkin plays the man who returns, claiming to be King's half-sister. Barkin gets one of the girlfriend/killers to support her ruse via crafty posturing. Meanwhile, Barkin is soon befriended by the dead man's pal Jimmy Smits, who like many men finds the masculine dandy irresistible:

Barkin: *Check out the headlights on that blonde. How'd you like to play hide the salami with that for a week?*

Barkin takes over his own old job, pursuing a possible major new client, C.E.O. Lorraine Bracco, who turns out to be lesbian—Barkin gets the account but doesn't consummate the relationship. Instead Barkin and Jimmy Smits have sex, Barkin's dual sexuality leading to numerous one-liners. (Barkin: *I can't think with all this hair!*")

But when the murdered Perry King is found, Barkin claims she is King. She is put in an insane asylum, pregnant with Smits's child. She dies giving birth, but the baby girl loves Barkin, so she goes to heaven, wondering if she/he will be a male or female angel.

Threesome (1994) tells how three college students—Lara Flynn Boyle, Stephen Baldwin, and Josh Charles—erroneously all assigned to the same college suite in a dorm, drift towards dandyism. Charles, a film major, is fastidious and repressed; Baldwin is a loud-mouthed, womanizing business major; Boyle an outspoken femme. Macho Baldwin tries to charm Flynn, but she is attracted to the aesthete, Charles, and tries to seduce him without success, writhing sexually while he reads aloud. (Boyle: "*I love it when you say big words!*") Then Charles realizes he's becoming attracted to Baldwin, and Boyle becomes obsessed with seducing Charles, a masculine dandy in her determination and logic.

Boyle: *I'll make you into a heterosexual with my bare hands!*

Later the three almost have group sex, but quarrel, Boyle accusing the apparently gay Charles of being "a closet heterosexual," a feminine dandy potentially, whose seemingly gay sexuality hides a secret desire for male-female sex he cannot admit. Soon Baldwin and Boyle start having sex, though she still longs for the effete Charles. At long last Boyle and Charles have sex, which Charles calls a fraud. Charles then tells Boyle he has decided the macho Baldwin is a secret gay, a masculine dandy, but when Charles makes a pass at Baldwin, he is told he is simply wrong. At long last, the three roommates engage in a sexual threesome, each pleasing the others, so each is at least momentarily

arguably a dandy, moved beyond their apparent sexual nature. A pregnancy scare causes the threesome to break up, and eventually all find happiness returning to their familiar sexual natures.

In & Out (1997) starts when young actor Matt Dillon wins an Oscar and thanks his small-town high school teacher Kevin Klein—whom, he adds in his address, is gay. This is news to Klein; in fact, he is just days from marrying his longtime sweetheart, Joan Cusack. Gradually Klein discovers, after much soul-searching, that he is not just a dandy, but is in fact gay (Cusack gets together with Dillon).

The Object of My Affection (1998) has straight Jennifer Aniston ask her gay friend Paul Rudd to share her Brooklyn apartment after his professor-companion dumps him. Aniston is pregnant by a boyfriend in whom she's lost interest, but Aniston and Rudd each become more dandyish—he doesn't mind her seeing other men, while she is jealous of his affairs (many conventional married couples' unspoken sexual tolerance, reversed).

If You Only Knew (2000) has young Johnathan Schaech become quite the dandy as he pretends to be gay while rooming with his dream girl, Alison Eastwood. (He moved in under false colors after his apartment burned.) Meanwhile, he accepts the masquerade, hoping it will lead to romance. (It does).

In recent years, dandy films have used the character type more as a comic device than to explore him/her as an aspect of real passion, romance, and love.

Chapter Five
First Love

Many romance films portray first love, where people are just naturally attracted to one another, with no secondary script or agenda of any kind going on. First love is often portrayed as a spontaneous, sincere experience, emotionally and sexually. Often it is essentially impulsive and erratic in judgment, idealizing the beloved and underrating the self. Reasonable and harsh realities are ignored and bypassed temporarily.

First love films often exaggerate or stylize this state of mind. One or both members of the loving couple has the special seductive, wild child aspects of youth—an innocent outlook, a child's fearlessness, a sense of wonder about the world, and an openness to experience. Notable actors who have portrayed period versions of the first love experience include Charles Chaplin, James Dean, and Leonardo DiCaprio. However first love films include a wide variety of pairings: teenage lovers with all the associated special stresses, middle-aged couples falling hard for the first time, couples with one naïve and one sophisticated partner—but all with some playful, wondrous element still present.

Psychology reveals that successful couples are brought together out of a mutual display of sympathy, caring for one other's real needs. Alternately courtship may be feigning and parrying, falsehoods and deceptions. Ovid calls lover and beloved "*shy predator and wily prey.*" With reason to hope and reason to doubt, passion can reach a fever pitch.

Research argues romantic love evolved out of sexual selection—the better mate being faithful and avoiding other courtship and copulatory behavior. The beloved is best a person suitable to project the lover's idealized image of love onto. Thus the couple sees each other as the means of satisfying their needs and dreams for eroticism and affection.

Numerous early silent films depicted simple, sentimental first love stories.

At the Crossroads of Life (1908), made by D.W. Griffith, deals with a worldly man who tries to seduce a poor young chorus girl whose family cast her out for seeking a stage career.

Mabel's Dramatic Career (1913) stars Mabel Normand, whose farmer boyfriend comes to New York City to search for her and then sees her face on a theater screen.

True Heart Susie (1919) has Lillian Gish (Susie) deeply in love, and paying her lover's way through college. Graduating, he falls for a sexy neighbor. That marriage is a disaster. He and Gish daydream of what might have been. When the wife dies of an illness, the true lovers marry.

By the twenties, first love films began to include real-life complications—a lover might have to awaken the beloved one's interest, or immature lovers might behave outrageously.

Dangerous to Men (1920) shows how Viola Dana must live with her guardian. She falls for him, but is treated like a child. He ignores her efforts to win his love. Finally she saves him from a fortune hunter, and he sees her for the beautiful, loving woman that she is.

Black Oxen (1923) stars Clara Bow as a spoiled, teen flapper rebel. When a family friend threatens to spank her for bad behavior, she cries, "*Can I depend on that?*" She smokes, drinks, and runs around with a wild crowd. To get the local cynical drama critic to propose, she flirts wildly and sneaks into his rooms to "compromise" him. By the end, she has romance on the way.

First love films of the thirties supported women's growing freedom to choose their own love lives, and men's willingness to accept this. The post-Crash economic crisis no doubt contributed to the films' "live for today" moods.

Hell's Angels (1930) features Jean Harlow as a beautiful young Englishwoman seeking love during World War I. She is shown rushing to meet pilot James Hall, telling him she is "*boiling,*" letting him run his hand over her skin as she trembles. Later at a party at a lavish estate, she runs out of the bushes looking disheveled with a soldier in tow, and then flirts with two pilots. Harlow takes one to her apartment and seduces him there, coming out of the bedroom obviously naked under a thin robe and panties, crying: "*Life is short. I want to live while I'm alive!*"

Hot Saturday (1932) stars Nancy Carroll as a small-town girl who wants love and marriage. She is engaged to Randolph Scott, who calls if off when he hears bad rumors about her. She responds by giving herself to likable Cary Grant. Next morning, when Scott appears, contrite, she announces the bad rumors are now true, and threatens to leave town with Grant. Scott quickly proposes.

A Farewell to Arms (1932), based on Ernest Hemingway's novel, stars Gary Cooper as an ambulance driver, and Helen Hayes as a nurse. They first meet one night when he is drunk, so he makes crude streetwalker talk to Hayes, then apologies to her. Courtship follows, then lovemaking. Hayes goes to Switzerland to have their child, who dies, Hayes seems to rally, and the lovers embrace. (In the European version, Hayes dies.) A 1957 remake was a failure.

The Tarzan film series can be seen as Hollywood's version of first love in a very American Eden (despite its African setting), without the drawbacks and complications of civilization.

Tarzan the Ape Man (1932) stars Johnny Weissmuller as a charming youth brought up by animals. He first sees beautiful Maureen O'Sullivan with her father's safari, and takes her captive, kicking and screaming. But soon the beauty is happily swinging from trees and swimming with the ape man, embracing him and teaching him to speak. The two are clearly pleased with what follows, smiling with coital pleasure. Jane decides to stay with Tarzan in their joyful relationship.

Romantically and sexually, the Tarzan series gradually declines. *Tarzan and His Mate* (1934), the sequel, has Tarzan and Jane living together (though unmarried). Jane wears an animal skin bikini and sleeps nude, the couple always touching and stroking each other. In an erotic sequence, Tarzan throws her into the lagoon, tearing away her dress, and then the two carry out a passionate swimming ballet together.

In *Tarzan Escapes* (1936) and *Tarzan Finds a Son* (1939) following the new Hays Code, the couple now lives in a jungle house with double beds, while in *Tarzan's Secret Treasure* (1939) and *Tarzan's New York Adventure* (1942), their lives seem asexual.

Foreign filmmakers worked with less censorship. *Ecstasy* (1933, Sweden) stars Hedy Lamarr, a country girl whose marriage is totally disappointing. On her wedding night, she lies on the bed, a longing expression on her face, then goes home and files for divorce. She is shown as nature's child, loving flowers, and swimming nude. Naked, she meets a young engineer who returns her clothes. Later, still sexually frustrated, she goes to his cabin to make love. When he begins, her face shows orgasmic ecstasy. They meet at a hotel and plan to go off together, but while he sleeps she goes off alone, although it is suggested they might get back together later.

Despite the new Hays code, Hollywood sought to depict romantic realities. In *The Song of Solomon* (1933) youthful Marlene Dietrich reads the bible's erotic Song of Songs to her father. Orphaned, she meets a young artist and soon is posing nude. *"Don't think of me as a male,"* he says. *"A model means no more to me than a tree!"* A seduction follows, showing her naked shadow as he strokes and fondles her clay counterpart. Revealing her needs, on a walk in the country she buries her face in the grass, crying out: *"You've got to bury your nose in it!"* Later he hints at a future together.

The late thirties saw the birth of the screwball comedy, which despite its sophistication sometimes dealt with first love stories. At least one character would show childlike qualities, if sometimes exaggerated into comic absurdity. *My Man Godfrey* (1936) stars Carole Lombard as the spoiled, childish daughter of a millionaire's family. On a scavenger hunt, she finds "a forgotten man"—clean, handsome, defiant tramp William Powell (Godfrey) from a hobo colony. She makes him the family butler and soon falls for him. Next the truth comes out—he himself is the son of a rich family. To win Powell, Lombard has phony "dead faints." Powell sees through it, and puts her in the shower, which she sees as love (*"Godfrey loves me: Godfrey loves me! He threw me in the*

shower!") Powell goes off to build a nightclub to give jobs to his hobo pals. Lombard shows up and demands matrimony.

>Lombard: *You love me and you know it. There is no sense struggling with a thing when it's got you!*

A marriage ceremony soon follows.

>Lombard: *Stand still, Godfrey. It will all be over in a minute.*

The film was such a hit it led to several variations: *Woman Chases Man* (1937), *Call It a Day* (1937), *Merrily We Live* (1938), and a remake, *My Man Godfrey* (1957).

Mr. Deeds Goes to Town (1936), another screwball comedy, has Gary Cooper as a childlike writer living in the country, who inherits twenty million. In New York he is shadowed by cynical girl reporter Jean Arthur, who pretends she is jobless. She faints in his arms, then ridicules him in the newspapers by calling him "Cinderella Man." Meanwhile, he writes her a poem and asks her to marry him.

Romeo and Juliet (1936), a big-budget Hollywood prestige project, stars Leslie Howard and Norma Shearer. The film follows the Shakespeare play closely, with Howard and Shearer as the star-crossed young lovers, and Basil Rathbone as Shearer's cousin, dueling with and killing Howard's friend John Barrymore. Howard kills Rathbone, is banished, and secretly weds Shearer. A scheme devised to circumvent her family's objections goes astray and Howard, thinking Shearer dead, commits suicide, as does she when she finds him dead. Numerous other film versions have been made.

The Awful Truth (1937), another screwball comedy, is in many ways a first love story with the couple forever infatuated. Husband Cary Grant supposedly cheats on wife Irene Dunne and is found out, and the two are ready to divorce, yet each behaves as if determined to win the other back. Dunne finds a new dull mate, Ralph Bellamy, and Grant does too, a second-rate singer. When the couples meet at a nightclub, it is clear their dates are not in the same league as the sparkling couple. Dunne realizes it and drops Bellamy.

>Dunne: *I'm still in love with that crazy lunatic, and there is nothing I can do about it.*

Grant gets involved with a socialite, but Dunne shows up as his low-class sister, and drives the socialite off, "exposing" his alcoholism. ("*We call him Jerry the Nipper.*") Alone, they find themselves in tune again, and ready to make love.

>Grant: *You're still the same...only I've been a fool, but I'm not now...as long as I'm different don't you think that well, maybe things could be the same again, only a little different, huh?*

As first love couples put it, they have always been together.

Some first love films of the forties still paired worldly women with guys who'd been sheltered one way or another, less extreme versions of the childlike heroes of the screwballs.

Remember the Night (1940) stars Fred MacMurray as a D.A. prosecuting streetwise jewel thief Barbara Stanwyck. Stanwyck realizes he is naïve, and

cares for her, so pleads guilty, telling him that if he still wants her after prison, she will be his.

Ball of Fire (1941) has professor Gary Cooper shelter stripper Barbara Stanwyck, brought on campus to study her show biz slang. She is teasing and coy, but the two quickly fall for each other; she cannot resist his unworldliness.

> Stanwyck: *I love those hick shirts he wears with the boiled cuffs, the way he always has his vest buttoned wrong. He looks like a giraffe and I love him. I love him because he's the kind of guy who gets drunk on a glass of buttermilk, and I love the way he blushes right up over his ears. I love him because he doesn't know how to kiss, the jerk.*

He does get a chance to display his manliness when gangsters show up.

It's a Wonderful life (1946) features the love story of "ordinary guy" Jimmy Stewart with the girl next door, Donna Reed. They're childhood sweethearts and grow up together, Stewart making his feelings plain.

> Stewart: *What is it you want, Mary? What do you want? You—you want the moon? Just say the word, and I'll throw a lasso around it and pull it down. Hey, that's a pretty good idea. I'll give you the moon.*
> Reed: *I'll take it.*

Later she gets a phone call from an old boyfriend, and she is both desiring and fearful when she talks to him, and to Stewart as well.

> Stewart: *I don't wanna get married. I want to do what I want to do!*

Next they're shown coming out of the church together—married. At one point he visits an "alternate world," a hellhole where he never married Reed, where she is an old maid librarian. Back home, Reed's wife, family, and friends stop his ruin and suicide.

Another film that suggests postwar attitudes towards men in love is *Without Reservations* (1946). On a Hollywood bound train, ex-flyer John Wayne meets blockbuster novelist Claudette Colbert, who wants him to star in her novel's film adaptation. Their attitudes towards romance are quite different.

> Colbert: *One must be sure of what is inside of us, our tastes, our interests, our gestures.*
> Wayne: *Oh, Ally, won't you stop thinking!*

Wayne explains his ideas about love to a pal: "*He is a man...she's a woman...that's all.*" He also has ideas about women:

> Wayne: *I don't want a woman who is trying to tell the world what to do. I don't even want a woman to tell me what to do. I want a woman who needs me.*

Nevertheless, when Colbert starts dating Cary Grant and others, Wayne soon appears, announcing: "*Thanks, God, I'll take it from here!*" Postwar romance is a woman's game.

Several postwar foreign first love films give portraits of young love full of confusion and suffering. In them, as a poet put it, "Love's pleasure lasts but a moment; love's sorrow lasts all through life."

Devil in the Flesh (1947, France) opens with teen Gérard Philipe preparing

for a funeral. It then shows his first meeting with Micheline Presle, an attractive nurse. A romance begins, and the teen spends days with her, but the youth can't handle his feelings—moodiness, temper tantrums, jealousy. Meanwhile, Presle lets her parents push her into a loveless marriage to an older man, a soldier. After a separation, the boy contacts her, and she realizes she still loves him, so she invites him home to make love. The relationship goes on. The girl won't tell her husband about it, read his letters, write him, or see him on leave. She becomes pregnant, and dies. The husband is grief-stricken and the youth guilt-ridden. It is her funeral he is attending. Raymond Radiguet, the source novel's author, said the story was largely based on his life. He committed suicide at age twenty.

The Game of Love (1954, France), based on a Colette novel, deals with two teenage cousins, Nicole Berger and Pierre-Michel Beck, who have grown up together and are very close. Summering with their families, they're soon very aware of their sexuality. Then Beck meets a beautiful, seductive, lonely older woman, Edwige Feuillère. In her mansion the sensual woman becomes his sex teacher. After he has "become a man" he returns to his cousin. The youth is discreet, but the treatment of the older woman has been termed painful and degrading by critics.

Illicit Interlude (1954, Sweden, aka *Summer Interlude*) stars Maj-Britt Nilsson as a ballerina who acquires a diary from old love Birger Malmsten, and reads it. A flashback shows the two courting and then making love. She gives the diary to her new love to read, so they may speak seriously of the demons in her life.

The American first love films of the fifties that deal with adults having their first real romantic experiences include many of the complex, conflicting feelings of youthful lovers, powerfully rendered by the extraordinary acting talent available.

The African Queen (1951) starts as World War I breaks out in Africa, with raffish, middle-aged river steamer captain Humphrey Bogart rescuing puritanical British missionary Katharine Hepburn from a destroyed mission. Bogart takes her aboard his small river steamer, but they're soon at odds. He calls her a "crazy, psalm-singing, skinny old maid." She pours all his liquor into the river. Meanwhile they sail down the river past gun emplacements and rapids, risking their lives. She convinces him they can reach Africa's central lake and destroy the German battleship patrolling it. As they overcome the obstacles—a broken rudder, rapids, a swamp—they fall in love. Running the rapids unleashes Hepburn's repressed erotic impulses.

 Hepburn: *I never dreamed any physical experience could be so stimulating. I don't wonder why you love boating, Mr. Allnut!*

Meanwhile, the seedy Bogart recovers his manhood.

 Bogart: *Fine specimen of a man I am!*

They attack the cruiser in a storm and are captured, but demand the German captain marry them before they're executed. Meanwhile the riverboat, with its homemade torpedoes armed, floats closer and finally sinks it.

The Wild One (1953) stars Marlon Brando as thirtyish, leather-wearing biker rebel who separates himself in every way from society to maintain his personal integrity, summed up in a brief exchange:

Citizen character: *What are you rebelling against?*

Brando: *What have you got?!*

Throughout the film, Brando stays a rebel, but has a clear attraction to a simple, hardworking waitress who shows common decency to him and his bikers.

A Summer Place (1959) has two first love couples. Sandra Dee, child of an unhappy marriage, begins a chaste affair with boyfriend Troy Donahue, asking, "*Have you ever been bad with girls?*" When he admits not, she is willing to go on. When she becomes pregnant, they marry. Her mother, Dorothy McGuire, divorces a cruel husband, and reunites with Richard Egan, her first love and Dee's father.

On the Waterfront (1954) stars Marlon Brando as a decent and defeated dockworker manipulated by the mob, who in time rebels. He starts seeing Eva Marie Saint, a local girl. He also is caring for pigeons and telling her: "*Pigeons marry just like people, and stay that way until one of them dies,*" suggesting his longing for love. But when he hesitates to testify against the mob, she tells him he doesn't have a spark of sentiment or romance or human kindness. Brando replies: "*What good does it do you besides getting you in trouble?*" Tormented, he breaks down Saint's door to make her admit she loves him. Then risking his life, he testifies.

Summertime (1955) stars Katharine Hepburn as an American spinster. Vacationing in Venice, she falls in love for the first time with a married man, Rossano Brazzi. He asks her to simply take joy in what has happened to her, not to intellectualize.

Brazzi: *What do you want to understand? The most beautiful things in life are things we don't understand.*

Picnic (1955) has drifter William Holden coming into a town, hoping successful pal Cliff Robertson will help him settle down. Holden and Kim Novak see each other, and it's love at first sight. Novak, the prettiest girl in town, was to marry Robertson. A friend, spinster schoolteacher Rosalind Russell, fears life is passing her by, but hopes for romance with Arthur O'Connell, a dull traveling salesman. There is also excitable teen Susan Strasberg. Holden goes around shirtless, pleasing the women. Novak's mom, experienced, warns her: "*A pretty girl hasn't got long....*" But she has already fallen for the ne'er-do-well.

Holden's chatter: *I've learned something today, and it's that, well, there comes a time in a man's life when he's got to stop rolling around like a pinball. Maybe a—a little town like this is it, a fine place to settle down where people are easy-going and sincere.*

At the Labor Day town fair, Holden and Novak dance together with great sensuality. Afterwards, she acknowledges it.

Novak: *I can tell a lot about a man by dancing with him. You know, some boys—well, when they take a girl in their arms to dance, they—well, they make her feel sort of uncomfortable. But with you, I have the feeling you knew exactly what you were doing, and I could follow you every step of the way.*

Russell also can't resist Holden, ripping off his shirt in a seizure of lust. Robertson learns the truth, so Holden has to run off, telling Novak that he's just a bum and a liar. Meanwhile, Russell forces her shy steady into marriage.

Russell: *It's no good living in a rented room. Each year I tell myself it is the last. Something will happen. It never does. You will marry me, Howard. Please marry me, Howard, please.*

Novak realizes her love counts for everything, and takes a bus going the same way Holden fled, hoping to catch him.

Rebel Without a Cause (1955) stars James Dean as a high school boy who rebels against his dysfunctional, quarrelsome family and searches for love and friendship. He finds first love with Natalie Wood, a school friend who is also a child of an unhappy marriage. Dean intuits his parents' conflicts, or thinks he does.

Dean: *If he had the guts to knock Mom cold once, maybe she'd be happy and stop picking on him. I don't want to ever be like him... How can a guy grow up in a circus like that?*

By contrast, Dean is sensitive and accepting towards Wood, just what the rejected girl needs and wants. He is ready for love.

Wood: *A girl wants a man who is gentle and sweet and doesn't run away.*

Dean: *I want to belong to someplace.*

Later, Dean, Wood, and their friend Sal Mineo, another teen outcast, take refuge in an old abandoned house. Wood says she loves Dean because she trusts him.

Dean: *I'm not going to be lonely any more, not you or me.*

As the film ends, it looks like the couple will stay together

The first love films of the sixties and seventies deal more with young people in love, and more explicitly treat real social, economic, and interpersonal problems which could complicate or derail a couple coming together. The films also deal with more sophisticated or daring material, to challenge mass-market television.

Where the Boys Are (1960) focuses on some college coeds going on spring break to Ft. Lauderdale, Florida, and having romantic adventures. Pretty, bright Dolores Hart has a fling with young George Hamilton, an Ivy League rich man's son, and she is seriously conflicted over whether it will last:

Hamilton: *You'll never lose your grip. You're a pretty strong girl, Merritt.*

Hart: *Not really. No girl is, when it comes to love. What she thinks is love. How do you know the difference? Do you love me, Ryder?*

Paula Prentiss falls for poor college guy Jim Hutton, but won't give in to him. The students' underlying economic stresses are nicely summed up by Hutton's comment to rich kid Hamilton:

Hutton: *You can afford to be wrong. I can't even afford to be right!*

Other problems are suggested by Connie Francis's infatuation with a bizarre musician, and Yvette Mimieux, who believes in love at first sight, who ends up assaulted by a fraternity. A remake, *Where The Boys Are* (1984), made the girls sluts and the boys worse.

*The Apartment (*1960) stars Jack Lemmon as a white-collar office worker trying to get ahead, and Shirley MacLaine as an elevator operator, both searching for love. They sum it up:

Lemon: *I used to live like Robinson Crusoe—shipwrecked among eight million people. Then one day I saw a footprint in the sand and there you were.*

MacLaine: *I've been jinxed from the word go. First time I was kissed was in a cemetery. I was fifteen. We used to go to smoke. His name was George. He threw me over for a drum majorette.*

MacLaine, however, is having an affair with executive Fred MacMurray, who says he'll divorce his wife. And in exchange for a promotion, Lemmon lets various married managers use his Manhattan apartment as a sex rendezvous, forcing him to hang out in the park some nights. In time, MacMurray refuses to marry MacLaine, so she attempts suicide. But Lemmon finds her in time, revives her, and blurts out his love for her. Lemmon tells off MacMurray, quitting, and goes home, to be joined by MacLaine.

Splendor in the Grass (1961) stars Warren Beatty as a high school athlete and natural charmer, "the best catch in town," son of a town oil king in 1928. His girl is the passionate, adoring teen Natalie Wood. The two are madly in love (when they walk down high school corridors, other teens step aside). They both have a strong need for each other sexually, but Wood's mom insists, "*Nice girls don't have such feelings.*" When Beatty walks Wood home and finds it deserted, she goes down on her knees and says she is his slave.

Wood: *I'm nuts about you, I would go down on my knees to worship you if you really wanted me to, and I can't get along without you, and bud...I would do anything you'd ask me to do. I would. Anything!*

Beatty wants to marry Wood, go to agriculture college, and have a family farm. But his driven father insists he go to Yale, then take over the family business. Beatty gives in, and the rejected Wood starts sleeping around, attempts suicide, and is hospitalized. Beatty at the hospital stands outside her room and begs her to marry him, but she is lost. Beatty quits Yale, and the Depression ends the business, so Dad commits suicide. Beatty marries a town girl and farms. Wood is treated, and marries a fellow patient, a doctor. At a last meeting, Wood seems grown up, Beatty still a bewildered youngster. The film was a great hit, but today it seems exploitative, with its parents who only want to control their kids and youngsters who can't control themselves. This seems to be a story that worships untamed adolescence.

The Stripper (1963), a well thought of independent film, stars Joanne Woodward as a Hollywood actress who joins a drama troupe, with a bouncy walk but vulnerable emotions. Back in Kansas for the summer, she stays with an old friend with a nineteen-year-old son, Richard Beymer. The teen is attracted, comes on, and proposes marriage. Woodward is pleased but knows it for an infatuation. Her former manager offers her work as a stag show stripper, and she accepts. The teen attends the show, and is torn apart by the other men's crude behavior. He again asks her to marry him, and she refuses, but then decides it is time to settle down.

Doctor Zhivago (1965) has the married-to-other-people couple Omar Sharif and Julie Christie unite so passionately and totally it's in effect a first love film. During the Russian Revolution, isolated on a beautiful winter estate where snow and ice make it seem a magic castle, the couple experience total bliss, a joy beyond normal experience, though they're aware of its fragility and lack of a future.

> Sharif: *Wouldn't it have been lovely if we'd met before?*
>
> Christie: *Before we did? Yes...we'd have gotten married, had a house and children. If we'd had children would you have liked a boy or a girl?*
>
> Sharif: *I think we may go mad if we think about all that.*
>
> Christie: *I shall always think of it.*

Circumstances cause them to separate, and never meet again.

Lolita (1962), based on the Nabokov novel, has handsome European professor James Mason renting a room in widow Shelley Winters's home, meeting her teenage daughter Sue Lyon (Lolita), and falling hopelessly in love with the youngster, an agonizing first love. Lyon is initially defiant, moody, and unapproachable. To stay near Lyon, Mason marries Winters, whom he despises. When Winters gets killed, Mason takes Lyon from her summer camp and on a cross-country road trip, trying clumsily to seduce her, without clear success. Meanwhile, the pair are shadowed by a mysterious wise guy, Peter Sellers, who persecutes Mason with arrest threats and finally steals Lyon. Years later, Lyon contacts Mason, asking for help. She is married, frowsy, and as disagreeable now as her mom, and won't leave her dull husband. Mason makes a last desperate try for his dream.

> Mason: *Lolita, life is very short. Between here and that old car is twenty-five paces. Come now, just the two of us. I've never been less crazy in my life. We can start fresh, forget everything. It's not too late. I've waited three years already. I think I could wait for the rest of my life.*

But she won't go. Mason leaves her and takes revenge on Sellers, the clever creep that Lyon worshipped and who tormented him. A remake, *Lolita* (1997), is closer to the novel.

Two for the Road (1967, England) features Albert Finney as a young architect and Audrey Hepburn as a student wandering through Europe who meet, fall in love, and go through several years of marriage and several more

trips, made at various points in the relationship. Switching back and forth between different episodes on different trips, the film illuminates the growing pattern of their love.

At first, Finney opposes marriage but Hepburn gradually charms him, the film finding a way to examine the on and off, fluctuating (sometimes passionate, sometimes skeptical) patterns of modern relationships being born and evolving.

> Finney: *Marriage is when a woman asks a man to take off his pajamas because she wants to send them to the laundry.*

John and Mary (1969) could be the essential first love romance of the sixties. Furniture designer Dustin Hoffman meets art gallery assistant Mia Farrow at Maxwell's Plum club, takes her home, and makes love. She tries to understand him by studying details of his apartment, as he does with her purse's contents. They eat breakfast, shown as a dating rite. She leaves her number and he destroys it, but she stays in his mind, so he searches her neighborhood. They meet, go to bed again, and exchange names—the beginning of a relationship.

Love Story (1970) opens at Harvard where pre-law student Ryan O'Neal meets Radcliffe coed Ali MacGraw. The two are very much alike. They're soon flirting:

> O'Neal: *You know you're not that good-looking.*
> MacGraw: *I know. But can I help it if you think so?*

They soon wed, though her being lower class leads to his family breaking off with him. In a few years, she dies. When O'Neal's dad tries to apologize. O'Neal cries: *"Being in love means never having to say you're sorry!"* The film was a tremendous hit.

Summer of '42 (1971) is narrated by the now adult Gary Grimes. During the summer of 1942, when he was a teenager, he was hopelessly smitten with lovely war wife Jennifer O'Neill, whose soldier husband was overseas. One day he visits her, and sees a war office telegram. She embraces him silently, and a seventeen-minute lovemaking interlude follows. The next day he returns, but she has moved out, leaving a note: *"I will not try to explain what happened last night because I know that in time you will find a proper way to remember it."*

Teen dream sex and grown-up feelings—having your cake and eating it too.

European adolescent love films of the seventies were bittersweet. *Murmur of the Heart* (1971, France) stars Benoît Ferreux as a fourteen-year-old boy, whose mom Lea Massari shares his carefree emotionalism. When he sickens, his mom brings him to a mountain retreat to recover. Each is looking for romance; neither succeeds. In their hotel room, they start drinking and eventually fall into bed together, where gestures of affection become lovemaking. The mother explains this is a one-time experience, and the son goes out to have sex with a teenage girl. His older brothers roar with pleased laughter—the young fellow is a man. How little they know.

To Die of Love (1971, France) has Annie Girardot, a schoolteacher, in love with a sensuous high school student, Bruno Pradal. An intelligent, girlish woman, the thirtyish teacher pursues the seventeen-year-old, but is jailed for it,

and he is placed in a psychiatric clinic. Her teaching career ruined, she eventually commits suicide in despair.

Several first love films of the seventies deal with topical material, from disco clubs to divorced people's search for their first honest romance.

Saturday Night Fever (1977) stars John Travolta as a teenage clerk in Brooklyn whose life revolves around Saturday nights at a disco dance palace, where he is a king pursued by promiscuous teens. His group parks their car by the disco to make "scoring" easy, as when a girl achieves orgasm while the guys look on approvingly. Soon Travolta meets Karen Lynn Gorney, a fine dancer with a Manhattan career. They soon win a big dance contest, but she refuses sex (their love affair is consummated on the dance floor). Later Travolta visits Gorney at her Manhattan apartment and apologizes for his aggressiveness. The two start a tentative relationship. A major hit sequel followed, *Staying Alive* (1983).

An Unmarried Woman (1978) stars Jill Clayburgh as a wife with a child whose husband goes off with a lover. It doesn't last, but after several weeks she starts a journey towards a new true love herself. Her therapist tells her to be part of the city, so she hits the singles bars where she meets Cliff Gorman, who explains himself:

> Gorman: *Let's get something straight right off the top, babe, huh. I don't get involved with my women. I'm a short-term guy. I don't fall in love. I don't want to get married. The only thing you can count on me for is sex. I am what I am. I make no bones about it.*

They have an okay time, but a relationship does not follow. At an art exhibit, she meets artist Alan Bates, who is gentle and thoughtful, more to her liking.

> Bates: *You know, there are three things we could do tonight. One, you could call a taxi and go home. Two, we could go on walking and I could lecture you on the real dilemmas of modern art; three, we could go to my place and thoroughly enjoy each other.*

Bates wants her, but Clayburgh wants independence and a say-so. She lands a great new job and a New England holiday with Bates, but she still wants things her way. The relationship goes on, with marriage a possibility.

Starting Over (1979), a masculine counterpart of *An Unmarried Woman*, stars Burt Reynolds as a lonely guy whose wife, Candice Bergen, has left to be free to discover "*who I am.*" When Bergen returns, Reynolds, a quiet, decent writer, must cope with a "new" songwriter-singer wife who is no good. He tries to accommodate her dream of "liberation," first going to Boston so his relatives can comfort him. Meanwhile Reynolds finds out Bergen is having an affair with her boss. He also meets Jill Clayburgh, a frowsy, single schoolteacher available for brief affairs, and joins a divorced men's workshop, whose psychiatrists give bad advice on "starting over." He soon starts an affair with Clayburgh.

> Reynolds: *I want to have sex with you.*
> Clayburgh: *I don't like the way you put it. It makes me feel very strange.*

Reynolds: *I know...it did...did sound a little bit like Tarzan. I was trying to avoid the whole romantic thing.*

Clayburgh: *I don't like that either. I hate that. But can't you just personalize it a little. I want to have sex with you...*

Reynolds (kneeling): *I want to have sex with you....*

Clayburgh: *I want to have sex with you.*

But Reynolds can't get over his ex. Clayburgh has seen it before

Claiborne: *I understand. It's too much and it's too soon, or you don't like me enough, or you like me too much, or you're feeling tense or you're guilty, you can't get it up or out or in or what.*

The first love films of the eighties often seem variations or exaggerations of those of the previous two decades. The strong commercial pressure to use a winning formula may be one reason for this tendency.

Urban Cowboy (1980) features John Travolta as a young oil worker who plays the cowboy by riding a big, surging mechanical bull in Gilley's Bar in Houston. He meets a local beauty, Deborah Winger, and the two are soon married and living in his trailer. She is as good on the bull as he is, and in their lovemaking she is writhing and sensual and soon dissatisfied:

Travolta: *My balls are killing me.*

Winger: *Does that mean you won't be able to do it?*

Soon he starts an affair with an upper-class girl, and Winger retaliates by getting close to a macho thug. After a faceoff between the guys, the couple decides to reunite.

The Blue Lagoon (1980) stars Brooke Shields and Christopher Atkins as two children marooned on a tropical island (played by young doubles), who grow up into the sexy teens Shields and Atkins, who fall in love and live out a sort of Adam and Eve life, with chaste nude displays of affection. Finally, they leave the island for civilization, in an open boat. A sequel, *Return to the Blue Lagoon* (1991), has their two children live out similar adventures.

Endless Love (1981) has teens Martin Hewitt and Brooke Shields fall in love. Her family wants a "*thirty days cooling off period,*" but Hewitt, obsessed, can't take it, and sets her house afire (his plan—save her and be a hero!). Instead, charged with arson, he is jailed for two years as unbalanced. Released, he tracks down Shields's family and indirectly causes her dad's death. Shields tries to end it: "*It was a once in a lifetime thing...you have to let it go,*" but he chooses to assault her in his hotel: "*We're not finished!*" He is put back in prison. At the end Shields seems to be coming to visit, but this may just be more madness.

Butterfly (1982) has Pia Zadora as a naïve but very sensuous teen, living in the country with Stacy Keach, father figure and perhaps dad. She tries to provoke him by stripping and letting him touch her intimately:

Keach: *It ain't right.*

Zadora: *Feels good to me!*

She flirts with others, but meanwhile the two become lovers. Keach and Zadora are arrested for incest, but she challenges the judge.

Zadora: *What we did was bound to happen. It was good for both of us!* In the end they're found not guilty.

Class (1983) stars Andrew McCarthy as a romantically inexperienced prep school student. Jacqueline Bisset picks up the teen in a bar, and five minutes later the rich, heedless society woman is tearing their clothes off in an elevator, believing his story that he is a graduate student. She doesn't know that her son, Rob Lowe, is McCarthy's roommate until he finds the two of them in bed together.

No Small Affair (1984) concerns Jon Cryer as a teen wise beyond his years, sophisticated enough to introduce himself to his mother's boyfriends as *"Charles Cummings, in case you're wondering whose mother you had your way with."* He soon begins an affair with glamorous twenty-three-year-old rock star Demi Moore. When things don't seem to work out, he leaves.

Cryer: *I'll never love anybody but Laura, never. I'll never make love to anybody again. That is almost definite.*

The Sure Thing (1985) opens at an East Coast college where John Cusack is a sex-hungry undergraduate, and Daphne Zuniga a prudish and schedule-minded coed. Cusack's dream is a responsibility-free relationship.

Beautiful bikinied blonde: *You want it...I want it...I want it, you know I want it. You don't have to bullshit me to get it. Even if you're untruthful with me...you still get it.*

Cusack and Zuniga dislike each other on sight. Meanwhile, Cusack's pal sets up a date with a California "sure thing" for Christmas:

Pal: *There's a certain someone here I want you to meet. She's a very, very special person. She was just released from parochial school; she's in her experimental phase. She loves sex. You remember the last snapshot I sent you? The blonde in the string bikini? Look at that and fixate on that. Are you fixating on it? She's a sure thing, kid, a sure thing.*

Zuniga has another boyfriend. She and Cusack wind up traveling together. Various troubles arise, and Cusack finds he enjoys caring for Zuniga, and she loosens up with him as they're stranded and escape a sex-mad truck driver. When their L.A. lovers don't work out, the two charmed new friends turn to each other.

Murphy's Romance (1985) shows two middle-aged people falling in love as if for the first time. Sally Field moves to an Arizona ranch and meets pharmacist James Garner in town. They build a friendship. When she is visited by her ex, unstable Brian Kerwin, he moves in, confronts Garner, then moves on. Garner kisses Field and tells her he intends to marry her:

Garner: *Take another tack, Emma.*

Field: *I don't know what tack to take.*

Garner: *I'll help you. Separate the men from the boys, Emma. I show some wear, I don't deny it. If the fruit hangs on the tree long enough, it gets ripe. I'm durable, I'm steady; I'm faithful. And I'm in love for the last time in my life.*

Field: *I'm in love for the first time in my life.*

Blue Velvet (1986), with a shocking psychological subplot, is a first love story with pathological elements. When college boy Kyle MacLachlan comes home, he befriends local girl Laura Dern. They investigate a crime, with McLachlan hiding in the victim's wife's home closet. The wife, Isabella Rossellini, starts seducing the teen, then closets him when lover-criminal Dennis Hopper arrives. The two play out a parenting-birth fantasy, Hopper as a tempestuous child threatening her. The two alternate parent and infant roles. At last Hopper leaves, and MacLachlan escapes and returns to his conventional teen romance with Dern. But soon he is drawn back, Rossellini again seductive. (*"Do you like me? Do you like the way I feel?"*) When she asks to be brutalized, the teen runs. He goes back to Dern's teen romance, but more intensely. Next he has sex with Rossellini. (*"Are you a bad boy? Do you want to do bad things?"*) They have childish sex and she says: *"You put your disease in me!"* The two symbolic adults perish, and MacLachlan matures to a passionate teen relationship, with Dern appreciating its safety and familiarity.

In one critical interpretation, the youngster has "worked through" the baby to adult stages of psychosexual development in civilized life, ending with a normal "adult" relationship, the film a comic nightmare of modern psychosocial enlightenment. He is an Oedipus that dodges the worst of the Oedipus complex.

Dirty Dancing (1987), a more conventional coming of age film, has teen Jennifer Grey at a Catskills resort of the sixties. Adolescent Grey meets hotel master dancer Patrick Swayze, who teaches dancing and runs the stage show. In their quarters the hotel workers do "dirty dancing," including erotic body contact to intense music. Grey sees it and falls for Swayze. Soon she and Swayze are making love often. When the lead female dancer gets sick, Swayze teaches Grey her moves, and the pair is a big success. Swayze puts on the big "end of season" show, including a Swayze-Grey "dirty dance" which all surrealistically join, celebrating their love.

Crossing Delancey (1988) features Amy Irving working in a bookstore for literati, and involved with a hot novelist. Her grandmother and a marriage broker suggest a match with a pickle store owner, but he and Irving have little in common until he reveals a poet's sensibility. Meanwhile the novelist seduces her with lines stolen from Confucius, not offering love but just scut work as his editorial assistant. Irving sees the light and rushes to a rendezvous with the pickle merchant/poet.

Getting It Right (1989, England) has Jesse Birdsall as a London hair stylist living at home. He attends a posh party where he meets Lynn Redgrave and starts an affair with her. Simultaneously he meets Helena Bonham Carter, a very upper class woman, who takes him home and tells her folks they are to be married. (Her patrician dad is soon cross-examining Birdsall.) The newly self-confident stylist is now attracted to his assistant, Jane Horrocks, and they start a fling. Each romance soon reaches a crisis. Redgrave is an experienced older woman with much to teach, but under great emotional stress drops him. Bonham Carter, seemingly a free spirit, reveals herself as mentally unbalanced and

suicidal. His assistant's problems—single parenthood, financial neediness, a loving nature—match Jesse's life pattern, "getting it right" for the two of them, As one of the women tells him insightfully: *"Don't worry about being loved. Worry about loving. It's far more important."*

The first love films of the nineties and start of the new century still fall into the categories found in the first love films of the previous decades, to their credit often showing new and significant variations on them, and even direct commentaries on them.

Say Anything (1989), a love triangle, features brilliant Ione Skye, conniving dad John Mahoney and goodhearted underachiever John Cusack. Cusack wins Skye with a romantic beach encounter, passionate love letters, and a night together. Her dad, ambitious for her, stops the affair. Cusack perseveres with phone calls and a boom box serenade under her window. Then the I.R.S. reveals that Dad's used his nursing homes to embezzle, while Cusack proves wonderfully supportive. Skye sees him anew as a mature, sympathetic, trustworthy lover.

> Skye: *Why are you shaking?*
> Cusack: *I don't know, I guess I'm happy.*

Frankie and Johnny (1991) stars Al Pacino as a sensitive ex-con (jailed for check forgery), now a master chef, and Michelle Pfeiffer as a coffee shop waitress. Pacino tries a prostitute, another waitress, then Pfeiffer. They're good together, at first:

> Pacino: *I want to go upstairs, watch you get ready for bed, then climb in and make love to you for ten hours.*
> Pfeiffer: *You expect me to be fooled with a line like that?*

But when they become serious, Pfeiffer becomes threatened and Pacino frustrated. From her window, she can see the next building's unhappy romances: a sexy kept blonde, a middle-aged couple that never speaks, an abusive pairing. Pacino's past includes a failed marriage, an ex-wife and kids now living good lives that he can't share. But he still pursues Pfeiffer:

> Johnny: *Chances like this don't come along often. You gotta take 'em, because if you don't, they're gone. Forever. And you may wind up not only screwing some other person you meet, but thinking you're in love with this person, and marrying them.*

The Crush (1993) has writer Carey Elwes meet Alicia Silverstone, a sexually provocative teen. He rents her parents' guesthouse, and she seduces him, spying on his daily routine, hacking his computer, and rewriting his articles. He takes her out, and secretly watches her undress. But when a new girlfriend makes him back off, Silverstone goes crazy, letting wasps loose on the girlfriend, humiliating him at a business event, even beating him unconscious. She is put in a mental home, but is soon busy there looking for her next victim.

Spanking the Monkey (1994) deals with mother-son sex. College kid Jeremy Davies comes home to learn he must stay to care for his severely depressed mom, Alberta Watson, including bathroom needs. His mother is attractive and sensuous, the teen frustrated, the mom mocking his sex life. He meets a cute

high school girl, but remains powerfully attracted to his mother in intimate moments. Making out with the teen he is too rough, she flees, and a complaint comes back to Mom. That night mother and son watch TV and drink, she giving advice on sexual intimacy, and slowly but surely mother and son become lovers, she asking him to express his impulses. Tormented with guilt, he finds his mother in denial—it never happened. His dad tells him to stay home to earn his tuition. The teen tries to confess, but the mother covers it up. When he tries to speak to the girl, his mother strikes her. He can't deal with things, tries to hang himself, and when his mom intercedes, he almost strangles her. He tries to leap to his death in a quarry, then hitches a ride to someplace far away.

Benny and Joon (1993) has Mary Stuart Masterson as a schizophrenic who befriends manic mime Johnny Depp. When the brother who cares for her starts going to work, Depp begins acting as her male companion and nurse, and the relationship evolves into love.

Forrest Gump (1994), one of the highest grossing films of all time, tells how Tom Hanks (Gump), a childlike man of subnormal intelligence, yet oddly wise (and lucky), is a tragic success. His love life starts as a child, meeting the love of his life Robin Wright. In their school days she warns him to run from his enemies, while he is supportive when she flees an abusive father. Wright tries to be trendy, and as a G.I. Hanks encounters her in a strip joint, naked, singing protest songs behind a guitar. After Vietnam she is protesting with fierce Black Panthers. Years later he returns to their Alabama hometown, where they sleep together. (Gump: *"I'm not a smart man, but I know what love is."*) Finally, again years later, he finds her living with a normal little boy, his son, and takes her home to live with him on the family farm until she dies, apparently from AIDS. At the film's end he is bringing up his son, sending him off to school. As Gump says at one point, *"stupid is as stupid does."* He found the love of his life, but she was too foolish, preferring dubious and ultimately disappointing life paths.

Before Sunrise (1995) is a romantic "road movie" set in Europe. Young tourist Ethan Hawke meets attractive Frenchwoman Julie Delpy and talks her into spending his end-time in Vienna with him before he returns to the U.S. Walking and talking, they "philosophize," trying to learn about each other. Their conversations often turn to love:

> Delay: *I've been wondering lately...do you know anybody who is in a happy relationship?*
> Hawke: *Yeah, I know happy couples, but it seems they have to lie to each other.*

For a while they role play, each calling a friend to describe their new love. In a record shop, the game is to glance at the other without getting caught. They sleep together in a park, wondering if they should have sex and finally deciding they will.

Next morning they agree to meet again in the future. A sequel, *Before Sunset* (2004), has the lovers meet nine years later and have another intriguing conversation, and ambivalent parting.

Jerry Maguire (1996) stars Tom Cruise as a sports agent who negotiates big salaries and endorsement money for clients. He announces to his agency they should provide more attention to the clients, not just money. Big mistake, he is fired, trailed by accountant Renée Zellweger, who wants him. He does hang onto one client, athlete Cuba Gooding. While Cruise is pitching Gooding, a romance blossoms between Cruise and Zellweger, prompting his girlfriend Kelly Preston to dump him:

> Preston: *It is all about you, isn't it? Soothe me, save me, love me! There is a sensitivity thing that some people have. I don't have it. I don't cry at movies. I don't gush over babies. I don't celebrate Christmas five months early! And I don't tell a man, who has just screwed up both our lives, uh, poor baby! That's not me, for better or worse. Nobody dumps me!*

She punches him in the nose, kicks him in the groin, and announces: "*I'm too strong for you!*" Zellweger, however, finds Cruise's concern for his clients is what makes him attractive:

> Zellweger: *I love him for the man he wants to be...and I love him for the man he almost is.*

They break up, but Cruise realizes what he really feels:

> Cruise: *Tonight, our little project, our company, had a very big night. A very, very big night. But it wasn't complete, wasn't nearly close to being in the same vicinity as complete, because I couldn't share it with you. I couldn't hear your voice, or laugh about it with you. I missed my wife. We live in a cynical world, a cynical, cynical world, and we work in a business of tough competitors. I love you. You complete me. And if I just had....*
>
> Zellweger (interrupts): *Shut up. Just shut up. You had me at hello. You had me at hello.*

Carried Away (1996) has schoolteacher Dennis Hopper drop his fiancée for a fascinating, unstable student, Amy Locane. When Locane arrives in the midwestern town she makes immediate sexual advances to Hopper, disrobing delightfully for her teacher and soon the two begin a wild, secret love affair. Unbalanced by his double life, he soon demands that his old fiancée Amy Irving join him in equally passionate sex. When news of his new, fiercely intense life spreads, the school board investigates, and Locane and her father depart the town.

Chasing Amy (1997) has Ben Affleck, promoting a new comic book he created, meet pretty Joey Lauren Adams and fall for her. Though he believes that she may be a lesbian, he remains fascinated, spending time with her and finally admitting he is in love. She soon says she is too. As a result he drops his creative partner, and she leaves her lesbian pals. Affleck finds out she had lesbian relationships as well as wild ones with other men. So he decides that he and Adams and his partner should all have sex together, and his partner will then he comfortable with lesbians and Affleck "*up to speed*" with her previous relationships. His partner is willing, but Adams feels the couple's new

relationship supersedes all her previous behaviors. The three separate, meeting a year later. Affleck's newest comic book, *Chasing Amy*, telling the story of their relationship, moves Adams, but she says that continuing their love affair has now become impossible.

Titanic (1997), a top-grossing film of all time, tells how poor young artist Leonardo DiCaprio takes the first (and last) voyage of the *S.S. Titanic* in 1912, and has a first love affair with Kate Winslet, a debutante traveling first class with her mother, who is pressing her to marry rich cad Billy Zane because they need money. DiCaprio saves her from suicide, opening her eyes to nature, art, ethnics, and youthful lovemaking. He sketches her wearing nothing but a precious diamond necklace. When the iceberg hits, they choose to take their chances together in the water, where he gives his life to save her. The sacrifice inspires her to live a long, joy-filled life.

Metroland (1997, England) starts with adman Christian Bale and his wife Emily Watson visited by old friend Lee Ross, who claims to live a wild bachelor life. This makes Bale flash back twelve years to his youthful Paris fling, trying to be a great bohemian photographer. He achieves neither, but does meet Elsa Zylberstein, a fantasy French girl—stunning, brilliant, and eager to teach him bedroom sex secrets. (Their first bedroom, encounter is realistically clumsy and unsatisfying.) Adolescent delights follow—making love over and over, foreign films, espresso bar evenings. But their differences begin to grate—he is too inhibited and cautious to express his feelings, particularly about her, or to advance the relationship. During the Paris student riots, he is scared to join in. Meanwhile he meets future wife Watson, a very practical English girl. When he says he won't marry, she says he will, because "*You're not original enough not to.*" Returning to the present, where he is married to her, Bale goes to a punk rock concert with his bachelor pal, then to a party where a seduction has been set up for the married man that almost comes off. Bale confesses his restlessness to his wife, who says she is bored too, that his bachelor pal has made passes at her, and she had a brief fling. But she is totally committed to the marriage, if Bale is. The film is a well done, if heavily slanted for courtship and commitment. (The French dream girl eventually grew demanding.)

An Affair of Love (1999, France, aka *A Pornographic Affair*) has Nathalie Baye put an ad in a sex magazine, to which Sergei López responds. At their first meeting in Paris, he admits he "likes" her, to which she replies "*You don't have to.*" In a Paris hotel they have their first interlude, the audience listening but seeing nothing. At subsequent meetings they express ever more carnality, yet stay polite and friendly. In time she asks: "*What if we made love? Would you mind being underneath?*" López wants her to express affection, which she does, while staying in control. In time they're seen naked at their meetings. He delays coming, so they have a simultaneous orgasm. She admits it was "*her first simultaneous orgasm.*" He responds "*It was far from perfect.*" Subsequently they begin to quarrel, and the relationship breaks down. Sergei realizes he has fallen in love, and she confesses her love for him, proposing marriage. But, in

the end, the couple separate, since their relationship is really pornographic and was doomed from the start.

Loser (2000) has Jason Biggs off to attend a university in New York City, where his country ways make him a victim—his roommates are drunken, womanizing, rich boors, and his professor is arrogant Greg Kinnear. He makes friends with sweet coed Mena Suvari, who is having an affair with the professor. They're both lower-middle-class outsiders trying to get by. They attend a rock concert ("*self-loathing, compliant rock you can dance to*"), but his roommates also invite her to a drinking party where she gets sick on date rape drugs. Biggs takes her to the emergency room, then to the animal lab where he works to care for her. They become close, caring for the lab animals, and enjoying tourist fun like museums and sneaking into shows. The professor shows up to take her away, but she returns. Decency wins out.

Intimacy (2001, England) starts with a London couple, Mark Rylance and Kerry Fox, who have begun to meet afternoons in the man's flat for violent, silent, anonymous sex. There is nothing more to the relationship, and they appear to know almost nothing about each other. Again and again, they attack each other in almost total silence. The man becomes obsessed with the woman's background, and starts shadowing her after their assignations. He learns she is married, but cool, unromantic, and unfulfilled in that relationship. He himself is married, but is bitter and dissatisfied. Their sex becomes rougher, almost leading to a nervous breakdown. They separate. One critic called this a stillborn first love that could not survive.

The Good Girl (2002) stars Jennifer Aniston as a young wife enduring a bleak life in a small Texas town, with an uncaring husband. (Aniston: "*As a girl you see the world as a giant candy store, but one day you look around and see a prison.*") She makes friends with Jake Gyllenhaal, who tries to write. (Aniston: "*I saw in your eyes that you hate the world; I hate it too.*") They soon start an affair, having wild sex and ignoring the world. But before long they're spotted by her husband's friend, who blackmails her, demanding sex, huffing and puffing atop her still form. The writer, feeling betrayed, calls her a hooker. Then Aniston becomes pregnant, and all three men are overwrought, as is she. The writer steals money and asks her to run away with him, but she refuses. The writer is caught and commits suicide. Her husband accepts the affair and child, and Aniston resigns herself to a life without joy or hope. One critic proposes that for the main characters facing dead-end lives, romance is simply a powerful drug to make life bearable.

Tadpole (2002) concerns fifteen-year-old prep school boy, Aaron Stanford, seeking erotic relationships with mature women. When he arrives home for Thanksgiving, his professor dad tries to interest him in a teenager, without success. That night he gets drunk, runs into a woman family friend, Bebe Neuwirth, and soon they're busy in her bedroom. He awakens guilty, though she is delighted to continue. Next he courts stepmother Sigourney Weaver, bringing her lunch, and chatting about passion. Then he again meets Neuwirth with some friends, who all go wild for him. When the two kiss, Stanford confesses their

lovemaking to Weaver, and when Weaver confronts her friend Neuwirth, her pal tells her the boy was irresistible. Later Stanford declares his love for Weaver, they kiss passionately, and he heads back to school, where he does show interest in a young classmate. But he still has had, and hungers for, full-grown beauties.

Garden State (2004) stars Zach Braff as an apparently very disturbed young man, flying in from L.A. to attend his mother's funeral in New Jersey. Highly medicated by his psychiatrist dad, he is almost zombielike, totally unfeeling. When he arrives, he decides to stop taking the pills, and soon meets Natalie Portman, a playful, goofy young woman who admits she is a compulsive liar. Portman is so friendly, warm, and straightforward, she soon lifts Braff out of his zombielike state. Her feelings come through when she talks of her little cemetery of dead pets, while she buries a hamster she loved. When he mentions his mother's death and funeral, she becomes serious and cries. Her love for him soon becomes clear, his own strong feelings about his family and life emerging. Instead of returning to Los Angeles, he decides to stay with Portman, his first real home.

The 40 Year Old Virgin (2005) stars Steve Carell who, due to unfortunate mishaps in his formative years, has since avoided sexual activities. As a clerk in an electronics store, he listens to his workmates' wild stories at poker games. When the truth emerges, his pals bombard him with advice, which proves comical but eventually an effective education in romance. One idea, for example, only dating drunken women, leads to a date throwing up in his face. In another scene, Carell and a coworker tease each other with clues to gayness, such as "because you like the movie *Maid in Manhattan.*" Another idea, always answering a woman's question with another question, likewise has comic consequences. Finally Carell meets a woman to whom he seems suited, Catherine Keener, a mother and grandmother. Their relationship progresses steadily, his secret kept, the woman not pressing for sex. At one point he panics, fearing he is losing his old self, and afraid of the inevitable consummation day. But all goes well, and their post-coital future seems assured.

Venus (2006) stars Peter O'Toole as an elderly actor who has spent his life as a hedonist, but is now a feeble old man. When he meets Jodie Whittaker, an attractive teen nursing his friend Leslie Phillips, O'Toole is attracted to the sullen, abusive teen, showing her the painting "Venus at Her Mirror," which leads him to call her that. Soon he is her slave: taking her out, buying her clothes and tattoos, letting her use his apartment for assignations, getting her a modeling job. In exchange he gets to smell and taste her, but no sex yet, as well as listen to her endless outrage about her place in the world. Meanwhile she revitalizes him by providing a reason to live.

Whittaker's boyfriend then beats O'Toole so badly, he'll soon die. Whittaker nurses him and brings him to a home where he can look at the ocean as he fades away. He dies in her arms. She is last shown modeling in the nude as in the Venus painting, for the first time liking and proud of herself after her first real love.

No new first love categories have emerged over the last few decades—the

films seem to show no clear patterns of development or comment, but rather suggest that the filmmakers working in them innovated or revised with the goal of making a successful film alone. Thus recent first love films are diverting but increasingly stultified. Some notable conventions have emerged, however:

- Borderline insanity films showing the lovers, or at least one of them, on the edge of madness, or pushed to the edge of breakdown. These include *Lolita, Endless Love, Blue Velvet, Getting It Right, The Crush, Spanking the Monkey,* and *Garden State.* In general, the stressed figures are treated unsympathetically, more or less accepting of what society does to them.

- Running away from civilization films, which often show lovers effectively outside society for much of the film. Examples here include *Saturday Night Fever, Butterfly, Blue Lagoon, An Affair of Love,* and *Intimacy.* The films are generally sympathetic to those protagonists who flee and then rejoin society, unsympathetic to those who will not or cannot.

- Inevitable adolescence films, more or less sentimentalized coming of age. These include *Love Story, Sure Thing, When Harry Met Sally, Dirty Dancing, Say Anything Before Sunrise, Titanic, Metroland, Loser, The 40 Year Old Virgin, Chasing Amy,* and *Metropole.* These films usually show no other path to love and maturity but undeviating faithfulness, and virtuous behavior as the only life that makes sense.

- Second time around films, such as *An Unmarried Woman, Murphy's Romance, Frankie and Johnny, Jerry MacGuire, The Good Girl,* and *Crossing Delancey* are about older singles recreating first love. They suggest that older, experienced lovers are entitled to, and even deserve, more time and freedom before their next commitment.

- Adult and youth affairs, such as *Class, No Small Affair, Tadpole, Summer of '42, Forrest Gump, Carried Away, Venus,* and *Johnny and Joan.* The theme here is an experienced adult with a virgin or a young adult. Films like these increasingly suggest such pairings should be tolerated and may even be beneficial, mostly when the adult is sufficiently wise, sophisticated, experienced, and rich, so that all goes well. Nevertheless, such pairings might be criminal in the eyes of society.

Chapter Six
The Coquette

The coquette delays passion's satisfaction, bouncing the lover between delight and frustration and holding him in servitude, with real pleasure always out of reach. The coquette may not seem to want or need the lover, turning hot or cold by turns. She charms, arouses, and then withdraws. She can play it either way—good girl or bad, as in Mae West's famous come-on: "When I'm good I'm very good, but when I'm bad I'm better."

The coquette is typically confident, self-contained, and independent—making her lovers seek her approval and favor. Her withdrawal fascinates the lover, so he stays with the "mystery" woman. Her independence makes her a sexual challenge. She likes making others jealous or otherwise playing on their feelings to manipulate them.

The coquette's behaviors appeal to the masochist, for whom more denial is more excitement. She arouses his core insecurity, so hope is reignited, and the pursuit continues anew—the more furious, the more enslaved!

The coquette's psychological strategy recalls the folk tale of Scheherazade. An Arab sheik, whose first wife was unfaithful, slept with a new wife each night and killed her the next morning,

Scheherazade fascinated the sheik with a story that reached a high point at dawn, so the king let her live to continue it. This went on for a thousand days (and three children), so the king at last married her. The coquette provided a three-year "courtship display" that made monogamy fun. Both males and females use the coquette strategy to win and hold mates. Silent romance films often had lovers who behaved like coquettes, if not always consciously so.

Male and Female (1919) deals with a boatload of vacationing aristocrats who are stranded on an island. Butler William Crichton (played by Thomas Meighan) takes charge and saves them, and a beautiful society girl seems to fall madly in love with him. But when they return to civilization, she resumes her noble manner.

This Plastic Age (1925) features beautiful Clara Bow. She toys with the emotions of a college athlete, causing painful emotional turmoil. Finally Bow decides she really loves him, which straightens him out so he wins the big game.

Our Dancing Daughters (1928) is the story of three coquettes. Joan Crawford ("Diana the Dangerous") is a sexy flapper—smoking, drinking, flirting, out until dawn, rebuffing her boyfriend but eventually marrying him. Dorothy Sebastian is provocative, telling her jealous first real love, *"Before I knew anything about love, things happened."* Anita Page tempts a man to trap him: *"I can't be free with love, I'm not a modern."* But a coquette at heart, her contradictory ways do her in.

Sound films made possible more complex characters and storylines, and the coquette was a natural protagonist.

Susan Lennox, Her Fall and Rise (1931) stars Greta Garbo as the runaway illegitimate daughter of a brutal farmer. She meets and lives happily with engineer Clark Gable, and flees her dad's search parties. She becomes a carnival exotic dancer, the owner's coquette. Gable finds her, calls her "gutter trash," and leaves. She promises to live up to it. She becomes coquette to a corrupt politician. At a dinner party that Gable attends, she attacks men as cruel and intolerant. Gable, tormented, goes to the tropics, ruining himself with drink and jungle work. Garbo follows and becomes a bargirl and dancer, manipulating men. She begs to be taken back, proving her love by seducing a rich man, then rejecting him.

> Garbo: *I'll make you believe in me. I always hated men until I met you. From now on, it'll be different.*

They unite to start a new life together.

Midnight Mary (1933) stars Loretta Young as a Depression-era beauty who joins a criminal gang. She later meets Franchot Tone, who hides her from the police, this knowing coquette who can flash hot and cold.

> Tone: *Now what do you suppose made me think of sex?*
> Young: *I can't imagine. Most men never do.*
> Tone: *I'm the intellectual type myself.*
> Young: *Me, too.*
> Tone: *But of course sometimes my baser nature gets the better of me.*
> Young: *That's the beast in you.*
> Tone: *How well you understand me.*

Eventually, Young tries to go straight, the moll playing a secretary, but a glimpse of her fine legs and neck makes her boss grab for her and she goes back to Tone.

China Seas (1935) stars Jean Harlow as mistress of Clark Gable, the captain of a Hong Kong-Shanghai tramp steamer. His ex-lover, Rosalind Russell, and Harlow hate each other, the lower-class Harlow, a natural coquette, continually provoking lover Gable:

> Harlow: *Loving you was the only decent thing I did in my life. And even that was a mistake. You can't quit me any more than I can quit you, and you can kiss a stack of cookbooks on that!*

Harlow spots pirates on board, but Gable won't listen, so Harlow throws in with the corsairs. Gable outsmarts the pirates, and in Hong Kong, Harlow is

arrested as an accessory. He tells the coquette he'll stay with her through the trial, and then marry her.

Jezebel (1938) stars Bette Davis as a New Orleans beauty of the 1850s. She and wealthy banker Henry Fonda repeatedly get engaged, but her coquettish nature always causes a breakup. Finally, Fonda gives up and leaves town. Davis now decides to give him everything, but he marries someone else. Davis will do anything to win him back. A yellow fever epidemic strikes, and Fonda, feverish, is to be sent to a leper colony where his survival will be uncertain. Davis begs to be allowed to accompany him to the isle of doom to help care for him, though it is a serious risk for her. In the end, she and Fonda go to their likely death together.

Gone With the Wind (1939) features film's greatest coquette, Vivien Leigh as Scarlett O'Hara, a beautiful Southern belle. She is first seen at her family's estate, playing up coquettishly to young male admirers. Her emotions start reversing and intensifying when she learns her secret love Leslie Howard is to marry Olivia de Havilland.

> Leigh: *Oh, I could never hate you...I'll hate you until the day I die,*
> *I can't think of anything bad enough to call you!*

She makes a spite marriage to a soldier who soon dies, then begins seeing blockade runner Clark Gable. Meanwhile the Confederacy starts to crumble. She tries to convince Howard, a Confederate officer, to abandon his pregnant wife and run away with her to Mexico, deserting.

> Leigh: *There's nothing to keep us here.*
> Howard: *Nothing except honor.*

Leigh now charms a man who wanted to marry her sister. (Leigh, flirting: *"It's cold and I left my muff at home. Would you mind if I put my hand in your pocket?"*) He marries her, and then this second husband dies, and she marries rich Clark Gable, who won't play her games:

> Gable: *This is one night you're not turning me out!*

The next morning she has a satisfied smile. De Havilland dies and Howard is overwhelmed. Leigh realizes he'll never marry her. She tries to tell Gable she now loves him, but he's had enough of her:

> Leigh: *Rhett, Rhett, Rhett—if you go, where shall I do, what shall I do?*
> Gable: *Frankly, my dear, I don't give a damn.*

Coquette to the end, Leigh decides to go back to her family's estate to find a way to bring Gable back (or yet another?). Leigh is a beautiful, self-centered coquette who presents herself as she needs to in order to get what she wants— Howard, husbands, the family estate, postwar survival, and Gable. She seems to prefer Howard because he's a passive Southern aristocrat who blindly adores her, though she's also drawn to Gable because he's wise to her calculating, ruthless, playacting nature—and shares it. They're two uneasy soulmates.

> Gable (to Leigh): *I love you because we're alike—bad lots, both of us.*
> *Selfish and true and able to look things in the eye and call them by*
> *their right names.*

Significantly, after all they've both been through, Gable goes back to Atlanta to find peace with a bordello madam friend and her staff, while coquette Leigh still seems to seek an emotional life with Gable.

Pride and Prejudice (1940), an adaptation of Jane Austen's novel, stars Greer Garson as the bright coquette from a poor family, and Laurence Olivier as the arrogant aristocrat.

Olivier (seeing Garson): *She looks tolerable enough, but I'm in no humor tonight to give consequence to the middle-class at play.*

Garson, the clever coquette, refuses to dance with him, and this intrigues Olivier.

Garson: *At this moment, it is difficult to believe you are so proud.*

Olivier: *At this moment, it is difficult to believe you are so prejudiced.*

They continue to meet, and he's further fascinated, and says he'll marry her, despite his disdain for her family and station. At this, she turns him down:

Garson: *If you want to be really refined, you have to be dead. There's no one as refined as a mummy!*

They later reunite and marry, and she turns off the coquette (or varies some more).

Garson: *Oh, Mr. Darcy, when I think of how I've misjudged you, the horrible things I've said, I'm so ashamed.*

My Little Chickadee (1940) stars W.C. Fields and Mae West as the two ultimate comic coquettes. They meet on a train headed West, and she notices his traveling bag is full of money. Pushing his advantage, he immediately proposes:

Fields: *I will be all things to you—father, mother, husband, counselor, Japanese bartender.*

West: *You're offering quite a bundle, honey.*

Fields: *My heart is a bargain, today. Will you take me?*

West: *I'll take you—and how!*

Married to Fields, West wastes no time coming on to another man.

Dick Foran: *Are you forgetting you're married?*

West: *I'm doing my best! Any time you got nothin' to do and lots of time to do it, come on up!*

West's coquette never stops making overtures:

West (to masked bandit): *You're the one man in my life—right now....*

Born Yesterday (1950) stars Judy Holliday as a shrewd low-class mistress and coquette to ex-junk-dealer, now Washington lobbyist Broderick Crawford. Henceforth, she'll be mingling with the rich and powerful, so Crawford hires journalist William Holden to educate her.

Holliday: *I am stupid and like it. I got everything I want. I got two fur coats...I tell you what I would like! I would like to learn to talk good.*

Holden teaches with honesty and respect, so she soon realizes how Crawford has shaped and controls her. At the same time, the coquette begins to fall for Holden.

Holliday: *Are you one of those talkers, or would you be interested in a little action?*

In the end, she realizes Crawford is no good, wrecks his rackets, and goes off with Holden.

Holliday (to Holden): *You love me and you know it. There's no sense in struggling with a thing when it gets you!*

A remake, *Born Yesterday* (1993), starred Melanie Griffith.

Pillow Talk (1954) stars Doris Day as the archetypal American coquette of the fifties, a New York interior designer with an amazing career and stunning apartment whose "party line" phone involves her with womanizing songwriter Rock Hudson. She's able to listen to his phony efforts to seduce one woman after another. The two grow to loathe each other. He says she has "bedroom troubles" and she claims he's gay, calling him a "stupid slimeball," though they've never seen each other. But he learns her address and masquerading as "Tex Stetson," oil millionaire, gets a date, and almost has sex before she catches on. She won't see him, but he hires her to redecorate his apartment, and she decorates it as a brothel. She's a coquette gone wild! He breaks into her home, carries her across town, across his threshold, and begs her to marry him. In the end the coquette has won by madly playing hard to get. They marry and go off happily to live an upper-middle-class lifestyle.

Lover Come Back (1961), in the tradition of *Pillow Talk*, has Doris Day as a hardworking executive, and Rock Hudson as an exec who triumphs through sex and trickery They meet and initially dislike each other.

Day: *He's like a cold and there are only two things you can do with a cold, fight it or go to bed with it. I'm going to fight it!*

But she's also attracted, so plays the coquette. Soon they get drunk together, and wake up the next day married. Day still plays it cool, but by the end Day's willing to agree they belong together.

Barefoot in the Park (1967) has newlyweds Jane Fonda and Robert Redford arriving at the Plaza for their honeymoon. Fonda is an attractive coquette, alternately affectionate or provocative:

Fonda: *If the honeymoon doesn't work out, let's not get divorced, let's kill each other!*

The couple chooses a Greenwich Village apartment. She thinks it's romantic, he thinks it's shabby, so she turns sarcastic:

Fonda: *You always dress right, you always look right, you always say the right thing, you're very nearly perfect.*

It's Jane's coquettishness, however, that holds them together.

Fonda: *You have absolutely no sense of the ridiculous. Like last Thursday when you wouldn't walk barefoot with me in Central Park. Why not?*

Redford: *Simple answer. It was seventeen degrees.*

Fonda: *Exactly. It's very logical. It's very sensible. But it's no fun.*

That Obscure Object of Desire (1977, Spain) by filmmaker Luis Buñuel, is surely the most sophisticated, analytic, and comic treatment of the coquette.

Rich, lecherous businessman Fernando Rey is in love with a young woman, Conchita, who has a dual nature. Two actresses, one a graceful, passionate Rita Hayworth type, Carole Bouquet, and the other a lusty flamenco artist, Ángela Molina, alternately play the two-sided lover on screen. The sophisticated mature man is teased and inflamed, but Conchita always eludes him as well as angers him so much he beats her. A deal with her mother to make Conchita his mistress fails—she always promises more but always escapes, so he ends up crazy with lust. She says she refuses to be a piece of furniture, screaming over and over: "I belong to no one—except myself!" She takes other lovers, but denies being intimate with them. When Rey and Conchita finally go to bed, she wears a chastity corset that he can't undo. She tells him: "*You only want what I refuse, that's not all of me!*" Finally she agrees to marriage. He sees her bloody wedding gown and becomes excited, but she rushes away, always defiant.

Something Wild (1986), a more conventional coquette movie, starts with young, successful tax accountant Jeff Daniels ducking out of a New York diner without paying. He's stopped by strangely dressed Melanie Griffith (big wig, African jewelry), who tells him she saw him do it, calling him "a closet rebel." She gets him to drive her to New Jersey in her car, drinking bourbon with the moody coquette. At a motel she takes his cash, handcuffs him to the bed, and sex follows. Using the phone she has him lie to his boss and wife about what's happening. Daniels decides to go with her through Pennsylvania (Griffith: "*I like big things between my legs!*"). At her mom's home she introduces him as her new husband. (Griffith: "*See, Ma? Just the kind of man you said I should marry.*") At her high school reunion, they meet a guy from his company. Griffith introduces herself as Daniels' mistress, making the executive envious. Suddenly they meet Ray Liotta, her estranged husband, just out of prison. Eventually Liotta chases them back to Daniels' family home (he's really divorced), and Daniels fights Liotta, knifing him with his own switchblade. The cops arrive, the body is taken away, and Griffith taken in for questioning. Later, Daniels again jumps the restaurant's check, and meets Griffith, beautiful and smiling. They go off together. Like Vivien Leigh and other coquettes, Griffith alternately gives in and makes demands, exciting him with her energy, beauty, and shocking commands.

In *The Accidental Tourist* (1988) William Hurt is a character who writes travel guides for people who don't really want to go anywhere. Hurt himself chooses to avoid new experiences. He's a male coquette, always switching his feelings and rewriting his emotions. Wife Kathleen Turner can't take the emotional rewrite and leaves him. When he takes his dog for training, he meets attractive divorcée Geena Davis; her cool demeanor is in tune with Hurt's. Soon they are living together and wed, though Turner tries to steal him back. But when he has to fly to Paris to do some work, Davis speaks of his inability to show emotion, to care:

> Davis: *Macon, are you really doing this? You mean to tell me you can just use a person up and move on—you think I'm some kind of bottle of*

something you don't need anymore? Is that the way you see me, Macon?

In Paris Turner shows up and tries to win him back again, but after a night of pondering he realizes others he's with call forth his feelings, his personality and nature:

> Hurt: *I'm beginning to think that maybe it's not just how much you love someone. Maybe what matters is who you are when you're with them.*

Hurt realizes even he is a coquette—everyone's a coquette—and decides to be Davis's coquette and she his.

White Palace (1990) stars Susan Sarandon as a tough hamburger joint waitress and skillful coquette, and James Spader as a middle-class, upwardly mobile Jewish executive still grieving over his dead wife. He stops at the joint and they chat; she's suffered too, after losing her young son. (Sarandon: *What can you do? The world spins around.*) They're opposites—he's a handsome, rich Jewish catch, and she's middle-aged, slovenly, and coarse, but soon they're seeing each other. Sarandon is a gritty, low-class Scarlett O'Hara. When he takes her to a party for the upwardly mobile with his mom, Sarandon feels rejected (correctly), and mocks the guests mercilessly, a cold coquette shiksa.

> Partygoer (of Spader): *Quite a catch. How'dja do it?*
> Sarandon: *I give a good blow job, I guess.*
> Partygoer: *Bet you do!*
> Sarandon: *Bet you don't!*

Sarandon later runs off, leaving Spader a note to forget her. But he follows her cross country to her new burger joint, sweeps a table clear, and demonstrates his love atop it!

Runaway Bride (1999) stars Richard Gere as a reporter accused of writing "diatribes against women." His next story is about country girl Julia Roberts, who has run away from three of her own weddings, leaving the grooms at the altar. Gere goes to the small town where she lives, meets Roberts, and soon has a love/hate relationship with this extreme coquette. He makes fun of her fiancées' proposals and she asks what a good proposal sounds like. He says he'd start by guaranteeing hard times ahead, but *"If I didn't ask you to marry me, I'd regret it the rest of my life, because I know you're the only one for me."* She asks about his divorce; he says the couple was not meant to be. When he guesses she ran because she couldn't decide things, she says angrily, *"I'm not the only one who's lost—am I right?"* At a wedding rehearsal, Gere is asked to play the groom, and she walks down the aisle and kisses him. The two now decide to get married, and she runs away again but eventually they unite. She says she loves him because she knows herself—what she likes and dislikes. And so perhaps no longer is a coquette.

Love and Sex (2000) stars Famke Janssen as a women's magazine writer who writes an article about sex skills that causes her to reflect on her own sex history, shown in flashback: a high school teacher, a married man, a basketball star, an action movie hero, and an artist. She's a clever coquette, who's learned how to manipulate men. Her current relationship, with an artist, is good but

flawed—she can't stop talking, and his lack of sexual experience bothers him. The modern equating of love and sex puts much pressure on them both.

Bridget Jones' Diary (2001, international), stars Renée Zellweger as a young British single coquette trying to marry. At a family Christmas party, her mom tries to set her up with dull but eligible barrister Colin Firth. Her attempts to win him with polite nonstop chatter only annoy him. At her publishing job, her cad boss, Hugh Grant, sends sexy e-mails about her mini skirt, leading to a tryst she makes delightful. But he's soon unfaithful. She goes into TV reporting and Firth turns up again, seemingly more decent until they have a fight. Zellweger is left to choose between them, which mean choosing the romantic games the coquette will have to play. A sequel, *Bridget Jones: The Edge of Reason* (2004), continues the chronicle of her sexcapades.

Down With Love (2003) tries for a modern *Pillow Talk*, set in the sixties. New author Renée Zellweger is trying to sell her book *Down With Love*, which argues that to fulfill her goals, a woman must avoid love at all costs (casual sex is okay—live like a man!). Writer and womanizer Ewan McGregor is assigned to do a story on her and assumes she's a bitch, so tries to avoid the job (calling with stewardesses on his lap). But her book is a huge success (*"It's bigger than the pill!"*), and on camera she calls him "the worst type of man." To gain revenge, when he meets her he masquerades as a sweet astronaut, Zip Martin, and they're soon a hot couple, with growing feelings for each other. Then she learns who he really is, and he announces he got her to fall for him. The coquette syndrome now kicks in. She says she's his ex-secretary who faked everything to hook him. After more complications, the two realize and admit they really are in love, and head off to marry, hanging from a helicopter. Viewers complained the *Pillow Talk* split screen, together-but-really-apart visual wit had been degraded to phony pornish encounters, and the couple lacked the sweet innocence and romantic chemistry of Rock Hudson and Doris Day.

50 First Dates (2004) pushes the coquette idea to infinity. Adam Sandler, a Hawaiian veterinarian with commitment problems, meets cute Drew Barrymore in a café and they seem a fine match. They agree to meet for breakfast, but when they do, she doesn't recognize him at all. The café's staff later explains Barrymore has had damage to the temporal lobes of her brain—she remembers everything up to the accident she was involved in, then each new day only as long as it lasts. Sandler tries various ways each day to win her love—the funniest is having a friend attack him, and Barrymore rescue him with a baseball bat. But nothing sticks. She's an ultimate coquette—loving, then indifferent. Eventually Sandler and her family find a solution. Each day when she wakes up she'll see a videotape that explains what happened to her, and brings her up to date. She'll also keep a diary to confirm it. It works, and Sandler and Barrymore go happily off together to Alaska to study sea lions. As in other coquette films, a love/hate, hot/cold conflict is resolved.

Chapter Seven
The Charmer

Charm is seduction without sex, the creation of a mood of pleasure and joy, lifting your spirits and your self-esteem, pumping up your vanity. The sexual tension is in the background. The charmer is like the bower bird that creates a beautiful bower to fascinate its possible mate, while wooing it with lovely songs. The charmer likewise focuses his or her attention on the lover, providing fine pleasures, beguiling excitement, matching moods, grace, and fascination. The sex is a diffused flirtation, generalized eroticism.

Socially, the charmer courts by offering resources, passionate love, and friendly mutual respect, implying sexual commitment for a long relationship. In a sense, the charmer is a trickster lover manipulating the possible mate, so that their familiar world and relationships fade away, and there is no one else—as in *Ninotchka*, *It Happened One Night*, and *Bringing Up Baby*. The lover-to-be surrenders her/himself to the charmer after all their hard work.

Psychologists have found people tend to choose lovers in whom they sense the same traits—similar attractiveness, class, social and political values, ethnicity, expectations, and degree of intellectuality. Technically, this is called "positive assortative mating" or "fitness matching." The charmer brings out this miraculous oneness, ecstatic bliss, and mutual recognition, so the possible mate wants the lover safe, cared for, and happy. An old saying goes, charm is the power to make someone else feel that both of you are wonderful. On the other hand, a romance based on charm starts with an illusion on one side, but can often end with disillusion on both sides.

The Mothering Heart (1913) opens with the marriage of Lillian Gish and Walter Miller in peril. At a nightclub he is fascinated by flirtatious beauty Viola Barry. Their affair starts, though he is just the latest of many. She is shown as not evil but just a lovely young charmer who in the end moves on to a new adventure. Good luck, Viola!

What's Worth While? (1921) has aristocrat Phoebe Morrison (played by Claire Windsor) fall for a boorish rancher, played by Louis Calhern, who then makes himself charming. But now that he seems to be a sophisticate like her, she is dissatisfied. ("*He had been her superior, her master! Now they were equals!*")

In the conclusion, she hears Calhern talking with a pal (*"I believe she is in my world for good."* *"Yes, and heaven help us if she ever suspects how it was accomplished!"*) Phoebe, however, tells her own friend: *"And heaven help me to keep him from ever suspecting that I suspect!"*

Dancing Mothers (1925) concerns a neglected wife who sits at home while her husband cheats and daughter flirts. When she learns her daughter is involved with a ruthless rake, she puts on her best makeup, chooses her finest gown, and sets out to charm him, which she does. Realizing her husband and daughter are now totally self-centered, she joins in, and sails for Europe with the handsome rascal.

It (1927) features Clara Bow as a mischievous, vivacious, and sexy charmer chasing handsome Antonio Moreno, head of a giant department store. At the start, his silly pal Monty speaks of "it," a magnetism that captures the opposite sex. Bow, an alert clerk in the store, spots Moreno and says, *"Sweet Santa, give me him!"* Bow lets Monty date her, so she can meet Moreno at a fancy club. When they meet at the store, Bow gets Monty to take her to Coney Island for some wild rides—they're both shown as exuberant. At work, he says he wants her as his mistress, but she refuses. Next, Bow gets Monty to take her on a cruise with Moreno and his ritzy friends, Bow masquerading as a society dame. When she poses in seductive profile, Moreno realizes he can't resist her—the charm effect. Then there is a collision and Bow and Moreno's girlfriend go into the bay. Bow, a terrific swimmer, saves the ritzy girl, and says she'll swim home. Moreno, fascinated, swims after her, and they end up cuddling on the anchor. *It* is a virtual training film on charm for man-hungry flappers.

The Depression put romance and charm in a new light. Charm was a way to win a lover, but lovers had to be realistic too, and realize there were social and economic stress elements working against them.

Ladies of Leisure (1930), a Depression romance, has rich Ralph Graves, driving past a lake, meet poor Barbara Stanwyck coming ashore from a yacht party. (Stanwyck: *"Do you tote a flask—you know, first aid for the nearly injured?"*) She gets a ride back to the city, lifts his wallet, and chatters: *"I'm the party girl. I'm the filler in."* She is alone, poor, and doesn't like being used. The rich man asks if she'd like to pose for his paintings. They begin to know each other. In a tender moment, he wipes away her lipstick and makeup. Later she says: *"Can't you call me Kay? I'm a human being!"* She wants to be respected before she'll love. When she sleeps over in her lingerie, the artist covers her with a blanket, and her face shows gratitude. She is becoming his world. Soon she is making his breakfast, and they're both happy, planning to go to Arizona. But his parents object. Stanwyck surrenders, but he's all she's got. She goes on a cruise to Havana and jumps overboard, but is rescued, and he comes to see her in the hospital. Stanwyck's character was new in films, a major, rounded female character who develops as the love story goes on.

She Done Him Wrong (1933) features Mae West as a comic charmer love interest, operating a bordello with white slavery elements. Undercover cop Cary Grant investigates her as he falls for her, finally visiting her rooms to propose.

He gives her a diamond engagement ring, telling her, *"I'll be your jailer from now on."* But it is the playful world she creates that he loves. When he asks if he can hold her hand, she tells him *"It ain't heavy. I can hold it myself."* When he brings out the handcuffs, West says: *"Are those absolutely necessary? I was born without them."* Grant replies: *"A lot of men would have been safer if you were."* When Grant scolds: *"You bad girl,"* West smirks: *"You'll find out."* Whatever her flaws, it is clear West has charmed Grant.

It Happened One Night (1934), an Academy-Award winning film directed by Frank Capra, starts with her millionaire dad scolding daughter Claudette Colbert for refusing to marry the man he chose for her. Defiant, she goes to Miami, buys a bus ticket, and meets Clark Gable, a first-rate reporter who has just been fired. Gable recognizes the runaway heiress (with a $10,000 reward on her head). He wants the story, so he stays with her. At an auto court, they take a cabin as man and wife to save money. He strings a line between the beds, and hangs a blanket. (*"Behold the wall of Jericho!"*) He also lends her his pajamas. In the morning he teaches her how to dunk a doughnut, and when detectives appear they masquerade as an arguing couple. They've found a new, happy world. Flashing a leg at passing cars, she gets them a free ride. Approaching New York, they repeat their sleeping arrangements, Gable telling her his romantic dreams:

> Gable: *I saw an island in the Pacific once. That's where I'd like to take her, but she'd have to be the sort of girl who...will...who would jump in the surf with me, and love it as much as I did.*

This is his charm. She goes over to his bed to talk.

> Colbert: *Take me to your island. I want to do those things you talked about. I love you. Nothing matters. I couldn't live without you.*

He runs for the "scoop" money, but she thinks he has run out, so goes home alone. Gable visits her dad, asking for the $36 he spent on Colbert. Gable admits he loves her: *"But don't hold it against me. I'm a little screwy myself."* Colbert leaves the fortune hunter at the altar and runs off with Gable. The last scene shows a motel cabin, its lights go out, and a trumpet is heard tooting (the walls of Jericho have fallen!).

The archetypal romantic charmer, Gable wins Colbert by providing a delightful, playful, adventurous new world for the two to live in, a "dance of attraction" with sexual overtures in the background (jumping in the surf).

Some of the most entertaining and moving "charmer" films were made in the Depression, from light comedy to deeply sentimental works.

Hands Across the Table (1935) stars Fred MacMurray as an ex-millionaire now trying to marry an heiress for security, and Carole Lombard as a gold-digging manicurist. When he admits he is broke, she lets him board with her, leading to much comedy. When an unwanted suitor calls, he pretends they're wed, even pretending to beat her; MacMurray's calls to the rich woman use Lombard as a dumb operator. Meanwhile their faces suggest that Fred and Carole long for each other, delighting in their Depression-free little apartment universe.

MacMurray (asking to be tucked in): *You're almost as good as my mother was. Mother used to kiss me goodnight.*

Finally they admit they're in love.

Make Way for Tomorrow (1937) is about an old couple charming each other at the end of life. Victor Moore and Beulah Bondi, moneyless, have their children decide that at best they can "rotate" the oldies in their homes, but not both at once. The couple spend what will probably be their last day together strolling through Manhattan, remembering the past. At their honeymoon hotel, they're given a free dinner, the band playing "Let Me Call You Sweetheart." They reenact their courting and learning about each other, coming together. At the train station, where they will likely separate forever, they continue to charm each other:

> Moore: *If I should never see you again, you're the nicest person I `ever met, Miss Breckinridge.*
>
> Bondi: *It's been lovely, every bit of it. The whole fifty years. I'd rather have been your wife than anything else on earth.*

Bringing Up Baby (1938) stars Katharine Hepburn as a madcap adventuress heiress and Cary Grant as a career-minded paleontologist. Grant, after seven years assembling a dinosaur, is waiting for the last bone, and needs a new research grant. He meets Hepburn at a golf course, where she wrecks a donor interview.

At the club, she tears his clothes, and he her dress, so they must shuffle off together. The bone arrives, but Hepburn has Grant go with her to visit an aunt. Grant admits he is attracted to Hepburn, but:

> Grant: *In moments of quiet I'm strongly attracted to you, but, well, there haven't been any quiet moments.*

She steals his clothes when he is showering, so he has a sort of comic breakdown (Grant: "*I just went gay all of a sudden!*"), dressing in available women's clothing. Hepburn explains that her aunt controls dinosaur funding, and her dog steals and buries the dinosaur bone. Hepburn is reducing his world to chaos, and it seems her charm is all that can save him. Her tame leopard gets loose and they hunt it, but a killer leopard is also loose. Hepburn starts crying—she admits she has tricked him to win his love, but has run out of tricks. The two are put in jail, and later, after their release, Hepburn finds the killer leopard by mistake. Grant saves her, then faints. Back at the museum, Grant works on the very tall dinosaur skeleton, Hepburn shows up with the missing bone, and the research funding he needs from her aunt. She climbs a ladder to hand him his bone, and he suddenly admits he had a wild, happy time with her.

> Grant: *I never had a better time. The best day in my whole life!*
>
> Hepburn (weeping, delighted): *That means that you must like me!*
>
> Grant: *I love you! Oh dear...oh well...mmmm.*

At this moment the entire gigantic dinosaur skeleton, seven years' work, collapses, but Grant is able to lean out of his work gallery and seize Hepburn by the wrist, saving her. The charmer has made his whole old world dissolve, and made her the center of his new one. They are in love.

Stagecoach (1939), considered a classic Western, stars young John Wayne as the Ringo Kid, newly escaped from prison in order to kill his brother's killers. Aboard the stage he is on he meets Claire Trevor, a loose but decent woman who has been driven from the town. Wayne sees her worth, as do the other characters. Although the marshal on the stage arrests Wayne, he demands courtesy and respect for Trevor, and speaks to her warmly of the ranch he owns.

Wayne: *A man can live there, and a woman. Will you go?*

His charm is direct and simple. When Trevor's past is revealed, Wayne says simply: *"I know all I need to know."*

After he shoots down his brother's killers, Wayne says to Trevor: *"I asked you to marry me, didn't I?"* The two go off to his ranch, a doctor character commenting: *"Well, they're safe from the blessings of civilization!"* Note the couples in *It Happened One Night* and *Hands Across the Table* likewise speak of escaping society as the key to happiness.

Ninotchka (1939), considered a classic love film, stars Greta Garbo as a trade representative of Soviet Russia in Paris on a critical mission, who is seduced by Parisian charmer Melvyn Douglas. His playful charm appears at their first meeting.

Douglas: *A Russian! I love Russians! I've been fascinated by your five-year plan for the past fifteen years!*

Ninotchka: *Your type will soon be extinct.*

They meet on the Eiffel Tower, and then visit his home. The sophisticated charmer endlessly promising pleasure, desire, warmth, union, and sexual validation:

Douglas: *Tonight one half of Paris is making love to the other half!*

Garbo: *You mentally feel you must put yourself in a romantic mood to add to your exhilaration? Must you flirt?*

Douglas: *I don't have to do it, but I find it natural.*

Douglas continues to wine and dine her, a human bowerbird always shaping his love nest, making love the center of the universe.

Douglas: *Ninotchka, why do lovers bill and coo? Why do snails, the coldest of all creatures, circle interminably around each other? Why do moths fly hundreds of miles to find their mates? Why do flowers suddenly open their petals? Oh, Ninotchka, surely you feel some slight symptom of the divine passion?*

It works. Ninotchka arrives at Douglas's apartment in an arty, silly hat and lipstick: *"I don't look too foolish?"* She confesses her love for him and they go dancing. After champagne, Ninotchka addresses the other dancers as comrades. In the end, Ninotchka decides she should stay with Douglas and remain a good communist, despite the decadence of capitalism. (Charm can reverse a whole life's logic!)

The ongoing Depression's harshness made winning (or winning back) a charming lover and sharing their happy world a fine basis for a romantic film.

In *The Women* (1939), wife Norma Shearer is told her husband is cheating with treacherous salesgirl Joan Crawford. Shearer decides to charm him back.

Her mother confirms that charm is essential: "*A man has only one escape from his old self—to see a different self in the mirror of some new woman's eyes.*" Shearer meets Crawford, the two swapping hints on dressing to charm (or undressing to achieve it):

> Crawford: *May I suggest that if you're dressing to please Stephen, get rid of that one. He doesn't like obvious effects.*
>
> Shearer: *Thanks for the tip. But when anything I'm wearing doesn't please Stephen, I take it off.*

The couple divorces, and Stephen marries Crawford, but she soon begins cheating on him. When she learns her ex-husband is unhappy, Shearer uses her feminine wiles to make trouble and win him back, rushing into his arms.

Honeymoon in Bali (1939) stars Madeleine Carroll as a woman who must learn to be charmed, and charming. The manager of a department store, she meets Fred MacMurray, a charmer with a Bali address and adopted daughter. They like each other, but that's it.

> Carroll: *I'm not a feminist, but the expression "It's a man's world" irritates me.*
>
> Carroll: *Why do I need a husband? I don't intend to fall in love.*

But spending time with his daughter, Carroll feels affectionate towards her and her father, but can't show it. When he becomes amorous, she can't deal with it.

> MacMurray: *You're afraid to become Miss Nobody.*
>
> Carroll: *You're a liar, a cheat, and a coward!*

She flies back to New York and the store, but soon grows unhappy, and goes back to Bali and surrenders, showing some charm herself:

> Carroll: *I keep crying for Rosie and you. A husband and children are necessary to make me complete.*

But MacMurray turns her down. She meets a window washer who counsels her: "*Your kind of woman needs a guy, not a fine gentleman.*" An old boyfriend adds: "*A woman's not supposed to be a boss. Your kind of boss woman needs a boss man!*" A woman friend sums up: "*You're going to find out you're a human being.*" She flies back to Bali and the film ends with the threesome singing happily on the shore.

Other films showing masterful women learning to be charmed and charming include *Third Finger Left Hand* (1940), *They All Kissed the Bride* (1942), and *Take a Letter, Darling* (1942).

Love Affair (1939) has Irene Dunne and Charles Boyer meet on an ocean liner bound for New York. Boyer is an international playboy, Dunne a rich man's mistress. Boyer tells her he thought there were no attractive women on the ship:

> Boyer: *Then I saw you, and everything was all right.*
>
> Dunne: *Have you been getting results with a line like that? Or would I be surprised?*
>
> Boyer: *If you were surprised, then it would surprise me.*

He asks about her fiancée. They soon decide they like each other, wasting no time revealing their feelings, creating a private little charming world, partying and flirting over champagne. They realize this is not just a shipboard fling—that they feel much more for each other than for the two other people they are currently involved with.

When they see the New York skyline, they agree to meet in six months. If they feel the same way, they'll get together. Meanwhile she works as a blues singer, and he gets started as an artist. Neither marries, hoping to meet again. But then she's run over and crippled. She gets a job teaching orphans, and misses the planned meeting—she doesn't want his pity. He waits for hours and then leaves, assuming she married her rich friend. Boyer becomes a successful artist. But when she buys one of his paintings, they meet again, and he talks about their missing the six months date. She says it was him that stood her up, but they are together again now.

The film was remade as *An Affair to Remember* (1957) with Cary Grant and Deborah Kerr, and as *Love Affair* (1994) with Warren Beatty and Annette Bening.

Romantic comedies of the forties often had heroines getting their man by bringing in a new woman with phony charm, then taking her away, so the man, now desperate for charm and romance, succumbs to the real charmer who truly wants him.

Hired Wife (1940) stars Rosalind Russell who has an "in name only marriage" with her boss for business reasons. She schemes to make it a real marriage by eliminating the competition—a gold-digging blonde model—explaining the situation to a pal:

> Russell: *I put him in his place.*
> Friend: *A good opening move.*
> Russell: *No, he stayed there!*

To win him she has a friend impersonate a South American millionaire bent on marrying the gold-digger. When the model runs off with the Latino, Russell is free to charm her boss.

Two-Faced Woman (1941) stars Garbo as the wife of Melvyn Douglas. When he loses interest in her, Garbo masquerades as her twin sister, a wild woman who loves to rumba and is sexually shameless. As her twin, she is just too out of control for her conventional husband:

> Garbo (as her twin): *I see my future...more burning flamelike years, and then...the end!*

Soon enough, he is happy to return to his wife's charms.

The Lady Eve (1941), a wonderful romantic comedy, also uses the phony charmer approach. Barbara Stanwyck, a confidence artist, and her dad are on an ocean liner when it stops to pick up Henry Fonda, the young heir to the Pike's Pale Ale millions, a naïve young man who studies snakes. Stanwyck goes after him:

> Stanwyck: *I need him the way the axe needs the turkey!*

She introduces herself by tripping him, breaking her shoe so he must bring her to her cabin. She moves in fast:

Stanwyck: *Do you like my perfume?*

Fonda: *Like it? I'm cockeyed on it!*

He is soon in love, and so innocent she falls for him, trying to hint what is really going on:

Fonda: *What I'm trying to say, though I'm not a poet, is that I've always loved you...I mean I've never loved anyone but you...I wish we were married and on our honeymoon.*

Stanwyck: *So do I, but it isn't as simple as all that, Hopsie. I'm terribly in love...and you seem to be too. So one of us has to try to think and keep things clear...and maybe I can do that better than you can. They say a moonlit deck is a woman's business office.*

Fonda proposes marriage. But when her unsavory past is uncovered the marriage is off. Furious, Stanwyck vows revenge. She gets a con man pal to pass off Stanwyck with a British accent and a haughty manner as a titled British lady. Fonda and family fall for it, and charmed again, Fonda proposes again. She accepts ("*...if anyone ever deserved me...you do...so richly!*") On their honeymoon trip on a high-speed train, "lady" Stanwyck delightedly lists her many past lovers, starting with stable boys, with each disclosure the engine phallically roaring into a tunnel! Eventually Fonda jumps off the train into a big mud puddle. But Stanwyck still loves Fonda. At the end they meet on another ocean liner, Fonda assuming it is the "innocent" Stanwyck con artist, whom he realizes he loves. They enter her cabin and close the door. Fonda's last speech might be the film's "moral":

Fonda: *I don't want to understand. I don't want to know. Whatever it is, keep it to yourself. All I know is I adore you. I'll never leave you again. We'll work it out somehow.*

In short, devious but decent crook Stanwyck quickly charms rich dope Fonda. When he turns on her, she charms him into marrying a classy aristocrat who proves a faithless nymphomaniac. The lesson: that in love one should be satisfied to charm and be charmed, and look no further. Beyond that, Stanwyck really truly loves him. (Though critics argue she is too smart to decide to stay.)

This and several contemporaneous films play with the nature and limits of charm in love.

That Hamilton Woman (1941) opens with Vivien Leigh as a drunken, wretched old woman. It flashes back to her as a stunning young sophisticate at the Court of Naples in 1781, soon the British ambassador's mistress, then his wife. Lord Nelson—Laurence Olivier—visits, asking help for the British war fleet.

Leigh, irresistible, charms him. When he is injured, Leigh is compassionate. (Leigh: "*They told me of your victories, but not the price you paid!*") The two become lovers. When they evacuate to London, she is carrying his child. His wife won't divorce him, but Leigh and Larry live together, Olivier hopelessly charmed.

Leigh: *Oh, let them talk. I don't care. Do you? Are you sorry?*

Olivier: *I'm only sorry for the wasted years I've been without you...I know that I must not come back, and nothing in this world can keep me away.*

Leigh convinces him to command the fleet. When he is killed, she has nothing to live for, and starts the decline that leads to how she appears at the film's beginning. What price charm?

Now, Voyager (1941) stars Bette Davis as a thirtyish woman humiliated at home, treated by psychiatrist Claude Rains at his sanitarium, becoming dazzlingly attractive. On a cruise she charms Paul Henreid, whose wife hates her own daughter. At one point, she shows him a family photo.

Henreid: *Who is that very fat lady with all the hair?*

Davis: *I am that very fat lady with all the hair.*

Returning home to Boston, she's soon engaged to a well-off widower (her mother's choice). Davis realizes she wants Henreid, goes back to the sanitarium, befriends his daughter, who is being treated there, and in time takes her back to live with her in Boston, becoming her godmother. Henreid tries to join them, but Davis senses he'll never leave his wife; she'll never charm him away from her. Nevertheless, she thanks him for giving her the daughter and a future.

Henreid: *You should be trying to find some man who'll make you happy.*

Davis: *I've been laboring under the delusion that you and I were so in sympathy, so one, that you'd know without being asked what would make me happy. Oh, Jerry, let's not ask for the moon when we have the stars.*

She makes a final comment when he at last accepts this.

Davis: *Now I know you still love me—and it won't die, what's between us; it's stronger than both of us.*

Jane Eyre (1943) stars Joan Fontaine as Jane Eyre, a young spinster with a passionate nature who gets work as a governess for Yorkshire man Orson Welles's ward, Margaret O'Brien. Welles tries systematically to seduce Fontaine, using probing conversations to learn about her private life, teasing her, setting up conflicts with others. Eventually he wins her affection, and they plan to marry.

Then Fontaine learns he is already married, and keeps his raving mad wife in the manse's attic. Defiant, he justifies this:

Welles: *This is what I wish to have, this young girl who stands so grave and quiet in the mouth of hell. Then look at the difference and judge me!*

Jane flees, but after years returns. She finds Welles blind, crippled, living in the ruins of his estate. His mad wife set fire to his estate, burned it down, and was burned to death. Welles is no longer arrogant, so Jane accepts him.

Brief Encounter (1945, England) starts with Trevor Howard, a physician, and Celia Johnson, a housewife, both happily married, meeting at a railroad station. He removes a cinder from her eye, and they depart. Each week after that

they meet at the tea shop—she is shopping, he is at the hospital. They chat about their lives, and grow closer. When his train is late one day, she gets upset, and they realize they are in love:

>Johnson: *We must be sensible.*
>
>Howard: *It's too late to be sensible.*

The couple can't handle their feelings, so meet secretly, their gestures overcontrolled, their glances suspicious. There is now little dialogue, only Rachmaninov's passionate Piano Concerto #2.

>Johnson: *I knew beyond a shadow of a doubt that he wouldn't say a single word—and at that moment, the first awful feeling of danger swept over me.*

They get an apartment rented by one of Howard's friends to consummate the relationship.

>Howard: *The feeling of guilt in doing wrong is too strong, isn't it? Too great a price to pay for the happiness we have together.*
>
>Johnson: *Nothing lasts really, neither happiness, nor despair, nor even life lasts long.*

They agree their love can go nowhere, so agree to end it. She watches him go. Charm has come, and been driven away.

>Johnson: *I stood there and watched his train draw out of the station until its taillight had vanished into the darkness.*

She runs across the platform, but it is too late.

The Enchanted Cottage (1945) finds a visual metaphor for charm. Robert Young is a facially disfigured, embittered World War I veteran while Dorothy McGuire is a nondescript girl who marries him. They find a lonely New England cottage, on whose walls dozens of honeymoon couples have carved their initials. Soon, Young grows handsome again, and McGuire turns into a young beauty. The visual change is a magic counterpart of lovers charming each other with words and deeds. A housekeeper explains:

>Housekeeper: *You have each other, and a man and a woman in love have a gift of sight not granted to others.*

The Paradine Case (1947) explores charm's destructive potential. Gregory Peck is an arrogant young lawyer defending Magdalena Paradine—played by Alida Valli—a sultry, secretive beauty on trial for her husband's murder. Valli quickly charms the immature Peck (*"She is a decent, lovely woman!"*). He learns she had an affair with her valet, and sensuously rubs her luxurious bed, lingerie, furs, and jewels. Then he drops the valet from the court testimony, infuriating her.

>Peck: *I was idiot enough to fall in love with you.*
>
>Valli: *You are my lawyer, not my lover...you will save me, but not at his expense*

Peck madly cross-examines, as if trying to win back her love, until the valet commits suicide. Afterwards she confesses, blaming Peck. (Valli: *"My life is finished. It is you yourself that has finished it!"*)

Charm films of the fifties had a conservative tone, like the decade—older, experienced lovers reaching out to charm, and perhaps settle down with the next generation.

Roman Holiday (1953) stars Audrey Hepburn as a small nation's princess, sweet and naïve, seeing a state visit to Rome as a chance to see life's other side. She runs off and the search is on. Reporter Gregory Peck spots her, charms her, and shows her the sights—going dancing and motorcycle riding with her, sleeping over:

> Hepburn: *This is very unusual. I've never been alone with a man before—even with my dress on. With my dress off—it's most unusual!*

At day's end they're both totally infatuated, although aware at some level that the commoner-royal match could never work out. Hepburn goes home, and Peck never sells the story, keeping their time together to himself.

Love in the Afternoon (1957) has Gary Cooper as an American roué seeing a married Parisian, an idea Audrey Hepburn, a French detective's daughter, finds exciting. She visits Cooper to warn him of the irate husband's possible arrival. Hepburn pretends she is a sophisticated woman of affairs, leading to more meetings at which she tells made-up tales of numerous lovers, charming the older guy. Cooper begins to fall for her.

> Cooper: (amused): *A girl may look as pure as freshly fallen snow—and then you find the footprints of a hundred men!*

When Hepburn disappears, the sleuth tries to find her. When he realizes the girl is his daughter, he tries to get Cooper to forget her. Waiting for the train to the south of France, she appears to say goodbye, but instead the two go off together.

Love Is a Many-Splendored Thing (1955) has Jennifer Jones as a Eurasian doctor falling for William Holden, a journalist.

> Jones: *You are gentle and there's nothing stronger in the world than gentleness.*

The couple must face the race prejudice of the British Hong Kong colony, and his wife's refusal to grant him a divorce.

> Jones: *I am so happy it frightens me. I have a feeling that Heaven is unfair and is preparing for you and for me a great sadness because we have been given so much!*
>
> Holden: *Darling, whatever happens, remember nothing is fair or unfair under heaven.*

He is sent to cover the Korean "police action" and is killed. She visits the hilltop where they spent many happy hours to read his posthumous letter:

> *We have not missed, you and I, we have not missed that many-splendored thing.*

The Lovers (1958, France) has Jeanne Moreau, a bored wife, begin a shallow affair in Paris on a friend's advice. Driving home, she meets a handsome scholar, Jean-Marc Bory, and the two are captivated with each other by the time they reach the chateau. Neither one can fall asleep, and soon they meet and make love in her bed, the bathtub, and a drifting boat. Next morning

the couple leaves the estate, Moreau seeking a new life, insisting, "*I will never regret it!*" Bory gives her an enigmatic look.

Charm-based romance films of the sixties and seventies are interesting in the sense of being more grounded, with lovers having empty, painful, or otherwise dissatisfying backgrounds that they're charmed out of.

Breakfast at Tiffany's (1961), one more old lover/young lover romance, features Audrey Hepburn as a beautiful, conniving New York City party girl who gets along on the favors of rich older men. George Peppard, a struggling "kept man" writer, moves into her building, and befriends her. Hepburn's Holly Golightly character, like her name, is mischievous and charming, but also frightened and unhappy. Neighbor Martin Balsam "explains":

Balsam: *She is a real phony. You know why? Because she honestly believes all the junk she believes in!*

Increasingly, she gets the "mean reds," anxiety attacks:

Hepburn: *The mean reds are horrible. Suddenly you're afraid, but you don't know what you're afraid of.*

Peppard charms her and gets her to face her loneliness and fears:

Peppard: *You're afraid to stick out your chin and say, okay, life's a fact.*

They both admit that they're two of a kind, lonely outsiders who each need a "Huckleberry friend," as the film's "Moon River" theme song describes.

The Birds (1963) is Alfred Hitchcock's fantasy treatment of charm gone wild, releasing fearsome natural forces. It starts with wealthy hedonist Tippi Hedren roaring into the seacoast town, Bodega Bay, in her sportscar, in ruthless romantic pursuit of handsome lawyer Rod Taylor. Hedren is a coldly sophisticated charmer who quickly steals Taylor away from his old girlfriend who really loves him. But as the new false-hearted relationship intensifies, so do vicious attacks on local inhabitants by flocks of furious birds. The birds can be seen as symbols of her wild, irresponsible charm. Hedren's gestures and movements towards them have been interpreted as voluptuous surrender and prostration to a more powerful version of her own nature.

In the French Style (1963, U.S., France), its theme charm's limits, stars Jean Seberg as a young American studying art in Paris. After several brief affairs, she meets Stanley Baker, a driven correspondent who begins a long amour with her. She is quickly charmed by this masculine, dominant figure. But the relationship never gets beyond brief, fiery interludes between his long work assignments. Eventually, she admits her lover will only provide brief ecstasies between long stretches of emptiness. She fears becoming "a bars and boudoirs bum." In the last scene she lists all the things she is tired of: international "darlings," airports, and telephones. Seberg gives a powerful performance depicting a frequent quandary of modern lovers.

A Man and a Woman (1966, France) has racecar driver Jean-Louis Trintignant and actress and widow Anouk Aimée meet at a boarding school where they both have offspring. He drives her home, and the two bright, attractive people spend a day picnicking and sailing, and soon charm each other.

He doesn't hesitate to explain he had a near-lethal accident, causing his wife to commit suicide. But he still races. When he races at Monaco, she telegrams him that she loves him. He drives all night to reach her, but her memories of her dead husband hold her back. When she takes a Paris train, he races to the city to meet and embrace her. One of the most popular films of the sixties, it was followed by a remake—*Another Man, Another Chance* (1977)—and a sequel, *A Man and a Woman, Twenty Years Later* (1986).

The charm-based romantic films of the eighties and nineties suggest charm, often the most fundamental force in a successful romance, is often barely able to ensure success. Of the films discussed, half require the lovers to have brilliant craftiness as well—*Working Girl, Shakespeare in Love, Nina Takes a Lover*, and *Bed of Roses*—while the others call for steely determination even to have limited success: *Sleepless in Seattle, A Walk on the Moon, The Age of Innocence, As Good as It Gets.*

Working Girl (1988) stars Melanie Griffith as an ambitious lower-class secretary with an unsatisfactory love life. She works for ruthless executive Sigourney Weaver, whose boyfriend is Harrison Ford, an investment banker. When Griffith meets Ford, she soon shows she is interested.

> Griffith: *I've got a mind for business and a body for sin. Anything wrong with that?*

He doesn't think so. When Weaver must take sick leave, Griffith sees her last chance to get ahead. She moves into Weaver's office and uses her clothes, grooming, and speech to project an upper-class persona. She also devises a new approach to make money for the company, and becomes intimate with Ford, who is deeply impressed, and charmed into helping her:

> Ford: *You're the first woman I've seen at one of these things that dresses like a woman, not like a woman thinks a man would dress if he were a woman.*

Weaver, meanwhile, decides it is time to make her own deal with Ford, wording it in a cute, work-obsessed manner.

> Weaver: *For the past few weeks I've had this funny little sound down inside...tick tock, tick tock, tick tock...my biological clock...and I've been thinking...let's merge...you and I...think of it, darling...Mr. and Mrs. Fabulously Happy...can big Jack come out and play?*

Weaver also claims credit for Griffith's important new moneymaker. But when questioned, she can't supply the details, and so is fired. Griffith justifies using her enormous charm and great bluffing as her only way to have a career.

> Griffith: *I mean think about it. Maybe you would have fed me a few drinks and tried to get me into the sack. End of story!*

In the end she still has Ford, and has her own manager's office. The point is business and personal charm overlap and the ambitious person must teach themselves what is necessary and not be afraid to push hard if they want to get anywhere.

Sleepless in Seattle (1993) starts with lonely widower Tom Hanks, whose young son connects him to a radio call-in show. Hanks' description of his joyous

marriage makes him seem perfect husband material, though for now he is "sleepless in Seattle."

Interviewer: *Tell me, what was so special about your wife?*

Hanks: *Well, how long is your program? Well, it was a million* things *that meant we were supposed to be together...and I knew it the very first time I touched her. It was like coming home...only to no home I'd ever known...I was just taking her hand to help her out of a car and I knew...It was like...magic.*

Meg Ryan, a romantic journalist, listens to the broadcast and is totally entranced, desiring only to be his new wife. Ryan has an ordinary boyfriend, and in the bedroom she is now restless and dissatisfied. The engagement is soon off, and the pursuit begins. She masks her search for Hanks as a journalism assignment, after many complications charming him into a meeting atop the Empire State Building (the rendezvous in *An Affair to Remember*, her favorite film, somewhat reenacted). Hanks and his son come early, Ryan late, but they're accidently united, and the three do quickly seem to have their own magic.

The Age of Innocence (1993) depicts romantic charm in a ruthless period of social power struggle, based on the Edith Wharton novel. In upper-class New York City of the late nineteenth century, Michelle Pfeiffer is a free-spirited, fascinating European countess whose marriage failed, while Winona Ryder is a husband-seeking American. Both are attracted to mild-mannered, vulnerable, youngish Daniel Day-Lewis. The countess has Day-Lewis visit her country home, charming him away from Ryder:

Day-Lewis: *You gave me my first glimpse of a real life.*

In response, Ryder confers with a canny "master matriarch" who maneuvers the countess into returning to Europe. When Day-Lewis tries to follow, Ryder tells him she is pregnant, so he must marry her. Much later, Day-Lewis, apparently in an unfulfilling marriage to Ryder, stands by the countess's apartment, still obsessed, but she has found a new life. Like *The Sign of the Dove*, the film makes it clear women may be as fierce and ruthless in pursuit of love and marriage as any man in his career or elsewhere.

Nina Takes a Lover (1994) has jaded married woman Laura San Giacomo telling a journalist the story of her affair. Bored and restless, she sees a pal start an affair, and is inspired. When her husband takes a business trip, she meets British photographer Paul Rhys, is charmed, and the liaison begins, making her life exciting again. One day in his studio she finds he has other lovers, which upsets her because this "affair" was actually meant to stir up her husband, as a way to rejuvenate their sex life. She next tries to steal her friend's partner in adultery, but fails. She then chooses to see her marriage clearly—she and her husband decide to try to put romance and charm back into their relationship. Faking charm has failed.

Bed of Roses (1996) starts with New York investment banker Mary Stuart Masterson, who receives a beautiful floral arrangement from a secret admirer—flower shop owner Christian Slater—when her father dies. Slater had seen her crying over the death. Charmed, she helps him with deliveries, but runs off when

he makes advances. He sends more bouquets, she falls for him, and they begin an affair. At Christmas, she asks him if she can stay with his family, admitting that she doesn't know who her own real family is—the man who died was a foster parent. She joins his family for the holiday, but when he proposes she runs off. Months later she comes back, ready to begin again.

Their charm and love, as in many relationships, has grown in a series of stops and starts.

As Good as It Gets (1997) is a story of people defiantly charming each other, without much chance of love beyond it. Helen Hunt is a fiercely independent single mom trying to get along as a New York waitress while caring for her disabled son. A relationship very slowly builds up between her and an extremely rigid and intolerant writer customer, Jack Nicholson. In time, he takes over her son's medical costs, for which she tells him: "Don't expect any sexual favors!" In fact he seems unlikely to care about that, but the two do grow closer, understanding each other as rigid yet needy personalities who appreciate each other's support in their permanently isolated worlds. At the end, Nicholson tells her: "*You make me want to be a better man.*"

Shakespeare in Love (1998) tells a made-up story about the real Shakespeare, in the lusty Shakespearean manner. In 1593 London, playwright Joseph Fiennes (Shakespeare) has writer's block yet must audition actors for a play he is working on. Women are forbidden to act, but a young aristocrat in disguise, Gwyneth Paltrow, convinces him to use her as the male lead. Later, he meets her as herself and doesn't spot her ruse. The two are soon lovers:

> Paltrow (to nurse): *I will have poetry in my life. And adventure, and love, love above all. Love that overthrows life. Unbiddable, ungovernable, like a riot in the heart, and nothing to be done, come ruin or rapture!*

Fiennes is also in love.

> Fiennes: *I was a poet until now, but have seen such beauty that put my poems at one with the talking ravens of the tower.*

At one point he is asked how he loves her:

> Fiennes: *Like a sickness and its cure together...oh, if I could write the beauty of her eyes. I was born to look in them and know myself.*
> *Oh...her lips! The early morning rose would wither on the branch, if it could feel envy! None of your twittering larks. I would banish nightingales from her garden before they interrupt her song.*

Paltrow continues to play the male lead. Her father promises her as a bride to a man she doesn't love, Lord Essex. Shakespeare accepts a wager from him that a play can "*show the truth and nature of love,*" his play *Romeo and Juliet.* When Paltrow's involvement in the play becomes known, she leaves the cast. The play opens on her wedding day, at another theater. However, when the boy actor who was to play Juliette finds his voice changing just minutes before the play is to open, Paltrow finds herself drawn back into the play in Juliette's role, as the Bard himself plays Romeo. Though the play is a smash, Paltrow's appearance in it nearly leads to its closure. The queen, however, was in the

audience and intercedes, declaring that Paltrow is surely simply an extremely skillful male actor. She has Essex pay Shakespeare the wager, but declares that Paltrow must stay with Essex. The film is a delightful, skilled, and knowledgeable recreating of period life and the lovers' exchanges, shaped from Shakespearean style verse, expressing their charmed states.

A Walk on the Moon (1999), a contemporary melodrama set during the first Moon landing, has married mother Diane Lane at a Catskills resort quickly charmed by handsome salesman Walker Jerome, played by Viggo Mortensen. Watching her teenage daughter's first sexual forays has perhaps made her vulnerable, along with her husband's prolonged absences at work back home. Jerome is an inspired lover, in particular under a waterfall. The lovers visit the Woodstock Festival, where Lane's adolescent daughter sees them but can't deal with it, calling her dad who arrives and detonates. Lane realizes her lover and she have no future, so he leaves, and everyone calms down. The "moonwalk" is over.

The romances of the new century are even more skeptical about charm's romantic powers, or to put it another way, exaggerate or transform it beyond the realm of conventional love stories. In three it has magical or paranormal powers—*Return to Me, What Women Want,* and *Serendipity,* while in several others charm works because of the lovers' more or less bizarre or inexplicable psychological states—*Sweet November, 40 Days and 40 Nights, Secretary,* and *Chaos Theory.*

Return to Me (2000) stars David Duchovny and Minnie Driver as star-crossed lovers. Architect Duchovny is a widower still recovering from his wife's death when he meets Driver, who helps run her family's restaurant and has just had a heart transplant. Soon the two are in love, and it turns out the transplanted heart was that of Duchovny's late wife. When this is explained, the two separate, and Driver goes to Rome to think about what to do next. But in the end the lovers unite. The viewer can explain what happened with charm or the supernatural.

What Women Want (2000) is a part fantasy and part social satire tale of charm or perhaps super-charm. Mel Gibson, an adman and rake, is "allergic to listening," but still wakes up with lipstick kisses and panties nearby. But at work he loses out on a promotion to Helen Hunt, though he is given some feminine products to strategize. By accident, a blow-dryer shock provides him with telepathic power to sense women's feelings, a kind of potential super-charm. He starts using it by reading Helen Hunt's work ideas, so she thinks he is an enthusiastic collaborator. He catches on to Hunt's moves, and so gets her fired, but when he senses another office worker is suicidal, he gets her promoted. He also uses it in his personal life, such as in bed, where he can sense when a woman just wants her climax over with, so she can watch TV. His gift eventually vanishes, but he gets Hunt back her job, and she is grateful. Maybe having more charm, even super-charm, would be a good thing; it could also be a great pain in the neck for many.

Serendipity (2001) has a couple meet that seem meant for each other, but charm is not enough. John Cusack and Kate Beckinsale meet buying gloves in Manhattan, then skate together, and dine out at Serendipity, a word she defines as "a fortunate accident." They're soon attracted.

> Beckinsale: *Is this your favorite New York moment?*
>
> Cusack: *This one is climbing the charts.*

But since each is involved with someone else, she decides all must be left to fate or chance. She puts her name and number on a book she plans to sell, and asks him to put the same on a five-dollar bill which he'll spend. If the universe wants them to unite, she explains, it will find a way to deliver these two messages. Years later, Cusack is about to marry, but can't stop thinking of Beckinsale. She's in San Francisco, engaged, but has never forgotten Cusack. Each starts frantically looking for the other, flying from coast to coast, looking in used bookstores, and after several all-but-impossible coincidences they meet.

Again, it is a case of charm plus, or as in the previous two films, charm is not enough.

Sweet November (2001) considers the relationship between charm and therapy. Keanu Reeves, a workaholic ad exec, meets Charlize Theron, and takes advantage of her, getting her to offer to "cure" him of his nastiness. He'd move in with her for a month. (Theron: "*Long enough to be meaningful, short enough to stay out of trouble*") Soon he is fired, dropped by his girlfriend, gets invited to Theron's place, and the two end up making love. He is her November Man. While he doesn't sense her obvious broken-heartedness, being with her slowly changes him into a decent lover (on Christmas he buys her a sack of gifts). When he begins to wonder why she is helping him, she won't explain:

> Theron: *You don't need to understand me. You just need to let it happen.*

Do they ever really charm each other? It is doubtful because Reeves never understands her:

> Reeves: *Why is doing something fundamentally trivial worse than living a responsible life, as boring as mine seems? Who made you the expert, the doc, the guru? Why do you have all the answers?*

Sweet November (2001) is interesting when compared with its first version, *Sweet November* (1968), with Sandy Dennis and Anthony Newley, and the remake *Autumn in New York* (2000). Unlike the earlier films, these remakes no longer have faith that sympathy leads to charm and love. Perhaps it is just a "thirty-night stand."

40 Days and 40 Nights (2002) pits charm against reason. Josh Hartnett, a web designer, needs women but doesn't understand them. Dropped by girlfriend Vanessa Shaw, he forestalls more bad romances by secretly giving up sex for Lent (forty days and nights). That very day he meets Shannyn Sossamon, his perfect lover. Keeping his secret, he begins a "platonic" affair. But his new girlfriend doesn't understand, and his old girlfriend is trying to re-charm him, doing things like seducing him in his sleep, and making sure the new girl learns

of it, thus making her explode. The new girl gives up, but after Lent the two meet up, and their real love affair commences.

Secretary (2002) boldly argues that different people have different deeply personal romantic turn-ons, which must be engaged, and charm must fit the lover's secret desires, and that is everything. Maggie Gyllenhaal, leaving therapy, takes a job at a law firm despite James Spader's privacy-invading job interview:

Spader: *Are you single? Do you have sex with your boyfriend?*

At work, he exploits her: she must dive into a dumpster to retrieve a missing file, and be spanked for typos (on his desk, one spank per typo). His spanking leads to her erotic excitement, visible on her face and so to a strutting walk, better clothes, and dumping her conventional boyfriend. Soon she is at work in shackles and a wooden yoke, smiling. At home, he bathes her and both excitedly speak of her wounds, orgasming when thinking of them. They've charmed each other, however bizarrely, and found their perfect matches. (Spader: "*We can't do this twenty-four hours a day.*" Gyllenaall: "*Why not*"?") They marry, and as he leaves for work she tells him: *We look like every other couple!*

Chaos Theory (2008) asks how much charm is to be trusted, if passion, romance, and love should rather be based on eternal skepticism. The film opens with a couple about to marry, Elisabeth Harnois and Mike Erwin, who panic. She has just had a week-long fling with another guy and wonders if she is a "slut in white." He is of course greatly upset. In response, the bride's dad, Ryan Reynolds, speaks with the groom, telling his own romantic history "Full of ups and downs, dazzling extreme certainty, doubt, deceit, and truth." Men hunger for love; women hunger for husbands. His wife-to-be at a New Year's Eve party said she'd only marry in her social circle, while the groom-to-be ferreted out her real sexual history, each seeking what will charm them. Love and marriage remain a gamble, in which you must guess what sort of wife or husband your mate would be charmed by, and happy to live with.

Perhaps the best way to understand the last few decades of charm-based romance films is to consider the old scriptwriting convention that a love story must have obstacles that keep the lovers apart. With *Romeo and Juliet,* it was their feuding families; with Rhett, Ashley, and Scarlett it was their independence, honor, and pride. But in modern society the old obstacles and barriers disappear, leaving behind excesses of freedom, reason, self-indulgence, mental imbalance, or occult and spiritual forces which charm must learn to deal with as best it can to reunite the lovers. This situation is surely messier and less elegant than the romances of the past, but it has nevertheless become the truth that such films treat.

Chapter Eight
The Charismatic Lover

The charismatic lover possesses overwhelming, irresistible qualities that excite ordinary people and draw them to him or her—personal magnetism, sense of purpose, lack of inhibition, vulnerability, sheer erotic promise, and more. These appear in the charismatic lover's manner of speech, hypnotic attractiveness, air of mystery, or other compelling attributes. If the charming lover is the busy bower bird, creating a delightful milieu and alluring songs, the charismatic lover is the bird of paradise or peacock—capturing love with its extraordinary surface qualities that cast a spell promising erotic rapture, extraordinary fulfillment, and intense experiences.

Films with powerfully charismatic lovers include *Camille, Only Angels Have Wings, Casablanca, The Bridges of Madison County,* and *Pretty Woman.* They suggest the variety of charismatic lovers: the vulnerable charismatic who fulfills your needs for masterful passion; the adventurous charismatic who will provide the thrilling life you crave, but are a little afraid of; the heroic charismatic who fulfills you and ends your insecurity; and the rebellious charismatic who will share the mutinous life with you.

As noted, psychologists have found people tend to be attracted to lovers who share their traits—similar class, level of attractiveness, social and political values, ethnicity, and degree of intellectuality. In the case of the charismatic lover, the viewer comes to believe this character empathizes with both their public self and most private dreams. Moreover, as noted, sexual selection of mates over millions of years of evolution tends always to choose the most desirable mates, which reproduce more and stronger versions of their kind. It is no surprise that by now most ordinary people find the most extremely attractive (star quality?) people virtually overwhelming and irresistible, their charisma striking like a thunderbolt. (Vulnerability is also increased, due to similar processes.)

It's been said that charisma makes people believe you are right even when they know you are wrong. But even the most powerful charisma has its limits, and charismatics are usually aware of the limits of their powers.

A number of silent films have charismatic lover characters that use their powers over ordinary people for good or ill.

Down to Earth (1917) has Douglas Fairbanks learning that his girlfriend has suffered a breakdown, and is at an asylum. He becomes "Mr. Action," quickly curing many patients' problems—including his girl's woes—with his uninhibited enthusiasm.

She Loves and Lies (1920) stars Norma Talmadge, an actress engaged to a millionaire, who falls for a youth. The rich man dies, and the youth goes into debt, so she energetically pretends to be a rich woman who saves him. Next she is a Greenwich Village vamp who wins the boy, so he falls madly in love with her.

Doubling for Romeo (1921) features Will Rogers loving a girl who only cares for movie stars. Rogers goes to Hollywood and makes himself a serials hero, then he goes home, finds he has won her, and literally drags her to the altar.

Enchantment (1921) stars Marion Davies as a rich, spoiled flapper, whose dad decides she needs a masterful husband (à la *The Taming of the Shrew*). He finds one and casts the couple in a production, the actor falling madly for her, overdoing his part and changing the final kiss to a colossal smacker—and the girl is his!

Love Makes 'Em Wild (1927) starts with a town weakling in love with the local beauty but too shy to do anything. Then his doctor tells him he has just six months to live. He goes completely wild and soon wins the girl—the doctor's "medicine" worked.

The Single Standard (1929) stars the irresistible Greta Garbo, searching for a free and equal love relationship. She is drawn to independent and uncompromising Nils Asther. On his yacht, the *All Alone,* they sail the South Seas and have an intense relationship, free and equal. Garbo then returns to her sophisticated social whirl, marrying and having a child.

The Last of Mrs. Cheyney (1929) stars Norma Shearer as an adventuress/thief casing a wealthy old socialite. Found out by Basil Rathbone, she turns on the charismatic magnetism:

Rathbone: *Are you a good woman?*
Shearer: *Not very.*
Rathbone: *But aren't you a good woman?*
Shearer: *There is more than one way of being a good woman.*

Rathbone says he won't reveal her schemes if she'll have an affair with him. Shearer, half undressed, calls together the socialites at the mansion to be her judge and jury. She is found guilty, but one fascinated guest sent her a letter with highly embarrassing secrets about those present. The socialites let the charismatic off; she is even accepted as an aristocrat. She and Rathbone then exuberantly plan a life together. This movie was remade with sound in 1937 with Joan Crawford, and again in 1951 as *The Law and the Lady,* with Greer Garson.

Sound films allowed for more subtle, complex charismatics.

The Divorcee (1930) stars Norma Shearer as a charismatic modern beauty—when she learns her husband is cheating, she immediately has sex with his best friend: *"I've balanced our accounts!"* When her husband decides to leave, not apologizing, she defies him, giving her view of love and life as a free woman:

> Shearer: *And I thought your heart was breaking like mine. But instead you tell me your man's pride can't stand the crap. I don't want to listen. I'm glad I discovered there's more than one man in the world when I'm young enough so they want me. Believe me, I'm not missing anything from now on. Loose women are great, but not in the home, eh, Ted? Why, the looser they are, the more they get! The best in the world. Well, my dear, I'm going to find out how they do it! From now on you're the only man in the world my door is closed to!*

Next she is shown dancing wildly at a nightclub on New Year's Eve. She goes back to an old flame, the two spending weeks on his boat together. Later, another lover tells her: *"Anything you do is all right as far as I'm concerned, because you do it."* She talks about her divorce to a friend:

> Shearer: *You don't exactly take the veil when your degree is granted. you know...What should an ex-wife do? Spend her life doing good deeds? Going to bed at night with suitable books?*

Shearer plainly doesn't think so.

In subsequent films, Shearer continued to play the charismatic.

Strangers May Kiss (1931) casts Shearer as a modern career girl in love with a foreign correspondent. When he dumps her, she decides to go to Europe to seek fulfillment. Her womanizing uncle tries to stop her, but she calls him a hypocrite and doesn't deny her appetites:

> Shearer: *Oh quit, will you. You make me sick! The only important thing you don't mention at all. You can't tell me anything! Women aren't human beings to you. They're either wives or sweethearts. "Get a house, and some furniture, and some rugs—and a wife!"*

Later she reconsiders her life. (*"I've tried freedom for two. I may try it for one!"*) The more love affairs she has, the more confident she becomes—a free soul. (A lover comments: *"She changes her men with her lingerie, that girl!"*) When her ex-lover, the globetrotting newsman, shows up, she is defiant.

> Reporter: *I won't spend the rest of my life shrinking from shadows on the wall!*
> Shearer: *Shadows on the wall? Well, I'm going to tell you something now that I couldn't tell you before. There were no shadows on the wall when we met!*

She has become the complete erotic charismatic—bold, energetic, shameless, and fearless, and not stopping at kissing.

Trouble in Paradise (1932) deals with Herbert Marshall as a sophisticated, charismatic con man who cons and robs the wealthy upper classes, aided by his lover/partner Miriam Hopkins. They're after Kay Francis, wealthy owner of an exclusive Paris perfumery. Marshall cons his way into becoming her male

secretary (stealing her handbag, then returning it), and Hopkins gets to be her maid. The upper-class milieu lends itself to charismatic behavior—witticisms, beautiful wardrobes, lovely architecture, and attractive people. The characters often seemingly are playing love games, as when he tries to stop her from going out:

> Marshall: *You can't go. I'm crazy about you.*
> Frances: *I know it.*
> Marshall: *Why do you want to go?*
> Francis (dazzling smile): *I want to make it tough for you.*

In another scene, the two lover/thieves tease and tantalize.

> Marshall: *I know your tricks.*
> Hopkins: *And you're going to fall for them!*
> Marshall: *So you think you can get me?*
> Hopkins: *Any time I want.*
> Marshall: *You're conceited.*
> Hopkins: *But attractive.*
> Marshall: *Now let me tell you.*
> Hopkins: *Shut up and kiss me! Wasting all this precious time with arguments!*

Crime and romance mix together, so the motives of the three are unclear in the end. Francis is robbed but so enjoys her time with the couple she hardly cares, while the criminal couple goes off for more high-class swag and kicks.

Grand Hotel (1932) employs several famous actors in its multiple subplots. In one of these Baron Lionel Barrymore sees the beautiful ballet dancer Greta Garbo and falls in love. He then uses his gentleness, sincerity, and looks to win her:

> Barrymore: *I'd like to take you in my arms. I've never seen anything as beautiful as you are...let me stay for just a little while?*

His middle-aged vulnerability and gallantry make him a highly desirable charismatic.

Red Dust (1932) stars Clark Gable and Jean Harlow as charismatics bound to fall for each other. Gable heads a rubber plantation in the Far East, and Harlow, a prostitute on the run, arrives by riverboat. Gable agrees to let her stay, a lively presence slouching around in a robe. (Harlow: *I guess I'm not used to sleeping at night!*") At one point she entertains some workers: "*Don't mind me, boys, I'm just restless.*" Gable is soon attracted by her beguiling, slutty nature.

> Harlow: *I'm Pollyanna, the glad girl.*
> Gable: *You talk too much, but you're a cute little trick at that.*

A new assistant, Gene Raymond, arrives with his wife Mary Astor, who fascinates Gable—middle-class cool, but provocative.

> Astor: *Do you think I could be happy here?*
> Gable: *Do you mind if I make it my job to see that you are?*

Harlow wants Gable, as suggested by her open-air bath, but he wants Astor. He sends the husband into the jungle, and Gable and Astor consummate their feelings. Astor is shown in bed, glowing with satisfaction. She tells Harlow: "*It*

was just one of those excitement of the moment things." When her husband returns, Gable takes up with Harlow, which enrages Astor so she shoots him in the arm. Harlow tells the husband Gable was coming on to his wife, so Raymond and Astor leave. Harlow helps Gable's wound heal, and the two really get along, Harlow uninhibited and reading him children's books, and the two ending up in each other's arms.

Noel Coward's *Design for Living* (1933) starts with three charismatic and artistic people on a Paris-bound train—Fredric March, Gary Cooper, and Miriam Hopkins. The two men fall in love with Hopkins as soon as they meet her. All have artistic temperaments, which makes their three-way nonsexual relationship possible. Hopkins describes hers at one point

> Hopkins: *Squirming with archness, being aloof and desirable, consciously alluring, snatching and grabbing, evading and surrendering, dressing and painting for history, an object of strong contempt.*

Hopkins explains that she can't choose. She is in love with both men, so she has created their "design for living."

> Hopkins: *A thing happened to me that usually happens to men. You see, a man can meet two, three, or four women and fall in love with all of them. And then by a process of...eh...interesting elimination, he is able to decide which he prefers, but a woman must decide purely on instinct, guesswork, if she wants to be considered nice.*

The three choose to live together in platonic mutual affection, until both men become jealous. To deal with this, Hopkins marries a dull man she doesn't love, her charismatic nature allowing her to remain honest about her feelings with him

> Horton: *Do you love me?*
>
> Hopkins: *People should not ask that question on their wedding night. It's either too early or too late.*

Soon bored, she rejoins her two old companions, who destroy a party she is at, then return together to Paris.

Dark Victory (1939) centers on Bette Davis, a charismatic Long Island aristocrat.

> Davis: *I'm young and strong and nothing can touch me!*

For all her charismatic magnetism, she suffers a brain injury that means death in a few months. Her fierce fighting spirit wins the love of her surgeon—and ultimately her husband—George Brent. (*"With every blow you strike you can say, 'That was for Judith, my wife,'"* Davis says.) Even when she gets the terminal symptom, blindness, she happily sends him off to a research conference.

> Davis: *Nothing can hurt us now. What we have can't be destroyed. That's our victory. Our victory over the dark.*

Then she prepares to die, victorious and alone.

> Davis: *I'm the lucky one. All I'll miss is growing old, getting worn out. When death comes, it will come as an old friend.*

Private Lives (1931), another film by Noel Coward, stars Robert Montgomery and Norma Shearer as a charismatic couple, recently divorced, who meet on a cruise ship where both are honeymooning with their new mates. At once they're coming on to each other:

> Montgomery: *"There's not a particle of you I don't know, remember, and want!"*

Each exchange comically spirals in on their mad passion.

> Shearer: *What have you been doing?*
> Montgomery: *Traveling about. I went around the world after...*
> Shearer: *Yes. I know. And how was it? China must be very interesting.*
> Montgomery: *Very big, China.*
> Shearer: *And Japan?*
> Montgomery: *Very small. Darling, I love you!*
> Shearer: *I never loved anyone else for an instant!*

Their love is powerful and mysterious, but also playful.

> Montgomery: *Let's blow trumpets and squeakers and enjoy the party as much as we can. Like very small, quite idiotic schoolchildren. Let's be superficial!*

They soon reconcile, going off on a train, finally staring at each other in silent passion with great intensity.

The Garden of Allah (1936) concerns convent-raised Marlene Dietrich, seeking regeneration, and a runaway monk, Charles Boyer. At the Sahara desert city Beni-Mora, Dietrich visits an infamous cabaret, where one dancer performs a wildly erotic dance before Boyer. Boyer and Dietrich, charismatic searchers for the meaning of life, soon fall in love. They marry, taking caravans from oasis to oasis. When Boyer eventually finds he must return to the monastery, Dietrich begs him to forget her, but he cannot.

> Boyer: *No, Domini! I will think of you always, until the end of my life. I was born, perhaps, to serve God, but I want to believe that I was born, too, that I might know your beauty, your tenderness. Since I have been able to pray again, I have thanked God in his mercy that I have loved you. For in knowing you, I have known Him.*

When he reenters the monastery, Dietrich becomes hysterical.

Camille (1936), one of the great love films, stars Greta Garbo as a Parisian beauty of no repute—charismatic, cynical, materialistic, but somehow saintly. Mistress to rich baron Henry Daniell, she leaves him for young Robert Taylor.

> Garbo: *Let me love you. Let me live for you. I don't suppose you can understand how someone as unprotected as you say I am can be lifted above selfishness by sentiments so delicate and pure.*

Taylor's father knows Camille's background and demands Taylor give her up, since it could ruin his career. Though she still loves Taylor, she leaves him, but he courts her lovingly:

> Taylor: *I'll love you all my life. I know that now. All my life.*
> Garbo: *Never be jealous again. Never doubt that I love you. More than the world. More than myself.*

Dying of tuberculosis, she is overjoyed when Taylor comes to her. She dies in his arms, her eyes opening at the last.

Holiday (1938) features Cary Grant as a young Wall Street banker who wants to make a lot of money fast so he can take a "holiday" to find out who he really is, and Katharine Hepburn as a rich man's daughter who "can't decide whether to be Joan of Arc, Florence Nightingale, or John L. Lewis." They're two free-spirited charismatics who clearly belong together. At the start, he is engaged to Hepburn's snobby sister, who wants him to marry her, join the family, and make money. But Grant's a charismatic rebel: *"I've been working since I was ten. I want to find out why I was working!"* At the family New Year's Eve party, Grant says he is ready for his holiday. The dad wants him to start working at once, but Grant says no to him and his fiancée:

> Grant: *We've got to make our own lives! I love feeling free inside even more than I love you!*

Hepburn decides she loves Grant, and says so:

> Hepburn: *I've got all the faith in the world in Johnny. Whatever he does is all right with me. If he wants to sit on his tail, he can sit on his tail. If he wants to come back and sell peanuts, I will believe in those peanuts.*

The two charismatics have found each other.

Many charismatic lover films of the thirties seem to take place in various spiritual and social vacuums, in which the charismatic lover or lovers shape a free, passionate, and exuberant new way of life. Surely these unhappinesses were meant as counterparts of the Depression which paralyzed or demoralized so many lives. In any case, starting with *Holiday* and henceforth in most of the charismatic lover films of the forties and later, society and spirituality work against them, and the charismatics must raise their consciousness to win and hold passion, romance, and love.

Only Angels Have Wings (1939) tells how a strong, determined, and charismatic character wins love almost in spite of himself. Head pilot Cary Grant runs a small South American aviation company, flying cargoes to remote locations at high risk. Though daring, he's fatalistic (*"No looking ahead to tomorrow. Just today."*) Jean Arthur, a stranded adventuress, tries to take up with him, intuiting his story. (*"Somebody must have given you an awful beating once."* That is to say, some dame.) Now Grant says he despises women because they want to *"have plans."* Asking a woman to stay with him would be a confession of weakness, something he is proud he's never done. Women *"think they can take it—but they can't."* Arthur tries to bypass Grant's rigidity, interesting him by taking a bath in his quarters and having him embrace her as she recites his creed: *"Never tie him down; never make plans; never bother him or ask him for anything!"* But when Grant gets a dangerous mission, she behaves in such a way that he has his best friend take the flight—and the man is killed. When Grant finally has to make the same trip, Arthur cries and pleads, defying his creed.

> Arthur: *Do you want me to stay or not?*

(Grant is silent)

Arthur: *You're hard to get. All you have to do is ask me!*

Not speaking, the charismatic gives her his "lucky coin" to make her decision with, and then goes out to take the flight. Arthur then realizes it is a two-headed coin—he wants her to stay, and she is jubilant. Outside, Grant weeps as he flies, releasing his feelings in secret.

The film's director, Howard Hawks, has been quoted as saying women find men who have no time for them impossible to resist. The true man is willing to risk his life, seeking "grace under pressure."

The Philadelphia Story (1940), based on a hit play, a classic, stars Katharine Hepburn as a charismatic beauty—eloquent, fervent, magnetic, contradictory, and daughter of a very wealthy family. She is about to marry stuffed shirt John Howard when her suave former husband, Cary Grant, whom she dumped for his drinking and womanizing, appears. His goal is to stop a sleazy newspaper exposé of her dad's adultery. The smear reporter Jimmy Stewart shows up, even as Grant criticizes his charismatic ex-wife (seeking to be forgiven and taken back?).

Grant: *Strength is her religion, Mr. Cooper. She finds imperfections unforgivable. Not interested in yourself? You're fascinated, Red, you're far and away your favorite person in the whole world...a marble maid with no regard for human frailty.*

Stewart gets drunk, falls for Hepburn too.

Stewart: *There's magnificence in you, Tracy. A magnificence that comes out in your eyes, your voice, in the way you stand, in your walk. You're lit from within. You've got fires banked down in you, hearth fires and holocausts. You're the golden girl, full of life and warmth and delight.*

Stewart carries the unconscious Hepburn to bed, meets the angry bridegroom, but is knocked out by Grant to avoid a confrontation. The bridegroom calls off the wedding though everyone's arrived. Stewart loves Hepburn and wants to marry, but she turns him down; her money is a potential obstacle. Next Grant says he will be her next husband, and she realizes she still loves him.

Hepburn: *Dexter, are you sure?*

Grant: *Not in the least, but I'll risk it. Will you?*

Hepburn: *You bet. You didn't do it just to soften the blow?*

Grant: *No, Tracy.*

Hepburn: *Nor to save my face.*

Grant: *It's a nice little face.*

Hepburn: *Never in my life have I been so full of love before.*

Critics have written that the character she plays in this movie is really Hepburn herself—charismatic, aristocratic, beautiful. The film was remade as *High Society* (1956) with Bing Crosby, Frank Sinatra, and Grace Kelly.

Casablanca (1942), for many Hollywood's greatest love story, stars Humphrey Bogart and Ingrid Bergman as charismatic lovers—fervent, eloquent, and adventurous. Bogart, tough, bitter, still in love with Bergman whom he lost,

runs a nightclub in Casablanca, in Nazi-controlled French Morocco. Two exit permits fall into his hands, but as he says, "*I stick my neck out for nobody!*" Then Bergman arrives with her husband Laszlo, a Resistance leader wanted by the Nazis. They hope to flee to the neutral U.S. After they leave his club, Bogart broods ("*Of all the gin joints in all the towns all over the world, she had to come into mine!*") He recalls their passionate affair in Paris. Bergman tries to explain, but Bogart hates her: "*Was it Laszlo, or were there others in between?*" Later, they meet and he tells her she will cheat on her husband with him. Her husband tries to buy the exit permits, but Bogart refuses, commenting cruelly, "*She knows why!*" Later she begs Bogart for them, threatening to shoot him.

> Bergman: *Richard, we loved each other once. If those days mean anything to you....*
> Bogart: *I wouldn't bring up Paris if I were you. It's poor salesmanship.*
> Bergman: *If you knew how much I loved you, how much I still love you.*
> Bogart: *Go ahead and shoot. You'd be doing me a favor.*

She explains she thought her husband dead when she and Rick met. Learning otherwise, she left him. The film hints they make love next.

Her husband appears and wants Bogart to use the permits to take Bergman to safety—he knows about their affair. Next the husband is arrested. Bogart makes a sly deal with the head French cop, Claude Rains—he'll give the Resistance leader the permits, so he can be framed for stealing them, and put into a concentration camp—and Bogart will get Bergman. But when Bogart, the couple, and the cop meet, Bogart pulls a gun and has the cop arrange for the couple to fly out on the next plane. Rains makes the call, but also alerts the Nazis, and meanwhile the lovers say goodbye:

> Bergman: *How about us?*
> Bogart: *We'll always have Paris. We didn't have it. We'd lost it until you came to Casablanca. We got it back last night. Here's looking at you, kid.*

Bogart also speaks to her husband.

> Bogart: *She had begged for the permits, pretending to be in love. But that was long ago. For your sake she pretended it wasn't, and I let her pretend.*

The implication is the Bogart-Bergman love affair will always go on. The plane takes off, Bogart kills the Nazi leader, and he and the French cop "take a stand," going off to join the free French forces. Bogart, symbolizing neutral America, joins the struggle.

Casablanca is beautifully constructed and acted, the noble charismatic lovers drawn together and pulled apart as new facts come out and political tensions appear, moving through character arcs that reveal aspects of their passions and nobilities.

To Have and Have Not (1944), a Howard Hawks film much resembling *Only Angels Have Wings*, has Humphrey Bogart on Nazi-occupied Martinique taking the wealthy deep sea fishing. He notices provocative young beauty Lauren Bacall; both of them are proud, independent, charismatic loners. When a

client shortchanges Bogart, Bacall lifts the client's wallet and visits Bogart in his room, kissing him immediately:

Bogart: *What'd you do that for?*

Bacall: *I'd been wondering whether I'd like it.*

Bogart: *What's the decision?*

Bacall: *I don't know yet* (kisses him again). *It's even better if you help.*

Bacall would like his help in getting off the island, or perhaps just wants him, period.

Bacall: *You know you don't have to act with me, Steve. You don't have to say anything and you don't have to do anything. Not a thing. Oh, maybe just whistle. You know how to whistle, don't you, Steve? Just put your lips together and blow.*

When she leaves Bogart gives a long "wolf whistle."

For money, Bogart delivers a DeGaullist patriot to Martinique, even removing a bullet from him, with Bacall as his nurse. At the bar, Bacall sings a suggestive love song in a slinky black dress.

Bacall: *Is this what I've waited for? Am I the one? Oh, I hope in my heart that it's so. In spite of how little we know.*

Bacall visits Bogart again, and he moves his hands down the shape of his body to show that he has no obligations:

Bogart: *Look, no strings.*

Bacall (walks around him): *No, Steve, there are no strings tied to you— not yet.*

Bacall mockingly offers to do what the French patriot's wife humbly offered: take off his shoes, make his breakfast, fix his bath. The charismatics constantly test each other. He doesn't like feminine passivity and weakness (like the Frenchwoman's), but Bacall passes his test. Bogart gets in trouble with the Nazis occupying the island, so he takes work aiding the free French at Devil's Island. Bacall will help. She's asked if she wants to, and replies, "*What do you think?*" She heads for the docks with Bogart, swinging her hips happily.

The Big Sleep (1946) is a classy detective film/romance with Humphrey Bogart as a witty, charismatic private eye. (Bogart: "*My, my, so many guns and so few brains!*") He meets Lauren Bacall, an upper-class sophisticate who falls for him as he solves a complex, confusing case. Half the film is their sex play repartee, as when he comes to see her dad about taking the case, and she teases him about his manners and height:

Bogart: *I don't like them either. I grieve over them on our long winter evenings.*

Bacall: *And you're not very tall.*

Bogart: *Next time I'll come on stilts.*

Still, Bacall's clearly interested in him, and they soon size each other up sexily, using racetrack slang, suggesting their very uninhibited charismatic natures.

Bacall: *Speaking of horses, I like to play them myself. But I like to see them work out a little first. See if they're front runners or come from behind. Find out what their hole card is.*

Bogart: *Find out mine?*

Bacall: *I think so...I'd say you don't like to be rated. You like to get out front, open up a lead, take a little breather in the back stretch, and then come home free.*

Bogart: *You've got a touch of class. But I don't know how you'd do over a stretch of ground.*

Bacall: *A lot depends on who's in the saddle.*

The two find ways that grown-up, polite people can playfully show affection yet learn intimate details about each other and also show commitment.

Bogart: *You look good, awfully good. I didn't know they made them that way anymore.*

As the film ends, they exchange clear signals.

Bogart: *What's wrong with you?*

Bacall: *Nothing you can't fix.*

The Fountainhead (1949) stars Gary Cooper as a driven, idealistic architect who insists his art must be executed exactly as designed. Rather than compromise, the charismatic works in a stone quarry, where he meets architecture critic Patricia Neal, another driven perfectionist, who tells her publisher: *"I'm a woman completely incapable of feeling. I'll never fall in love!"* The two charismatics soon fall violently in love, seemingly attracted by their mutual aloofness:

Neal: *If it gives you pleasure to know you are breaking me down, I'll give you greater satisfaction—I love you.*

Cooper leaves her abruptly to take a design commission, and Neal falls for her publisher, rich, arrogant Raymond Massey, whose newspaper attacks Cooper's stunning new designs. But soon Cooper gets more work, befriends Massey, and has Neal falling for him once more. But when Cooper finds his housing project designs were altered, he dynamites the buildings, and wins his case as their creator. Cooper wins Neal, and starts building a mile-high Manhattan skyscraper. At the end, proud Neal rides the construction elevator to the tower's top to join Cooper who stands atop it, triumphant.

Hitchcock's *To Catch a Thief* (1955) stars Cary Grant as an ex-Resistance fighter and principled cat burglar: *"I never stole from anyone who would go hungry."* Under suspicion on the Riviera, he is joined by luscious Grace Kelly in hunting the real cat burglar, starting with a picnic where she makes her interests clear. (Kelly to Grant: *"Would you like a leg or a breast?"*) Their relationship grows more intense at a nighttime fireworks display.

Grant: *If you really want to see fireworks, it's better with the lights off. I have a feeling that tonight you're going to see some of the Riviera's most fascinating sights.*

She pulls him onto the couch, the camera framing her necklace and décolletage.

Kelly (tauntingly): *Here, hold them...They're the most beautiful things in the world, the one thing you can't resist.*

Grant: *You know as well as I do this necklace is imitation.*

Kelly: *But I'm not.*

They embrace in an explosive kiss, intercut with the fireworks. After more complications, Grant captures the real thief, and goes back to his Riviera villa with Kelly, who admits she loves him. Grant: *"That's a ridiculous thing to say,"* coolly charismatic as always.

Smiles of a Summer Night (1955, Sweden). This critically acclaimed romantic comedy opens in 1900 at an estate, where during one evening three charismatic couples run away, rekindle old passions, or reconcile.

One is a married couple—a lawyer, Gunnar Björnstrand, and his still virginal wife of two years, Ulla Jacobsson. He goes through losing her, attempting suicide (with blanks), fainting, and being revived by his loving former mistress, Eva Dahlbeck.

Björnstrand: *This can't be heaven.*

Dahlbeck: *Is that because I'm here, perhaps?*

Björnstrand: *Desiree, you were a fine help.*

Dahlbeck: *You're right. I was a fine help!*

He decides to rekindle his love for his mistress.

The lawyer's stepson, Björn Bjelvenstam, is also interested in his father's past mistress. The son is unable to face his feelings.

Bjelvenstam: *Oh lord, if your world is sinful then I want to sin. Let the birds build nests in my hair, take my miserable virtue away from me, because I can't bear it any longer.*

Bjelvenstam is about to kill himself, but the specially constructed floor and walls spin so that the adjacent rooms exchange beds, and his stepfather's virginal wife appears in his bedroom, and he can't resist her:

Jacobsson: *I've loved you all the time.*

Bjelvenstam: *I've loved you all the time.*

The two run off together.

Meanwhile a count and countess, Jarl Kulle and Margit Carlqvist, make a mockery of their love relationship:

Carlqvist: *Swear to be faithful to me for at least...*

Kulle: *I'll be faithful to you for at least seven fake eternities of pleasure, eighteen false smiles, and fifty-seven loving whispers without meaning. I'll be faithful to you until the last gasp separates us. I'll be faithful to you in my way.*

In time, the titled couple reconcile. A maid and coachman also have a romance. The special pleasures of *Smiles of a Summer Night* include the extraordinary acting, and the many ways that various kinds of love—married, unmarried, legitimate, profane, sincere, and mistaken—are contrasted and juxtaposed.

Indiscreet (1958), a romantic comedy, stars Ingrid Bergman as a rich British actress introduced to Cary Grant, a Wall Street genius and bachelor who

pretends to be married to control his love life. When Grant explains he's separated and his wife won't divorce him, Bergman says she just wants to have an affair. Grant must return to the U.S., and Bergman plans a visit, then she is told he is really single and becomes furious.

Bergman: *How dare he make love to me when he isn't a married man!*

Bergman and Grant are clearly very much alike, charismatics who use their fascinating surfaces and manner to avoid real involvements. Bergman schemes revenge by claiming she is having emergency surgery, and that her chauffeur has become her new lover.

Grant arrives, claiming he is at last divorced and can marry her. But when the chauffeur appears, Grant is enraged (how dare she cheat!). He now says he'll never marry Bergman. Finally he learns the truth, drops his masks, they reconcile, and Grant proposes.

Grant: *What are you crying about, Anna? Don't cry, Anna. I love you. Everything will be all right. You'll like being married. You will. You'll see.*

Several films set in other countries featuring charismatic lovers from literature and recent history provide different perspectives on such characters. Made as art films, they clearly anticipate reasons the charismatic lover would gradually become less fascinating or sympathetic.

Lady Caroline Lamb (1972, England) opens with protagonist Sarah Miles riding furiously across the English countryside, implying a fierce nature. She is involved with a member of parliament, Jon Finch, but their personalities clash. Visiting the coliseum she cries: "*They built with passion.*" To him: "*They built correctly.*" She next starts a scandalous affair with the manic poet Lord Byron, played by Richard Chamberlain, soon her wild passion: "*You are fearless and free...I am trivial!*" Miles does everything to win him, dressing as a Nubian slave or a young attendant riding Byron's carriage. They're both charismatics and their sexual excitement takes one form after another. Soon she lets Byron deliberately degrade her, so she is driven to attempt suicide at a formal dinner to win him. "*This is love,*" she screams as she slits her wrists. Her family provides drugs, then institutionalization, and at last she dies, according to her physician, "*of a broken heart.*"

Lady Chatterley's Lover (1981, England), based on the classic and infamous D.H. Lawrence novel, stars Sylvia Kristel as the aristocratic, charismatic heroine, married to a British lord, Shane Briant, a bitter impotent crippled in World War I. Their gamekeeper, Nicholas Clay, is a vigorous outdoorsman. Kristel, sexually frustrated, kisses her nude image in a full-length mirror, masturbating and dreaming of stallions and tree trunks.

Wandering in the woods, she finds the gamekeeper swimming naked in a pool. Soon the two are having a passionate romance, which provides her multiple orgasms in the pool, the woods, and his cottage. When he exclaims: "*You want me for fucking!*" she carries out a pagan love ceremony to express their spiritual union. Her husband suggested she have such an affair, but now becomes enraged because her lover is a common servant. (Briant: "*He's just so*

much human meat!") When she becomes pregnant, he sends her elsewhere to have the child. Meanwhile the gamekeeper is dismissed, and when she returns, she searches for him. He has become a coal worker, but she makes it clear to him he is the only man she loves, and he is equally captivated. (Clay: *"I never knew what a woman was like before!"*) They face problems, but are determined to stay together.

Out of Africa (1985) is the story of European aristocrat Meryl Streep and her love affair with African adventurer Robert Redford, two charismatic figures whose lives parallel Africa's great changes. Streep narrates, starting with how, while on safari, she proposed to Klaus Maria Brandauer in 1913, a marriage seemingly doomed. (Brandauer: *"You bought the title, Baroness. You won't buy me!"*) More conflicts follow. They buy and run a farm in Kenya, en route meeting Robert Redford, a charismatic wanderer in the wilderness. Out riding, she meets Redford again, who saves her from a lion attack. She admires his independence and storytelling, he her self-assurance. At another point, she loses her way, and Redford gives her his compass. Her womanizing husband gives her syphilis, and the treatment is painful, disfiguring, and sterilizing. She makes her husband move out, and has Redford move in:

Brandauer: *You should have asked permission.*

Redford: *I did. She said yes.*

With Redford, Streep is fulfilled for the first time in her life—by his poetry, love of Mozart, and viewpoint on life. They love for the moment. (Redford: *I mate for life—one day at a time."*) In time, Streep asks Redford to marry her.

Streep: *There are some things worth having. But they come at a price. And I want to be one of them.*

But the offer of marriage drives Redford off. The charismatic must come and go by his own rules, though this torments Streep.

Streep: *When the gods want to punish you, they answer your prayers.*

A fire destroys the farm, but with Redford's help the local people are saved. Streep and Redford spend a last night together, and soon afterwards Redford dies. But her experiences with her charismatic lover make Streep into a world-renowned writer.

In general, charismatic lover films of the eighties and after are lighter in tone. The charismatic lovers are not burdened by their magnetic attractive qualities, and are better able to deal with love without it becoming a great crisis of character.

Roxanne (1987) is a modern updating of *Cyrano de Bergerac*, with Steve Martin as the handsome, cultured, charismatic, small-town fire chief hero (Martin: *"Why should we sip from a teacup when we can drink from a river?"*) His one flaw is his exceedingly large nose, which can't be fixed with corrective surgery. Like the original Cyrano, Martin is obsessed with finding his true love. When stunning young astronomer Daryl Hannah moves into town to study the sky, Martin is strongly attracted. They become close when she is accidently locked out of her home naked and calls on Martin for help. But meanwhile she falls for one of Martin's dumbest firemen, who, as in Cyrano, calls on Martin to

write his love letters to her and provide romantic advice. Martin finds himself tormented as he finds himself expressing his love for his dream girl in the service of a rival suitor. Fortunately, he finds a clever way to win her love in spite of this complication.

Pretty Woman (1990) brings together two charismatic lovers, Julia Roberts, a lovely, still trusting prostitute, and Richard Gere's shrewd yet honest Wall Street takeover artist. Meeting, they make a series of deals, Gere paying for her driving skills, a night at his penthouse, and a week's companionship. Both are cheerfully direct. Roberts spells things out:

> Roberts: *I appreciate the whole seduction thing you got going, but let me give you a tip—I'm a sure thing.*

A price is negotiated, but when Roberts tries to shop for upper-class clothes in her hooker boots and mini skirt, she is ridiculed. Gere goes back to the store with her and has the contemptuous staff people dismissed, and the two become closer. They talk of their pasts: Gere became a corporate raider because of his dad's betrayal, so spends his life outwitting "dad figures"; Roberts still believes a prince will someday rescue her (she does look like a princess). Gere sees parallels.

> Gere (sarcastically): *You and I are similar creatures. We both screw people for money.*

But there are other parallels: charm, good humor, intelligence, stunning looks, determination, and charismatic magnetism that is pulling them together as the days go by:

> Roberts: *You're late.*
> Gere: *You're stunning.*
> Roberts: *You're forgiven.*

Being with this sweet girl changes Gere. When his creepy lawyer comes on to hooker Roberts, he beats him up. Gere decides to stop raiding; he'll save old Ralph Bellamy's shipyard and build—boats! The week ends, and Roberts takes her money and goes.

> Hotel manager (to Gere): *It must be difficult to let go of something so beautiful.*

Gere realizes that he loves her, and in spite of his fear of heights, climbs her fire escape to win her:

> Gere: *So what happens after he climbs the tower to rescue her?*
> Roberts: *She rescues him right back.*

Which she does, like other lovers of charismatics, rescuing him from what are in some ways disabling strengths. Downstairs, a balladeer reminds us an unreal story may have value: "*Always time for dreams, so keep on dreamin'!*"

The Bridges of Madison County (1995) tells how two mature charismatic characters, *National Geographic* photographer Clint Eastwood, and Midwestern wife and mother, Meryl Streep, escaping from lifelong obligations, have a passionate four-day love affair. The film starts with Streep's children discovering affair mementos after her death, then flashes back to Iowa, 1965. Her family away, Streep's Italian farm housewife encounters Clint Eastwood's

photographer on assignment to get pictures of some of the county's historic covered bridges. When she provides directions, they are immediately attracted to each other. Eastwood is later picking flowers, reciting poetry, and telling tales of his assignments in Africa and Italy. The next night they become lovers. They spend a perfect day and night together, Eastwood saying he is attracted to her earth mother quality, Streep writing in her diary her certainty that such an experience comes once in a lifetime. Then, as he packs to leave, Streep angrily attacks him—he is off to find another lonely woman to seduce and abandon. Instead he tells her she is his one true love, and wants her to run away with him. She packs her bags, and then realizes she cannot leave her husband and young children. Eastwood leaves, and soon her family returns and Streep returns to her "life of details." A few days later the two happen to meet again in town, and Eastwood again offers his invitation, this time silent, to join him. Streep again refuses, instead returning to her family for the rest of her life. The two charismatics are able to return to their old lives, and follow those familiar paths onward.

Notting Hill (1999, England) has world-class charismatic movie star Julia Roberts enthrall very ordinary, sweetly awkward Englishman Hugh Grant, in his bookstore, leave, then come back and kiss him, so he doesn't give up. Grant visits Roberts' luxurious hotel suite for what was supposedly an intimate meeting, only to be part of a noisy press conference for her latest film. He takes her to a family birthday party, where she meets his friends and relatives, lovable eccentrics who ridiculously try to pretend his date isn't the world's top celebrity. His sister announces: "*I know that we could be best friends!*" Next Roberts's obnoxious American lover, Alec Baldwin, arrives, which seems to mean the affair's end. But a sudden scandal—youthful nude photos of Roberts—leads her to beg Grant to conceal her in his flat, which gives the couple their chance to become close. The interlude ends when Grant's roommate innocently lets the press know where she is, so Roberts becomes enraged and storms out. After a year and a half, Roberts returns to Grant, asking him to give her another chance as a serious companion:

> Roberts: *I'm also just a girl standing in front of a boy, asking him to love her.*

Starting in the eighties, charismatic lover films tended towards self-consciousness and exhaustion. The charismatic lovers work in the arts (*Bridges of Madison County*—photography; *Notting Hill*—the movies), or are socially detached (*Out of Africa*—a man who is an adventurer and outsider; *Lady Chatterley's Lover*—a woman who is self-centeredly focused on sex). The exotic raptures they offer are tawdry (*Notting Hill*—movie star's husband; *Roxanne*—fireman's wife), or crass (*Pretty Woman*—stockbroker's mistress). By contrast, many earlier films about charismatic lovers gave them glamorous careers (death-defying bush pilot; Paris's leading mistress; Philadelphia's top socialite; defiant, God-seeking priest) as well as dramatic or rapturous milieus (Nazi-occupied battlegrounds, honeymoon cruise ships; encounters with high-

class broads and gangsters). In the new century, the charismatic lovers film moves beyond all of this to self-satire and self-parody.

Kate & Leopold (2001), a comic fantasy romance, has a door open in time, so English duke Hugh Jackman from the nineteenth century comes to New York City, where he meets marketing executive Meg Ryan. Jackman is a charismatic aristocrat with smug ideas about class, speech, and manners, who quickly fascinates Ryan. He rescues her a number of times with his athletic prowess as well as quick thinking, and she can't resist his poise, charm, and virility. But Jackman actually pushes the idea of the charismatic lover to absurdity, making him a pompous, arrogant, haughty, aloof, silk-stocking superior to all modern guys. In the end, the sophisticated feminist Ryan decides she'll nonetheless be much better off living in the past with the stuck-up swashbuckler.

Something's Gotta Give (2003) is another comic charismatic lover's fantasy romance: all the characters mock their supposedly charismatic natures. Jack Nicholson is a sixtyish music mogul who devotes himself to chasing twenty-something women; Diane Keaton a fiftyish Broadway playwright who can't find a fella; and Keanu Reeves, a young doctor who dates Keaton. The aging Nicholson, a powerful music industry mogul, explains himself: though over sixty, he only dates women under thirty. When he has a heart attack he convalesces at Keaton's beachfront villa, where they grow close until he resumes chasing young women:

Nicholson: *The truth is, I...I just...I don't know how to be a boyfriend.*
Keaton: *That's what you've got to say after all of this? That you don't know how to be a boyfriend?*

Keaton puts on a Broadway smash ridiculing older playboys like Nicholson, and she settles down with young Reeves, imitating Nicholson's fascination with young flesh. The two new-century charismatics, power figures in the arts, have no higher goals than perpetual puberty. Finally all three meet in Paris, where Nicholson's charismatic falls into further self-indulgence and self-pity:

Nicholson (sheds a tear): *At the end of the day, I'm nothing but a sap, a stupid old sap, standing on a bridge in Paris, crying my eyes out.*

Finally he surrenders any of the personal strength and erotic magnetism of the charismatic. He sees himself as a total sexual fraud and bewildered adolescent. Keaton buys it:

Nicholson: *When I went to see all those women* (again), *I found out I was never really present for any of them...I finally get what it's all about. I am sixty-three years old and I am in love for the first time in my life...How do we figure out a way to make this work?*
Keaton: *Okay....*

Why have charismatic lover films evolved this way? Most simply, the old strong-willed, inspiring charismatic lovers seem out of date today. In a sense, they represented the finest aspects of an idealistic culture with coherent values, upholding its best ideals—they were disciplined, serious, faithful, and self-denying. But around the eighties, they became progressively either more rigid and unreal (e.g., *Kate & Leopold*) or weak and self-indulgent (e.g., *Something's*

Gotta Give). In a word, ridiculous. The earlier charismatic lovers assumed responsibilities, responded to needs. Such characters were admired in those old movies, but today's audiences think they know better.

Put another way, there is a British cartoon of two lady peacocks looking over a magnificently beautiful male peacock. One of the females turns to him and says simply, "Cut the crap and show us your willy!"

Chapter Nine
The Self-Saboteur

Every love affair, Ernest Hemingway said, ends badly. Romance breakup films usually involve some sort of self-sabotage, which takes many forms. Sometimes lovers are just unbearable brutes, windbags, bumblers, vulgarians, or people with no patience or insight. (They can be fascinating for a while, for their looks or the sympathy they offer.) More often breakups are due to psychological problems: insecurity, neediness, anxiety, or great self-consciousness, which prevent a person from relating successfully to others. If love is a special caring, such psychological woes keep lovers from feeling safe or cared for (e.g., in Woody Allen films, the hero comically forces his lover to live in his neurotic universe). Other no-future lovers may be charming at first, but soon reveal themselves as ungenerous, argumentative, judgmental, moralizing, "happiness junkies," or otherwise just too much trouble.

Films about romantic breakups and failures seem to have a special appeal—the three greatest film couples all wind up apart at the end—Romeo and Juliet, Rhett and Scarlett, and Rick and Ilsa. The reasons film couples break up may be ones listed above, but they usually get more dramatic treatment, e.g., masochistic tendencies (*Of Human Bondage*), egomania (*Citizen Kane*), or generalized anxiety (*Annie Hall*). Like real couples, some movie couples break up because they never understand each other, others because they understand each other too well. Movies have made their own contribution to the breakups of real-life lovers by setting impossible standards of beauty, manliness, femininity, success, and sexual fulfillment. But they also provide understanding of a kind for romantic situations, as detailed herein.

New biomedical research suggests divorces and breakups are at least partly due to human brain biochemistry. Couples' frequently intense initial infatuation usually lasts three to four years, set up by the "excitement amine" (PKE, Psycho Kinetic Energy, which when given to mice causes them to jump and squeal, called the "popcorn syndrome"). When it wears off after three-plus years, some couples feel love has died and quit. (Thus the peaking of divorce statistics at the fourth year of marriage.) Others have brain endorphin chemicals that produce "affection high." Still others sooner or later have a "surfeit response," and are

driven to move on, like flocking birds. Thus real-life breakups may be nobody's fault.

Psychologists who study breakups find that when the woman says the man is now "boring," or the man says the woman is "cold," what's often happened is that the partner in question feels unwanted, ignored, left out. (Mae West: "Husbands, like fires, go out when unattended.") Then an outsider appears who is sensitive to the unwanted one's mood changes, admires his or her interesting qualities, and listens and responds to what they have to say. The outsider may be vastly inferior to the current companion in many ways, but their caring overcomes all that. A breakup soon follows:

A number of silent films deal with romantic breakups and love self-sabotage, sometimes caused by compassion, a quest for justice, or other motives.

The Love Liar (1915) is about a womanizer whose conquests include a society girl who drops him when she gets bored, and a cabaret dancer who gives him his own medicine, so he commits suicide.

In Search of a Sinner (1920) has Constance Talmadge come to New York to find a "wild man," pick up a Bohemian gent who is just a clean-living fellow, and try to "corrupt" him to get what she's after, without success.

Flames of the Flesh (1920) deals with an attractive young woman who seeks revenge on a lover who has abandoned her, eventually enslaving him.

Smouldering Fires (1925) has Pauline Frederick as a businesswoman who falls for a young worker. They plan to marry, then her college coed sister comes home, and soon she and the young man fall in love, keeping silent about it. After marrying the man, the older sister, aware of the youngsters' love, pretends the marriage has failed. She divorces him, knowing the young couple will unite in time.

It's self-sabotage, giving up happiness for someone else!

Torrent (1926) stars Greta Garbo, who becomes an opera diva and courtesan, then meets her childhood sweetheart. Too cynical and aware of their differences, Garbo in the end breaks up with him and emerging from the theater, steps into her limo, her face unreadable.

The coming of sound film, here too, made possible more subtle and elaborate treatment of the subject.

A Woman of Affairs (1928) stars Greta Garbo and John Gilbert, lovers who cannot marry because he seeks a diplomat's career and her family is dissolute. Garbo marries another, who commits suicide. Garbo claims he died for "decency," since he said she was no good and she proved it by having several tawdry affairs. Years later Gilbert learns the truth—the husband, an embezzler, was about to be arrested. Gilbert meets Garbo and they realize they're still in love. He says he'll leave everything for her. Garbo tells him: "How little you know of my kind of love!" and commits suicide.

The Animal Kingdom (1932) has Leslie Howard tell his live-in lover artist Ann Harding he's fallen for siren Myrna Loy. Their relationship has cooled, but they remain friends:

Harding: *That side of it was never so much to us, not in comparison, not after those first crazy months. But I thought that was natural—I was even glad that it was other needs that kept us together.*

She explains that since that's so, he doesn't have to marry the siren.

Harding: *I just thought maybe you just wanted her, wanted her most awfully—for all our big talk, you know, we still belong to the animal kingdom.*

Howard gradually realizes that he does just want Loy for sex. It's with Harding that he really gets excited, as they share what they care about and that is true love. Loy is just a rich huntress on the prowl. In the end he tells Loy's butler: *"I'm going back to my wife—my wife, I said!"*

Hallelujah I'm a Bum (1933), a comic view of breaking up, stars Al Jolson as a homeless man living in Central Park. His friend mayor Frank Morgan wrongly believes his glamorous mistress June Marcher, played by Madge Evans, is unfaithful. He tells her so, and she walks out. She tries to commit suicide, and Jolson saves her, but the shock of it all gives her amnesia, and the two fall in love. He gets a job, and after a sensuous nude scene together, they plan a quick marriage. But then Jolson introduces the girl (he calls her Angel) to the mayor, and the sight of her former lover makes her forget her love life with Jolson (she's now repelled by him). Jolson gives her up and goes back to his bum's life.

Of Human Bondage (1934) has clubfooted doctor Leslie Howard meet vindictive waitress Bette Davis, who turns their love affair into hell on earth. Attending medical school, he falls for Davis, who learns to manipulate the cripple's emotions.

Davis: *You cad, you dirty swine. I never cared for you—not once! I was always making a fool of you. You bored me stiff. I hated you. It made me sick. I had to let you kiss me. I only did it because you begged me. You hounded me; you drove me crazy! And after you kissed me, I always used to wipe my mouth. Wipe my mouth! But I made up for it— after every kiss I laughed at you. We had to laugh at you—Miller and me and Griffiths and me. We laughed at you because you were such a mug, a mug, a monster. You're a cripple, a cripple!*

Howard meets a sophisticated novelist who courts him, but Davis tells him she's pregnant. Howard can't resist her, promises to marry her, and leaves the novelist. Davis then drops him and runs off with another medical student. She returns with her child and pleads for shelter but refuses him sex. She leaves again, destroying some of his belongings and some bonds he needed to pay for medical school. He has to quit school and become a salesman, but is soon too sick and depressed to work. Nursed by a woman friend, he inherits money and has his foot fixed. He hears Davis is dying in a charity ward and goes to visit her, but she's died. With his obsession gone, he's free to marry the woman who nursed him back to health, Frances Dee.

Like *Of Human Bondage*, other Depression era self-sabotage films have plots in which the passionate protagonists' impulses push them towards self-destruction, a metaphor for audiences' most secret fears in that desperate time.

Reckless (1935) stars Jean Harlow as a Broadway actress who meets rich businessman Franchot Tone. Obsessed with her, he buys all the seats in the theater so he can watch her alone. They marry, but he tells his mistress it's false and empty. When Harlow turns to her agent for sympathy, the unstable Tone commits suicide, and scandalmongers cry she killed him. At a new show, Harlow tells the audience the truth, and the show succeeds!

The Devil Is a Woman (1935) stars Marlene Dietrich as a manipulative vamp, Lionel Atwill and Cesar Romero as military officers. Atwill is her love slave, who pays for her every luxury.

When she disappears, he finds her, and she takes everything he has. Dietrich then runs off to Paris with Romero, but soon returns to Atwill to enslave him again. As she tells an admirer: *"If you really loved me, you would have killed yourself!"*

Dangerous (1935) stars Bette Davis as a self-destructive star. Artist Franchot Tone falls for her and tries to help her, but she only ridicules him, performing romantic scenes while making cruel comments. In response, he asks her to marry him! She visits her ex-husband, who is still madly in love with her, to ask for a divorce. They take a drive, and she threatens to crash if he won't divorce her—and she does! She allows Tone to return to his old lover, and visits her husband in the hospital, bringing him flowers (an added-on happy ending?).

Wuthering Heights (1939), set in 1841, has a visitor to the ruined old Wuthering Heights mansion told a tale of tragic lovers by the caretaker. Years before, a gypsy boy was brought to the manor to better his life, and lost his heart to the owner's daughter. The two pledged undying love. They grew up into Laurence Olivier, a stable boy, and Merle Oberon, part of the cultured social set. She is drawn to young aristocrat David Niven, though Olivier is still obsessed with her. Olivier runs away, and Oberon marries Niven. Later Olivier returns, now rich, and buys Wuthering Heights, acts cold towards Oberon, and marries Geraldine Fitzgerald, which torments Oberon. Olivier tortures Fitzgerald, who hopes Oberon will die, so Olivier will forget her. Oberon does die, slowly, but before the end, she and Olivier swear their love will survive even death. Oberon says she'll wait for him; Olivier asks this even if it may drive him mad. Then the film returns to the present, a visitor arriving to say he saw Olivier walking outside with a woman, then found him dead on Oberon's grave. The caretaker says the two lovers are together at last, and the film ends with their ghostly images. Other versions of the story include a 1920 British adaptation, a 1953 Mexican translation, and a 1970 American remake.

As World War II spread, wartime preoccupations showed up in self-sabotage romance films—a man's duties forestalling passion, the masculinization of women, and isolationist mindsets killing love (e.g., *Citizen Kane*).

Waterloo Bridge (1940) features Vivien Leigh and Robert Taylor as a vivacious, beautiful ballet dancer and young officer respectively, who meet at Waterloo Bridge in London during a 1917 air raid. She drops her purse; he retrieves it. He attends her performance of *Swan Lake* that night and is smitten.

Afterwards, both confess their attraction for each other. Taylor proposes marriage, and Leigh accepts. But the proposal violates military regulations, and before they can wed, his regiment goes to the front. Leigh bids him farewell at Waterloo Station. But this makes her miss a performance, so she's dropped from her ballet troupe. Leigh remains close to Taylor's aristocratic family, but while having tea with them, she spots Taylor's name on a casualty list. Leigh gives up hope and becomes a prostitute at Waterloo Bridge. Months later, she runs into him there, a returned P.O.W., but hides her current situation:

>Leigh: *I loved you. I never loved anyone else. I never shall. That's the truth, Roy. I never shall.*

Their love resumes. But Leigh thinks her dark past may come to light, disgracing Taylor's aristocratic name. She tells his mother the truth and then runs away. Taylor searches for her, but finds she's committed suicide. The film flashes forward to World War II, where an older Taylor is mustering his regiment.

This Thing Called Love (1940) has rather masculine business executive Rosalind Russell, a dandy of sorts, marrying a fellow professional but wanting a kissless honeymoon and a companionate three months celibacy period in their marriage to test it. The groom objects and so is driven off:

>Ann Winters (a friend): *Someone has to do the pioneering!*

>Russell: *But he doesn't want to be Daniel Boone!*

Instead, groom Melvyn Douglas tries everything he can to get the marriage going, climaxing with putting a giant Mexican fertility god in the center of their living room!

>Russell (furious): *You couldn't make spinach grow in the Garden of Eden!*

The Letter (1940), by contrast, deals with the bitter roots of self-sabotage in love. As it starts Bette Davis in a dressing gown shoots to death rake James Stephenson. She later explains:

>Davis: *He tried to make love to me, and I shot him.*

However, it gradually becomes clear the married Davis had a ten-year affair with Stephenson, It was only when he left her to marry an Eurasian woman that she decided to kill him. Davis admits it.

>Davis: *I was like some person with a loathsome disease who only wants to get well.*

Her false claim that she was raped lets her escape prosecution, but she is endlessly tormented by guilt and her new twisted passion for the now dead Stephenson ("With all my heart, I still love the man I killed"). Finally the Asian woman, Stephenson's new wife, taking vengeance, kills Davis.

His Girl Friday (1940), a newspaper comedy, is also a love triangle shaped by self-sabotage. Rosalind Russell is the ex-top reporter and ex-wife of charming, vicious newspaper editor Cary Grant. Russell comes to the city room to quit and say goodbye. She's about to marry nice insurance agent Ralph Bellamy. Grant reacts by joking nastily:

Grant (sneers): *I intended to be with you on our honeymoon, honestly I did!*

Next Grant states he owns her sexually, smiling meanly:

Grant: *How long has it been?*

Russell: *How long is what?*

Grant: *You know what. How long has it been since we've seen each other?*

Russell: *Well, let's see...I spent six weeks in Reno, then Bermuda...oh, about four months. Seems like yesterday to me.*

Grant (points to self): *Seeing me in your dreams?*

Russell: *No, no, Mama doesn't dream about you any more. You wouldn't know the old girl now.*

Grant: *Oh yes I would! I'd know you* (cruelly, with great emphasis) *any time, any place, anywhere!*

In the end, Russell surrenders to Grant, self-sabotaging her new love and life, and staying with him (or at least the newspaper business). Grant acts as if he owns her:

Grant: *Why divorce doesn't mean anything, Hildy. Justa' few words on paper, mumbled over you by a judge.*

Only at the end do they show possible affection (more likely a sarcastic prelude to future agonies like past ones):

Russell: *I thought you didn't love me.*

Grant: *What were you thinking of?*

Russell: *I thought you were going to let me go.*

Grant: *What did you think I was, a chump?*

The film's satiric tone supposedly makes the audience feel Russell is better off leaving the decent, dull Bellamy for whatever sly, manipulative games Grant feels like playing, like the self-sabotage he's led her to.

Citizen Kane (1941) has protagonist Orson Welles sabotage all of his love relationships. An early, brilliant montage of breakfasts with his wife shows him gradually poisoning the relationship, so at the start they're passionate about each other, and by the end don't even speak.

First wife: *People will think...*

Welles: *What I tell them to think!*

Later, when he runs for governor and the opposition threatens to reveal he has a mistress if he doesn't quit, he refuses to give in. (Welles: "*Nobody tells me what to do! I'm Charles Foster Kane!*")

The smear wrecks his marriage for once and all. Later, he meets with his one friend, Joseph Cotten, and tries to justify his egomania (no compromises, please!).

Welles: *A toast, Jedidiah, to love on my terms. Those are the only terms that anybody ever knows, his own.*

His friend Cotten tries to explain to him that his ideas about love are destructive to all involved:

Cotten: *The truth is, Charlie, you just don't care about anything except you. You just want to convince people you love them so much that they should love you back. Only you want love on your terms. It's something to be played your way, according to your rules.*

So when Cotten writes a bad review of Welles's second wife's singing for Welles' newspaper, Welles fires him. Welles in fact forced her to sing opera, which she can't do, so she's ridiculed and finally attempts suicide. Afterwards he makes them live in an enormous castlelike retreat, in near total isolation. Finally his second wife, Dorothy Comingore, comes to the same conclusions as Joseph Cotten, and decides to leave him.

Welles: *You can't do this to me.*

Comingore: *I see. It is you this is being done to. It is not me at all. Not what it means to me. You don't love me. You want me to love you. Sure, I'm Charles Foster Kane—whatever you want, you just name it, and it's yours. But you gotta love me!*

Welles' character winds up living alone, surrounded by servants but in total isolation. He tries to make Cotten or Comingore come back, but they won't (his first wife died). They admit in the film that they both feel sorry for him, even like him at a distance, but in the end find his self-sabotage too unpleasant and perhaps dangerous. (His opera star mania drove Comingore to attempt suicide, though Welles never admits it.)

The self-sabotage romance films of the late forties seem not to share in the period's postwar exhilaration, warning or blaming women for being unable to deal with their romantic fantasies. *Humoresque, Leave Her to Heaven, Possessed,* and *The Heiress* are about women who lose control in romance and wreck relationships. In *Letter to Three Wives* the women each realize a marital split is likely due to how they've mishandled their husbands. In these "women's pictures" for female audiences, the men can't see women's agony and in the case of *Letter to Three Wives,* are too insensitive to see or understand even a normal woman's point of view.

The women protagonists' behaviors reflect period theories of psychology, some now passé. For example, in *Possessed* (1947), Joan Crawford's psychopathology starts with a catatonic stupor. In the hospital Crawford has symptoms of catatonia—muteness, immobility, repeating others' words, and keeping body parts rigid for no reason. She also has thought blocking, inability to speak. Throughout the film Crawford insists Van Heflin loves her, when he never did—erotomania. Her overall condition resembles schizophrenia.

Humoresque (1946) has ambitious, talented violinist John Garfield visit wealthy patroness of the arts Joan Crawford. Crawford is a nymphomaniac trapped in a loveless marriage, whose husband allows her to have affairs with the artists she supports, indulging her extraordinary sexual powers. But Garfield is tough, independent, and music-obsessed. He resists, and Crawford falls for him.

Crawford: *He's what you find in a van Gogh painting—a touch of the savage.*

His parents see Crawford as a dilettante and married slut, and reject her, although she actually loves Garfield. The two remain wildly in love, but are always at odds—just seeing him with an old flame tortures her. Crawford finally decides it's just another empty affair. While listening to a radio broadcast of Garfield playing, she walks into the ocean to her death.

Leave Her to Heaven (1945) has beautiful Gene Tierney fall for Cornel Wilde. Tierney is pathologically jealous:

Tierney: *I love you so. I can't bear to share you with anybody!*

She becomes pregnant, but because a child would divert Wilde's love, she has a staircase miscarriage. Tierney tells Wilde she caused the miscarriage so they'd always be together, but this makes him decide to separate from the madwoman. Tierney then sees her stepsister, Jeanne Crain, as love competition. Afraid she'll lose Wilde, Tierney poisons herself in such a way that Wilde and Crain will be blamed. On her deathbed Tierney cries: "*I'll never leave you, Richard!*" (Total self-sabotage.) The two are found innocent, but Wilde is a guilty accessory for keeping her secrets. Crain will wait for him until he serves his sentence.

Possessed (1947) begins with Joan Crawford dazedly wandering a town's streets, asking for David (Van Heflin). She's brought to a hospital, and explains to the doctor there that she was a nurse caring for an invalid woman, and had become romantically obsessed with a neighbor, Van Heflin.

Crawford to Van Heflin: *I want a monopoly on you, or whatever it is that people have when they don't want anyone else to have any of you.*

Not loving her, and feeling smothered, he ends any relationship.

Van Heflin: *Don't bring the subject around to marriage again. I like all kinds of music except a little number called "Promise Me." It's a duet, and I want to play solo.*

Her patient claims Crawford is having an affair with her husband, and commits suicide. Crawford begins to imagine she caused the wife's death, drifting towards madness. She marries the late woman's husband, played by Raymond Massey, but remains obsessed with Heflin, who starts an affair with the late woman's daughter, Geraldine Brooks. Crawford confronts Van Heflin:

Crawford: *I explained to you how important it was that you didn't leave me again!*

When Heflin says he's going to marry Brooks, Crawford shoots him. In a daze, she walks the streets—back to the film's beginning.

A Letter to Three Wives (1949) deals with three wives all on a dayline cruise, each having been informed her husband may run off with a neighbor. Each reviews her relationship, fears, and doubts, realizing she has reason to fear she's so damaged her marriage that she may be the abandoned one. Jeanne Crain remembers her mistakes at an upper-class dance, leading to her husband's ongoing feelings for another woman (her husband Paul Douglas: "*It's a man's world. You see something you want—go after it!*"). Ann Sothern's badly paid teacher husband resents her big-money radio job. Kirk Douglas (her husband): "*I'm willing to admit that many of my fellow citizens think I'm a slightly comic*

figure—an educated man!" Linda Darnell broods on how she sexually manipulated her rich husband into marrying her (Darnell: *"Porter says Adele Ross has class—and he knows class!"*).

In the end, each of the husbands decides not to break up, but to stay with his wife. Critics argue the film's real point is that all the marriages are permanent low-grade warfare. The wives are forced by social or economic factors to sabotage their feelings and values.

The Heiress (1949), based on Henry James's novel, is about extremely wealthy Olivia de Havilland, whose father has convinced her a man would only want her for her money. When a handsome young man, Montgomery Clift, pursues her, her father, Ralph Richardson, says he's just a fortune hunter. When she decides to marry him, Richardson threatens to cut off her allowance, and Clift disappears on the elopement night. Her father dies, she inherits a vast fortune, and becomes a recluse in his mansion. Years later Clift returns, agonized and apologetic, claiming he ran so she wouldn't lose her fortune. She stands behind the door, listening to his pleas, smiling coldly. He bangs and bangs on the door, but she walks up the great staircase to her room, choosing self-sabotage rather than a chance for happiness.

The self-sabotage romances of the fifties, considered largely a conformist era, dramatize violent sorts of breakups, seeing these often as pathetic—such as in the films *Gun Crazy, Sunset Boulevard*, and *And God Created Woman. La Strada, The Lovers of Lisbon, The Goddess*, and *La Ronde* reduce the quest for erotic novelty to absurdity. *Marty* spells out common social forces and personal weaknesses favoring a breakup in a conventional romantic situation, which may in the end not work out after all.

Gun Crazy (1950, aka *Deadly Is the Female*), a famous cult thriller, starts with Peggy Cummins, dressed as a, cowgirl at a carnival, firing six-guns erotically. A gentle local man, Bart, played by John Dall, aroused by her, joins the carnival, and they begin an affair.

> Dall: *Everything is going so fast.*
> Cummins: *Next time you wake up, Bart, look at me lying there beside you. I'm there and I'm real.*

Dall inspires her to follow her impulses.

> Cummins: *Bart, I've been kicked around my entire life. From now on I'm gonna start kicking back.*

When she's fired by a sexually jealous boss, Cummins talks Bart into armed robberies. She sits on the bed next to him and starts slipping on her nylons.

> Cummins: *Let's finish it the way we started it.*
> Dall: *We go together, I don't know how. Maybe like guns and ammunition go together.*

Dall is won over—they're driven by the same dooming demons. They marry, but it's their crimes that Cummins finds sexually exciting. Dall acknowledges his pleasure in this as well.

> Cummins: *We're in real trouble this time.*
> Dall: *Laurie, I wouldn't have had it any other way.*

Totally sabotaged, they go on to die together.

La Ronde (1950, France, aka *The Round Dance*), adapted from an Arthur Schnitzler play, cuts back and forth between a carousel and late nineteenth-century Vienna interiors. A dozen period characters sometimes ride the carousel, sometimes are busy in bedrooms and similar locales, then are on the carousel again while moving from coupling to coupling: soldier to maid, maid to bashful student, student to foolish wife, wife to husband, husband to model, model to poetic playwright, playwright to actress, actress to hussar, hussar to maid. A clever narrator gives details of the various seductions. Sexual acts are not shown, just the preliminaries and what follows—the desire, then the heated passion, and the lies told to win it and afterwards. The higher up the social ladder, the more elaborate the lies, but it's always the same game. The point is that relationships are ephemeral and disappointing; love is about changing partners, breakups, and self-sabotage.

Sunset Blvd. (1950) has William Holden, an unsuccessful Hollywood screenwriter, accidentally meeting and falling into an intimate relationship with a very disturbed but rich silent-film-era star played by Gloria Swanson. The fifty-year-old, long retired actress is delusional, and thinks the two of them can write a screenplay that will enable her to resume her career and status as a Hollywood star. Holden is soon her paid, unwilling lover. He's also a shifty sellout as a scriptwriter, telling an ex-girlfriend about it:

> Holden: *Look, sweetie. Be practical. I've got a good deal here. A long-term contract with ten options. I like it this way. Maybe it's not very admirable. Well, maybe you and Artie can be admirable.*

When the comeback fails, Swanson goes mad and believes her lover has betrayed her

> Swanson: *No one ever leaves a star. That's what makes one a star!*

She murders Holden, then retreats into a dream world.

And God Created Woman (1956, France) stars Brigitte Bardot as a "child woman," attracting every man in St. Tropez. Two youths pursue her, the awkward Michel, played by Jean-Louis Trintignant, and the macho Antoine, played by Christian Marquand. After a brief affair with Antoine, she chooses to marry his brother Michel, warning him that she will only bring misery. They're briefly happy (due to continuous sex), but she returns to Antoine, still flirting with others. In the end she leaves Michel, gets drunk, and dances wildly at the local bar. Michel appears, threatens her, and slaps her. Excited by this; she goes home with him, clearly not forever. *And God Created Woman* is highly regarded for its raw intensity and sensuality. It's an example of the power of compulsive self-sabotage between lovers, without apology.

Marty (1956) stars Ernest Borgnine as a kind, lonely, overweight, middle-aged butcher surrounded by people who complicate his love life: his demanding mother, his brother, who is in a bad marriage, and his women-hating friends. He hates himself:

> Borgnine: *Ma, when you gonna give up? You got a bachelor on your hands. I ain't ever gonna get married. Whatever it is that women like, I*

*ain't got it... I'm a fat little man. All that ever happened to me was that
girls made me feel like a bug.*

He meets Betsy Blair, a schoolteacher whose life is also flat and empty, and
they start to talk and date. But his friends tell him she's a "dog," and his mother
seems threatened. Borgnine breaks up with Blair, but in the end, he tells her he
loves her and proposes. The breakup seems healed. He also answers his friends'
negativity.

Borgnine: *All I know is I had a good time last night. I'm going to have
a good time tonight. If we have enough good times together, I'm going
to get down on my knees. I'm going to beg that girl to marry me. If we
make a party on New Year's Eve, I got a date for that party. You don't
like it, that's too bad!*

La Strada (1954, Italy, aka *The Road*) takes place in postwar Italy, where
Giulietta Masina plays a dimwitted country girl who is "purchased" by Anthony
Quinn, a strongman who wanders the countryside on his motorcycle with a
small trailer, making money performing for villagers' entertainment. Masina
acts as his announcer, but she's also clearly an extraordinary clown and comic of
great skill and beauty. Quinn treats her like a kind of pet and mistress, who
doesn't care if he sleeps with any available woman. At one point they meet
Richard Basehart, another traveling entertainer, who displays affection for
Masina though she remains loyal to the insensitive Quinn. When they meet
Basehart again on a lonely road, Quinn fights him and accidently kills him.
Because Masina was a witness, Quinn plays it safe and abandons her. Later he
realizes he cares for her, searches for her, but learns she became an outcast and
died. In despair, crying, he throws himself on an empty nighttime beach, only
admitting he loves her after it's too late.

The Lovers of Lisbon (1955, France, aka *Les amants du Tage*) is a tragedy
of sophisticated, damaged characters whose new affair intensifies their need for
self-destruction. When Daniel Gélin returned from war and found his wife
unfaithful, he killed her, and now trusts no woman. He meets Françoise Arnoul,
a new widow, and falls for her. But she in fact caused her husband's death, and
is under investigation. Their affair is violent and unstable for both, their love
torture. In the end, the police use Gélin's distrustful nature as a cruel tool to
prove her guilt.

The Goddess (1958) opens showing Kim Stanley as a child, receiving no
love from a mother who wishes she'd never had a baby. She becomes the
plaything of teenage boys, while dreaming of Hollywood stardom. To advance
her career, she marries a drunken serviceman who is the son of an actor, and
abandons her own child. In Hollywood, she marries a famous athlete, but drives
him away when she poses for nude photos and has encounters with powerful
film producers. In the end, she tries to reconcile with her mother, now a
fundamentalist, but again gets no emotional support. When her mother dies, she
turns to alcohol and drugs, unable to show her own daughter any love. Featuring
a character who has never really grown up, this is thought to be the best film
depiction of Marilyn Monroe's life.

The breakup films of the sixties, a decade notable for its questioning, rebellious spirit, extend and explore the subject. They fall into several categories. Several films explore, with greater or lesser sophistication, the roots of characters driven towards self-sabotage—*The Hustler, The Sterile Cuckoo, My Night with Maud.* A few question films' usual condemnation of breaking up and self-sabotage, proposing that characters who can't live in conventional relationships could be accepted, if not admired—*Morgan, Belle de Jour.* Finally, some films give the self-saboteurs their due but conclude they're often too dangerous to everyone else—*Bonnie and Clyde,* and *The Collector.*

The Hustler (1961) stars Paul Newman as a pool hustler obsessed with success, whose woman, Piper Laurie, has faith in him, leading to ruin. When Newman meets the alcoholic, shy prostitute Laurie, its love at first sight:

Laurie: *Two ships that pass in the night should always buy each other breakfast.*

Laurie has immediate faith in Newman's skills and praises his spirit. The trouble is, he has no faith in himself.

Laurie: *You're not a loser...you're a winner...I love you.*

Newman: *I got no idea of love. Neither have you. Neither one of us would know what it was if we saw it coming down the street.*

Coldhearted gambler George C. Scott forces Newman to leave Laurie behind because he must have total control of him. Abandoned, she commits suicide. Newman's character can't face what he's done.

Newman: *I traded you for a pool game... I made you up, didn't I? You weren't real. I made you up like everything else. But...I wanted you to be real.*

Newman refuses to pay off Scott, and his competitor, Minnesota Fats (Jackie Gleason), praises him as a sportsman, despite what happened.

Pathological gamblers like Newman's character resemble drug-dependent people, or other obsessives in that gambling is their drug of choice. The euphoric rush of gambling is termed "the action," a way to escape life's problems, and for which almost anything else in their lives may be sacrificed. This makes Scott's manipulations easy.

The Collector (1965) dramatizes a case of total romantic self-delusion—a romantic relationship superimposed on a person who does not truly exist. Terence Stamp plays a dull London clerk who is stalking a beautiful art student, Samantha Eggar. His obsessive, controlling vision of love is suggested by his glass-cased collections of hundreds of butterflies. Kidnapping her via a van, he locks her in a prepared basement apartment, and explains that he won't molest her. He just wants her to love him. She is frightened and revolted, and refuses:

Eggar: *How many butterflies have you killed? All the living beauty you have killed!*

After several escape attempts, she tries to seduce him, hoping to be freed in exchange for sexual favors. But he's a sexless creature, weeping and calling her a whore, explaining:

Stamp: *I belong to you. I just want you here.*

He wants a sexless union with her, though they have nothing else in common. She's really just another butterfly. But when she tries to escape again, he's hurt, hospitalized, and by the time he's released she has died. Soon he's driving his van, stalking another young girl.

Romantic self-delusions range from situations that are not romantic at all, though they may be thought of as such, to acquaintances that are imagined to be secret lovers, people in love with men or women they have never met, lost loves, phantom loves, and total fantasies. Such delusions, while meeting a person's emotional needs, are at best pathetic and at worst, as *The Collector* suggests, extremely dangerous.

Morgan! (1966, England, aka *Morgan, A Suitable Case for Treatment*) stars David Warner as an artist from the working class married to aristocrat Vanessa Redgrave, who spends much time fantasizing that he's a sort of Tarzan swinging through the jungle trees. (Warner: "*I believe my mental situation is extremely illegal.*")

He's soon divorced, while Redgrave plans to marry a British stuffed shirt. (Redgrave: "*I don't want you back, but I'm glad I had you.*") Redgrave still loves him, but is tired of his mad ways, while Warner will do anything to get her back: hiding in her car, rewiring her home so that when her new guy shows up there are explosive thunder sounds, and trying to wire up a bomb to kill him. Warner sleeps with Redgrave one night, so her determination wavers, and then he kidnaps her until she's rescued by her parents. On her wedding day he puts on a gorilla suit and crashes the reception, then flees on a motorcycle, He's put into an asylum, where he's visited by a very pregnant married Redgrave, who hints, with a smile, that the child is his. Still a rebel, he's last seen doing the asylum's gardening, slyly arranging their flower display into an immense hammer and sickle.

Belle de Jour (1967, France, Italy) stars Catherine Deneuve as a French beauty married to a handsome young doctor, who secretly seeks out a bordello to work in part time, since she's only sexually aroused by its perverse clients. Each scene is filmed so it might be reality, or her erotic daydream. As the bordello interludes go on, the madam finds out her true situation, and threatens blackmail. Her husband, furious, appears at the bordello, but he's shot, so he becomes wheelchair bound and unable to speak. The madame is arrested, and events work out so to spare Deneuve any shame—or is most or all of it Deneuve's erotic fantasy?

The point seems to be that any way you look at it, her marriage and relationship with her husband is nullified by her true sexual nature, which she neither hides nor denies. To put it simply, she goes for the rough trade she can't get from her husband at home.

Bonnie and Clyde (1967) is a gangster crime film, yet also a love story whose lovers drive each other to destruction. Faye Dunaway, a beautiful, slutty Texas waitress, spots ex-con Warren Beatty, and picks him up—fondling his gun, going for a wild ride, coming on to him until he admits: "*I ain't much of a lover boy.*" But he knows how to charm:

Beatty: *All right, all right. If you want a stud's service, you go on back to West Dallas and stay there the rest of your life. You're worth a lot more than that. You know it and that's why you came along with me. You could find a lover boy on every damn corner in town. It don't make a damn to them whether you're waitin' on tables or pickin' cotton, but it does make a damn to me...You're different, that's why. You know you're like me. You want different things. You got somethin' better than bein' a waitress.*

They steal a car and become the "Barrow gang," though Beatty remains unable to perform sexually. But he's given her an erotic life of a kind, with the "rushes" of the robberies and getaway car chases. Beatty shows her love and support, and their relationship deepens, though she's clearly smarter than him and sees their luck must run out. (He idiotically says they would be able to live in one state, if they commit robberies in another.) Dunaway realizes that asking him to stop would end their exciting lovers' relationship, and not save them in any case.

At one point, she writes a poem about their future, and Beatty is so delighted he finally performs sexually. (*"That was perfect,"* she tells him, soothing him like a child.) But, she's already resigned to their self-sabotage, as the poem says:

Someday they'll go down together.
They'll bury them side by side.
To a few it'll be grief, to most a relief.
But it's death for Bonnie and Clyde.

The Sterile Cuckoo (1969) stars Liza Minnelli as a bright but emotionally damaged college student who seeks love with classmate Wendell Burton. They meet en route to their colleges, Burton quiet and inexperienced, Minnelli a very quirky loner brought up by an unloving dad. Later Minnelli visits him in his dorm for the weekend, and they end up having a great time, Minnelli explaining her mom died giving birth (*"My first victim!"*). They start seeing each other and soon it's love. Burton has no sexual experience and when they go to a motel, he's too shy to undress. So Minnelli strips and announces, *"Okay, Valentino—hit it!"* Sex starts, their relationship is enriched, but Burton spends Christmas with his roommate, causing the anxious Minnelli to announce she's carrying his baby. Upset, he asks her to marry him, but she refuses. She admits there's no baby. At school he takes her to his friends' party, where she gets drunk and insults everybody. She apologizes, and since he's staying at school over Christmas they decide to study together. It doesn't work, and he suggests they spend some time apart. After several weeks they meet and he suggests she go home and straighten out her bleak relationship with her father. But the romance is over, and she says goodbye. Minnelli's character appears simply too offbeat for the extremely conventional Burton, as the following suggests:

Minnelli: *You know what the trouble is? The trouble is that probably all the good things in life take place in no more than a minute—I mean all added up. Especially at the end of seventy years, if you should live*

so long, you still haven't figured it out. You spend thirty-five years sleeping. You spend five years going to the bathroom. You spend nineteen years doing some kind of work you absolutely hated. You spend 8,759 minutes blinking your eyes. And, after that, you've got one minute of good things. So one day you wonder when your minute's up.

My Night with Maude (1969, France) concerns characters who all steer themselves toward eventual breakups. Jean-Louis Trintignant, a bright, but timid and rigid Catholic, spends the night talking about various topics with Maud (played by Françoise Fabian), a vivacious, sophisticated divorcée. Though they have a wonderful, revealing time, Trintignant can't start a relationship, remaining faithful to the admittedly dull young girl he plans to marry. He appears Maud's equal, but won't face the challenge of the exciting woman. Maud herself, although an experienced young woman, can't really size up Jean-Louis as a lover, since he won't respond to her clear signals of romantic interest. She also rejects his friend, who really does love her, and enters another bad-choice marriage. So the film has no less than four cases of self-sabotage.

The self-sabotage films of the seventies fall roughly into the same categories as those of the sixties, though the films are often more powerful and subtle treatments of similar themes. This seems at least partly due to the stressful social times, making personal relations a still more difficult business. Films examining the roots of romantic breakups include *Five Easy Pieces*, *Diary of a Mad Housewife*, *Carnal Knowledge*, and *The Way We Were*. Films treating breakups more playfully, saying it's perhaps all for the best, include *Play It Again, Sam*, *Annie Hall*, and *A Touch of Class*. Films emphasizing personal pain and danger in breakups include *The Music Lovers*, *Klute*, *The Story of Adele H.*, *In the Realm of the Senses*, and *Looking for Mr. Goodbar*.

Five Easy Pieces (1970) deals with sophisticated, talented pianist Jack Nicholson, who cannot accept himself. He sabotages each of his love relationships. As he tells his dad: "*I move around a lot, not because I'm looking for anything, really, but I'm getting away from things that get bad if I stay.*" The title refers to five women whose affections he spurns. His sister is talented but too unstable to perform, and is obsessively attached to the family's sadistic male nurse. Nicholson's girlfriend Karen Black is warm-hearted but lower class, and he can't take her simple ways. (Nicholson: "*You play that* [song] *one more time, I'm gonna melt it down into hair spray!*") His brother's sophisticated mistress coldly analyzes him as "*having no respect for himself, no love for himself.*" Not choosing to explain himself, he treats her as another cynic.

Nicholson: *I faked a little Chopin. You faked a big response.*

Two lesbian lovers he meets appear too stupid and childish to bother with. At the end it's implied his rejection by his artist father, perhaps unjustified, led to what he's become. For no reason, he dumps his loving, loyal girlfriend, and goes off with an Alaska-bound trucker to where "*It's colder than hell.*"

Diary of a Mad Housewife (1970) is a straightforward tale of self-destructive "relationship addict" Carrie Snodgress, trapped in a loveless, sexless

marriage, who begins an affair with narcissist Frank Langella, learning to enjoy masochism.

Sex on the floor of his apartment lets her escape total emptiness at home. *"Sex isn't so important to me,"* she says *"Sex is just an instinct."* For a relationship addict, this is true, but it's a distraction. Langella responds: *"I'm a rat, a bastard, that's why you come here,"* which sums him up. She realizes he's a sex addict. She tells him what he wants is *"not a woman, but a sex machine."* He accuses her of being *"the perfect willing victim."* In the end she confesses what's happened to her marriage, and is last shown in group therapy, the final outcome open. Two addictions, no connection.

The Music Lovers (1970), based on the life of Tchaikovsky, is an extreme case of lovers destroying one other and themselves. Glenda Jackson, raped and abandoned by a Russian officer, sees Richard Chamberlain (Tchaikovsky) perform and writes, declaring her love. (*"I can't go on without you."*) Chamberlain, gay, chooses to marry her to escape society's disapproval. On their honeymoon, aboard the thundering Moscow Express, Jackson is madly sexual, Chamberlain, sexually terrified. A writhing white and sweaty monster seems about to destroy the delicate music maker! At the film's climax, the composer's patrons learn his sexual secret, stop all support, and he must conduct, which he loathes. Meanwhile, Jackson is put in a czarist era madhouse. In the end, Jackson is pimped out by her mother, and living in a delusionary state, waiting for the composer to save her. Chamberlain deliberately exposes himself to cholera, during the boiling water immersion treatment for it screaming: *"I tried to love her!"* over and over. He soon dies, while she remains trapped in the czar's madhouse.

Carnal Knowledge (1971) is the story of twenty years in the erotic lives of two college friends, whose early attitudes towards sex and love wreck their romantic lives on the rocks of predatory perfectionism and Peter Pan childishness. Jack Nicholson and Art Garfunkel are college students in the forties, both involved with young coed Candice Bergen, the first love for both:

> Garfunkel: *I can really talk to her!*
>
> Nicholson: *You can talk to me too. Does that mean you're in love with me?*

Garfunkel eventually marries Bergen. He's a successful middle-class M.D., but their sex life is boring and mechanical. (Garfunkel: *"Maybe it's not supposed to be enjoyable with women you love."*) Nicholson, a successful lawyer, becomes a total cynic about women:

> Nicholson: *You think a girl goes for you and you find out she's out for your money and your balls. The women of today are better hung than the men!*

Yet he's obsessed with finding the "perfect" woman.

> Nicholson: *This one came so close to what I wanted. Good pair of tits on her, not a great pair. Almost no ass at all and that bothered me. Sensational legs. I'd have settled for the legs if she'd had two more*

inches here and there. And three more here. Anyhow, that took two
years out of my life.

Nicholson finds a beautiful live-in lover, Ann-Margret, but she winds up
sleeping all day, eventually attempting suicide to get him to marry her.
Nicholson by now is also crazy,

Nicholson: *Very slick! Very clever! But it's not going to work.*

Next he tries to drive her away.

Nicholson: *You don't want me. Walk out! Leave me! Please...leave me!*
I'd almost marry you if you'd leave me.

They marry, divorce, and she's soon "*killing him*" with alimony. At the
film's end, fortyish Garfunkel has left wife Bergen for a silent, childlike hippie
girl, whom he says is now his "*love teacher.*" In the final scene, to achieve an
erection, Nicholson acts out an elaborate sexual scenario with a seedy prostitute.
Rita Moreno, who plays the prostitute, concludes, "*The purest form of love is to*
love a man who denies himself to her. It's up!... It's in the air!"

Psychologically, the Nicholson character is a perfection seeker whose
fantasies are never realized, so they let him stay emotionally uninvolved. As a
non-involvement lover, he tells women that he can't get involved, yet he does
more and more for them, so they expect the affair to progress. But he always
insists he's not involved, and so conflict becomes inevitable. Garfunkel is the
type of middle- aged man desperately in search of his youth, only dating very
young girls.

Klute (1971) is about New York prostitute Jane Fonda falling for detective
Donald Sutherland, but also about her breakup with and persecution by
industrialist Charles Cioffi, whose brief relationship with her pushed him into
homicidal mania. Fonda is a high-class prostitute whose sophisticated approach
to her clients is too much for the extreme dominant now stalking her.

Fonda: *What's your bag, Klute? What do you like? Are you a talker, a*
button freak? Love to have your chest walked on with high-heeled
shoes? Maybe you like to have us watch you tinkle? Or wearing
women's clothes? Or you get off ripping things? Goddamn hypocritical
squares!

Fonda tries to discover her johns' dark, forbidden sex needs in order to
provide them satisfaction. In, this case the industrialist's need for control,
mocked by her mastery, pushed him from masculine dominance into mania.

Cioffi: *You play on the sexual fantasies of men like us!*

Her line, "*Your only responsibility is to enjoy!*" is an invitation to lash out.
Realistically, the film is only an extreme exaggeration of many men's needs to
make a woman helpless and dependent. The man reveals himself as dominant as
the woman is made more and more a loving slave through bullying, punishment,
or other devices. In time she realizes this, and they break up. But sometimes the
dominant cannot accept this.

Play It Again, Sam (1972) deals comically with the romantic ups and downs
of the master self-saboteur Woody Allen. Losing his wife (Allen: "*I wonder if*
she had a real orgasm in the two years we were married, or was she faking it

that night?") Allen imagines Humphrey Bogart's ghost giving him date advice, but it does no good.

Allen (to pretty girl): *What are you doing Saturday night?*
Girl: *Committing suicide.*
Allen: *How about Friday night?*
Allen (to dancer*)*: *I love you, Miss, whoever you are. I want to have your child.*
Allen (to blonde): *I'd sell my mother to the Arabs for her.*

He is friends with Diane Keaton, wife of his best friend, and the two are always swapping stories of their love troubles. The friend is a workaholic who has no time for his wife, so his wife eventually sleeps with Allen. At the film's end Allen gives Keaton back to her husband, who seems to accept the situation. But Allen has gained new confidence, as he tells Bogart's ghost.

Allen: *The secret is not being you. It's being me. I'm short enough and ugly enough to succeed on my own!*

A Touch of Class (1973, England) is one more comic treatment of a romantic breakup through self-sabotage. George Segal, a U.S. executive living in London with his family, meets Glenda Jackson, a divorcée with two children:

Segal: *I have never been unfaithful to my wife...in the same city.*
Jackson: *Where is your wife now?*
Segal: *Out of town.*

They arrange a week-long tryst in Spain, making sure that his wife stays home during this "business trip." Meeting an old pal there who might spill the beans, Segal bribes him with the limo he had ordered for the trip, so the couple ends up with a crummy midget car. The ride wrenches Segal's back, so there's no sex until morning, when their dissimilar sexual viewpoints become clear:

Jackson: *Very nice.*
Segal: *Very nice is hardly the phrase to describe two bodies locked in heaven's transports!*

The old pal and his wife join them at an ill-matched dinner party; then Segal and Jackson wrestle in their room. In London they rent a flat, but the job-family-affair workload is too much, and Segal ends the affair, comes back again, then has Jackson leave him, letting her go.

The Way We Were (1973) stars Barbra Streisand as a radical Jewish college student in the thirties attracted to charming writer-to-be Robert Redford, who is politically indifferent. They meet again during World War II, and, infatuated, she pursues him until they marry, despite great differences (e.g., politics):

Redford: *I can't be negative enough. I can't get angry enough. I can't get positive enough.*

He remains indifferent to her intense political passions, even as she constantly works to hold him.

Streisand (to the sleeping Redford): *Tell me I'm not good enough. Tell me you don't like my politics. Tell me I talk too much. You don't like my perfume, my family, my pot roast...I want, I want...I want us to love each other.*

During the "Hollywood Ten" political crisis, her agitation leads to his adultery and decision to end the marriage:

Redford: *The trouble with some people is they work too hard... You're unhappy unless you're doing something. Because of me, you've been trying to lay low, but that's wrong, wrong for you.*

They break up; she remarries and stays political, he stays single.

Psychologically, one sought a partner with special talent and attractiveness, a desirable object or trophy. In a sense, Redford was Streisand's "10." But in time their political differences are so annoying he finds a way to protect her pride. It's a one-way romance addiction he doesn't need.

The Story of Adele H. (1975, France) is based on the life of Victor Hugo's daughter. Adele, Isabelle Adjani, falls in love with a young, uncaring British military officer and womanizer. She's helpless to deal with the situation:

Adjani: *Do you think we can control our emotions? One can be in love with a man and yet be aware he is utterly despicable.*

He soon deserts her, but meanwhile she's become obsessed. She writes of him endlessly in her journals, shadows him, and even spies on him when he makes love to other women, from her face enjoying it. She starts paying prostitutes to seduce him, taking joy in orchestrating his sex life. She attends a party he's at, dressed in tuxedo and top hat, perhaps implying she doesn't need him, and is ever more sexually defiant. As the film ends, Adele is rejected by her family, friendless, and appears very disturbed. She is finally institutionalized, where she dies. A similar film, *Camille Claudel* (1988) has the sculptor Rodin keeping the beauty Camille from her own creative efforts, and using them to advance his own career.

A biochemical explanation of Adele H's tragic behavior is that the special brain chemistry that triggers lovers' years-long feelings of infatuation is such that if the lover is at that time rebuffed, battered, or otherwise abused, this pain is associated with the infatuation chemistry, so the victim seeks further torments which for them provide delight. This syndrome may also explain the lover's behavior in *Lady Caroline Lamb*, another film biography, and similar stories presumably based on real life, such as *Possessed, Dangerous,* and *In the Realm of the Senses.*

In the Realm of the Senses (1976, Japan) is Nagisa Ôshima's film of a brothel servant's affair in which the couple's ever more extreme passion leads to destruction. Brothel manager Tatsuya Fuji is attracted to chambermaid and whore Eiko Matsuda. (Fuji: *"Life is made for pleasure."*) Matsuda is aroused by his sexual prowess, tells him to stop having sex with his wife, and the couple find a love nest. Her needs grow extreme—all positions and moods are tried. In time, he delights in how she controls him, including beatings and semi-strangling during sex. When he visits his wife, she demands he return, torturing him. (Fuji: *"Hurt me, Sada!"*) Next he begs her to strangle him during intercourse to the point of death. (Fuji: *"Our bodies have melted into one, bathing in a common pool!"*) Soon he dies of a heart attack, and she mutilates

him, the two collapsing in a pool of blood, the woman clutching his erect penis in total devotion!

Looking for Mr. Goodbar (1977) stars Diane Keaton as a character whose early loveless experiences lead her to seek out destructive love relationships. Keaton's first affair in college is with a self-centered, married professor who rejects her. Her sister, Tuesday Weld, has accepted a life of loveless affairs. At night Keaton hits the singles bars using cocaine for energy. Her dull affair with a decent social worker, William Atherton, ends with her humiliating him in bed. A lower-class barfly, Richard Gere, provides an exciting interlude, but they can't get along. When Gere tries to start it up again and gets violent, she calls the police. On New Year's Eve, she visits her favorite bar, telling the bartender she's decided to quit the bar scene. Instead she picks up an unstable bisexual, played by Tom Berenger, who has just broken up with his male lover.

Berenger: *Why did you pick me?*

Keaton: *I don't know. You seem friendly. A nice smile.*

Keaton takes him home, but in bed she ridicules him sexually, by now her frequent bedroom pattern. High on amyl nitrate, Berenger rapes her, then kills her.

Annie Hall (1977) stars Woody Allen as a New York comedian recalling his romantic history, emphasizing the impermanence of love (working title: *A Roller Coaster Named Love*). The film opens with Allen brokenhearted over his breakup with singer Diane Keaton (Annie Hall), with whom he was madly in love. Their early romance was awkward:

Keaton: *I bet he thinks I'm a yoyo.*

Allen: *I wonder what she looks like naked?*

In his first marriage, he obsesses over the JFK assassination to avoid sex. In his second, his wife says he uses sex to express hostility. Keaton and Allen move in together, and are affectionate. But he soon imagines problems in the relationship:

Allen: *A relationship is, I think, like a shark. You know it's got to constantly go forward, or it dies. And I think that what we have on our hands is a dead shark.*

Allen insists he must be Keaton's mentor in all ways. For example she must stop using marijuana during sex, and instead completely submit to his "performance skills." He also has a distressing obsession with death. When they break up for a while, Keaton says, "*You only gave me books with death in the title.*" Keaton is charmed by a hip record tycoon and moves to California. Allen flies out to see Keaton and insists they marry. But she turns him down. She accuses him of being unable to enjoy life. They have a final friendly lunch, and bid farewell. The film ends with an empty street, the lovers having departed. Allen concludes people keep entering new relationships even if they are crazy, irrational, and absurd, because they deeply need them.

Psychoanalytically, Allen's character suffers from generalized anxiety disorder (G.A.D)—too much anxiety he can't control. For example, he asks many questions about Keaton's past relationships, and then is envious about her

past experiences. They break up because his hyperactive imagination and self-doubts keep him from providing the caring, affection, and support of a happy, loving relationship. Allen's second wife in the film also has G.A.D., being so edgy that ordinary city sounds—airplanes and car horns—disrupt their intimacies.

The breakup self-sabotage films of the eighties and nineties fit the categories of the previous decades, but the lighter ones are lighter, the harsher ones bleaker and more painful. A number again show the roots of breakups—*Modern Romance, Swann in Love,* and *Falling in Love.* Several others treat breakups more or less playfully—*Four Weddings and a Funeral, Forget Paris,* and *My Best Friend's Wedding.* And a good number concentrate on the pain and even danger stemming from separations—*The Lonely Guy, Dangerous Liaisons, A Heart in Winter, Dream Lover, Leaving Las Vegas, Miss Julie, The End of the Affair,* and *Romance.* A few arguably rework previous films' approaches—*Modern Romance* resembles *Annie Hall,* and *Leaving Las Vegas* resembles *Looking for Mr. Goodbar.* The comedies still treat failures of love and complexities of relationships playfully, and the breakup pain and danger films depict them with ever more naked fury or inescapable agony.

Modern Romance (1981) stars Albert Brooks as a Hollywood film editor unable to commit himself to wed lover Kathryn Harrold. In the opening scene, he announces, as he has several times before, that he no longer wishes to see her.

> Brooks: *You've heard of a no-win situation. Vietnam. This. They're around. I think we're in one.*

Brooks tries to deal with it via vitamins, jogging, old friends and dates, and his work. He says, "*Alone is a kind of a nice place to be,*" but shortly he's leaving gifts on her doorstep, and doing everything else he can think of to win her back. He does, and takes Harrold to the country, where his dreams of a perfect love come out.

> Brooks: *I can't believe it. I love you. Now you watch, it's going to be perfect. I promise. Oh, Mary. Perfect, perfect.*

They marry, then are divorced days later, then remarry, then are divorced, then....

Psychologically, the film's hero displays the self-sabotaging qualities of all romantics—falling in love fast, demanding total commitment, being obsessed with an ideal love and fantasy. All this makes him fearful and uncertain, so he seeks total control, wants a lover as extension of himself—deep dependency disguised as macho power.

The Lonely Guy (1984) has Steve Martin dropped by his girl, trying to find a new one, but meanwhile joining the world of lonely guys. His friend Charles Grodin is a permanently lonely guy, having given up hope that things will change. Martin, however, is still somewhat hopeful.

> Martin: *Look at that guy. He's got a girl. He wasn't born with his arm around her—he must have gotten her somewhere.*

The lonely guys' world is depicted in surreal, comic fashion. When Martin loses a girl's phone number, he goes up to his apartment house roof and howls

her name—and other lonely guys howl in sympathy from their roofs. Asking for a table for one in a restaurant, he finds all the heads turning to look at him. At home he waters his plants, while his friend scours the newspapers for obituaries of lonely guy suicides.

Psychologically, *The Lonely Guy* is a surreal fantasy of the so-called hit-and-run-lover syndrome—men who need women and sex in the abstract, but are insecure and wondering so much about what manhood is that relationships are impossible. The hit-and-run-lover wakes up in bed with a woman and asks, *"What the hell am I doing here?"* and is soon off seeking another one-night stand.

Swann in Love (1984, France) stars Jeremy Irons as Proust's nineteenth-century romantic, whose strategy is to hold back, telling his friends he can take a woman or leave her. But meeting Ornella Muti, he's soon worshipping at her bosom, entranced by her scent, crashing a party where she's a guest and so humiliated, paying for her trip alone to Egypt, being stood up and then searching Paris for her. Soon, it's clear she's attracted to both sexes, yet he's ever more entranced, buying her expensive jewelry, making love to her minutes after another has left her. He admits to his terrible need:

Irons (to her): *You have put substance into my life!*

Irons (to others): *Without her love, I'd cease to exist!*

Despite all he says and does, Muti refuses to be faithful:*"I'm not a museum piece!"* Moreover she sees the two of them as incompatible. (Muti: *"You fear affection...it is all I look for."*) In the midst of their lovemaking she speaks of a friend's marriage, ending their courtship. After the breakup, his sophisticated friends are pleased, commenting derisively, *"To a dog in love, a bitch's ass smells sweet!"* The film's conclusion shows an older, smiling, prosperous, Muti-Swann couple. Perhaps he has finally won her...or perhaps not.

Four Weddings and a Funeral (1984, England) stars Hugh Grant as a young, happy British bachelor with some offbeat, fun friends. He attends a wedding and immediately falls for the charming American beauty Andie MacDowell.

Grant: *Do you really suppose there are people who can go "Hi, babe, name's Charles, this is your lucky night?"*

Friend: *Well, if there are, they aren't English.*

MacDowell comes on to him and they have a great night at an inn together, then she leaves. At the second wedding, she's engaged and Grant takes it calmly and helps her find a wedding dress, then expresses his true feelings.

Grant: *I think I love you, and I just wondered if, by any chance if you wouldn't like to no, of course not...I'm an idiot, he's not. Lovely to see you, sorry to disturb you, got to get on.*

She marries the other guy, and Grant tries to marry an old girlfriend, but his brother reveals he really loves MacDowell.

Finally Grant meets MacDowell, now divorced, and makes his charming unique "proposal of un-marriage":

Grant: *I realized I totally and utterly loved one person. It's the person standing opposite me now...the truth is, I've loved you from the first second I met you...Do you think, after we've spent lots more time together, you might agree not to marry me? And do you think not being married to me might maybe be something you could consider doing for the rest of your life?*
MacDowell: *I do.*

Grant's character's psychological problem, avoidant personality disorder, keeps him from taking risks or partaking in new activities, keeping him mired in self-reproach and fearful of ongoing intimate relationships. His ingenious "anti-proposal" allows him to circumvent this hangup. We hope.

Falling in Love (1984) exemplifies Hollywood's sly ways of sidestepping showing the breakups and self-sabotaging behavior that's often part of a romance. Meryl Streep and Robert De Niro are two attractive people whose marriages are breaking up, but you couldn't guess it when they accidently meet at a bookstore, and then on their commuter train. All you see is that they are a little self-conscious and needy. Quickly, they're in a fast-moving (adulterous) romance, meeting for Chinese takeout, amusement park rides, and photo booth fun. Their dying marriages are very briefly shown as dead: Streep's husband's face is a perpetual sneer; De Niro's wife has the audacity to slap his face when she learns of the adultery. Meanwhile the exciting affair races on: sneaky phone calls, desperate driving in rainstorms, running for the lovers' express:

Streep: *We were meant to be together! It was the right thing! Everything else is wrong!*

Finally each one drops their marriage partner. What the breakups do to their ex-mates and their children doesn't matter. At the close, the lovers reunite on their commuter train of fulfillment, but beyond their immediate romantic frenzy, their own future is a total blank. (Divorcing their exes? How unsexy!)

Dangerous Liaisons (1988), set in eighteenth-century France, has aristocrats and former lovers Glenn Close and John Malkovich now seeing romance as games of strategy and tactics, carried out to amuse. The next debauchery they choose is to have Malkovich seduce pure young Michelle Pfeiffer, and then drop her.

Malkovich: *To seduce a woman famous for strict morals, religious fervor, and the happiness of her marriage, what could be more prestigious?*

Malkovich's plan is to claim she's made him fall for her.

Malkovich: *You see, until I met you, I had only ever experienced desire. Love, never.*
Pfeiffer: *That's enough!*
Malkovich: *Now, I'm not going to deny that I was aware of your beauty. But the point is, this has nothing to do with your beauty. As I got to know you, I began to realize the beauty was the least of your qualities. I became fascinated by your goodness. I was drawn in by it. I didn't know what was happening to me, and it was only when I began*

to feel actual physical pain every time you left the room that it dawned on me. I was in love, for the first time in my life. I knew it was hopeless, but that didn't matter to me. And it's not that I want to have you. All I want is to deserve you. Tell me what to do. Show me how to behave. I'll do anything you say.

Very soon he has her under his spell.

Pfeiffer: *You are right. I can't live either, unless I make you happy. So I promise no more refusals! No more regrets!*

Malkovich himself can't deny he's affected by Pfeiffer's words, though he proceeds with the plan to coldly disregard her.

Malkovich: *She was astonishing. So much so that I ended up falling on my knees, pledging eternal love. And do you know that at the time, and for several hours afterwards, I actually meant it.*

In the end, however, all are ruined.

A contemporary version of this story was made in France in 1960 with Jean Moreau and Jean-Louis Trintignant It was remade as *Game of Seduction* (1960), *Valmont* (1989), and *Untold Scandal* (2003).

A Heart in Winter (1992, France, aka *Un coeur en hiver*) features Daniel Auteuil as a master violin craftsman with André Dussollier as his businessman partner. Auteuil lives for his craft; Bussolier has fallen for a stunning, talented concert violinist, Emmanuelle Béart. She's to record a Ravel sonata, an achievement that is critical to her career. When she visits Auteuil to perfect her violin, there's a strong erotic charge between them. She's entranced by his skill and detachment. She reveals her excitement to his partner, who stands aside. Auteuil attends the recording session, where she is magnificent. Later she ecstatically gives herself to him, but he turns away! She goes out on a drunken binge, then furiously confronts him, shaming him in public. His partner then appears, furious—their partnership is over! He and the beautiful Emmanuelle go off together as lovers. Auteuil is now a master craftsman alone.

But why did he reject her? In the last scene, he meets the beauty again, and says he now realizes he loved her. She kisses him goodbye, and goes off with his partner.

The film has two alternate critical interpretations. In one, isolated Auteuil, who had no passions, has at last acknowledged he loved her, and can perhaps love again. Alternately, it's that Auteuil is really gay, lusted for his partner, and manipulated Emmanuelle to hurt him. In both these cases Auteuil and Emmanuelle broke up in accordance with his nature.

Dream Lover (1993), a Hollywood thriller of sorts, dramatizes the commitmentphobe's worst nightmare: the perfect lover turning out to be the perfect adversary. Lonely, divorced architect James Spader meets stunningly beautiful Mädchen Amick, and thinks he's found his dream lover. After an art gallery pickup (they're both cultured!), they have a delightful sushi restaurant dinner date. (Both speak Japanese!) Jokes, opinions, and sexual styles match up perfectly—she's inventive and insatiable! They're soon married with a terrific home and child. But next, troubling inconsistencies show up in what she says

and does—details of her past, hints on the phone. Spader checks out her Texas home, where she was a dirty-mouthed, sleep-around slut. Suspecting sexual betrayals, he finds her turning on him, wrecking their home, bruising up her own face, calling the cops and blaming Spader, who is soon jailed. Her therapist tells the authorities he's brutalized her for months (according to her). Next she's got a divorce, alimony, Spader in an asylum, and his child, home, and whatever else he had. But by being ruled insane, he's no longer responsible, even when he tricks her into visiting him in the asylum and gets her all alone....

Since commitmentphobes and other avoidant people tend to have low self-esteem, are shy, and avoid situations where they are likely to face embarrassment or conflict, *Dream Lover* is best seen as such a person's ultimate nightmare scenario.

Forget Paris (1995) shows Hollywood can do a decent breakup drama if it chooses. Billy Crystal, visiting Paris, falls for perky Debra Winger, and the two have a quick romantic courtship, marry, and go to Los Angeles, where the trouble starts. Winger can't find a job she likes, and Crystal's glamorous work as a professional basketball coach keeps him away for weeks at a time. They bicker, split, come back together, bicker, split, come back together, She tells him she fell in love with him in Paris because he made her laugh, but forget Paris.

This is a common early marriage syndrome, one party feeling that the other is ever more possessive and demanding as there are more and more both real and imaginary demands. This makes their mate harder and harder to live with, so eventually they don't.

Leaving Las Vegas (1995) opens with an alcoholic Hollywood executive, Nicolas Cage, leaving a liquor store, his arms full of bottles. Having thrown away family, friends, and career, he drives towards Las Vegas to end it all. Driving the Strip he picks up attractive hooker Elisabeth Shue, charms her, takes her to his room and passes out. Later he explains their attraction. (Critics see her as too perfect for a real hooker.)

> Cage: *We both know that I'm a drunk and you're a hooker. I hope you understand, I'm a person who is totally at ease with that, which is not to say I'm indifferent or I don't care. I do. It means that I trust and accept no judgment.*
>
> Shue: *I bring out the best in the men who fuck me.*

She says he's the first man she's felt comfortable with, and she will never ask him to stop drinking. Their relationship comes to include the shakes, slurred speech, vomiting, and hangovers. (Cage: *"Don't you think it's a little boring, living with a drunk?"*) Later, he challenges her to share his suicidal madness.

> Cage: *Are you desirable? Are you irresistible? Maybe if you drank bourbon with me, it would help. Maybe if you kissed me and I could taste the sting of your mouth, it would help. If you drank bourbon with me naked, if you smelled of bourbon as you fucked me, it would help. It would increase my esteem for you.*

Eventually, despite her clear love and sympathy for Cage, he must go off and drink himself to death.

Alcoholism is now recognized as a disease, the alcoholic's body chemistry such that his feelings from the consumption of alcohol overwhelm every other aspect of his life, including passion, romance, and love.

My Best Friend's Wedding (1997) is a comedy about a woman trying to break up a couple about to marry, out of jealousy. Julia Roberts is a restaurant critic whose best friend since college, Dermot Mulroney, made a pact with her to marry at thirty, but informs her he's marrying another shortly. Roberts flies to Chicago to try to steal him back. The bride, Cameron Diaz, is young, wealthy, innocent, and beautiful. Roberts cooks up schemes to show her flaws: she gets the tone-deaf girl to sing, but this only wins the guests' sympathy. Diaz wants to be a "fulltime supportive wife," which Roberts ridicules without success. Then Roberts brings in her handsome, charming gay friend Rupert Everett to pretend to be her own lover, making the groom jealous, which works a little. Finally, she schemes to use e-mail to make it seem Diaz tried to wreck the groom's job. At last Roberts, in despair, reveals her scheming, uniting the couple.

> Roberts: *Walk down that aisle and marry the man of our dreams!*

At the wedding banquet, Roberts ponders a relationship with the handsome, gay Everett, since arguably the groom is a clod who wants a dumbbell wife.

> Roberts: *Maybe there won't be a marriage, maybe there won't be sex, but oh God, there'll be dancing.*

Psychologically, jealousy often wrecks a relationship. In a love triangle, the outsider is often dealing with feelings of inadequacy. Capturing or recapturing the relationship is less important than besting the competition. Once the competition is gone, the exciting edge in a relationship is gone too, and the jealous lover may very well lose interest. In *My Best Friend's Wedding*, for example, one is tempted to ask—why didn't Roberts grab the groom earlier if he's so wonderful?

Miss Julie (1999) is a screen treatment of August Strindberg's play about a self-destructive, aristocratic Swedish maiden. In 1894 at a count's estate, tall, beautiful, high-strung Saffron Burrows enters the kitchen. Previously, Pete Mullan, a suave, cynical valet, has spoken of her bright, unstable nature. She has him drink to her, and he cautions her about lady-servant relations. When a fierce soldier enters, the couple hides in the cupboard, pressed together, her expression pleading. The high-strung girl asks the valet to love her. He tells her they must steal the count's money and run away. He says they're both contemptible. She came on to him like a prostitute, so don't play the lady with me! She says she loves him! He packs a suitcase; she steals the count's money. But after hearing the count's bell, he is all at once submissive. Abandoned, she takes his razor and goes into the garden to commit suicide.

The alienation of both characters leads to their doom. The valet uses the aristocrat sexually, yet hates her as part of the crushing social system. The girl yearns for the love and sex she never had, but has class feelings too, pleading for upper-class style affection from him. The heroine is a tragic figure, a sensitive, perceptive individual misused by her family, society, and finally her lower-class

"savior." Strindberg's feelings about the characters were possibly close to contempt for the aristocrat and class sympathy for the bright, oppressed valet.

The End of the Affair (1999), based on the Graham Greene novel, is centered on the agonies of abandoned lovers in a broken relationship. In 1938, Ralph Fiennes, a writer, meets Julianne Moore, a "restless" woman at a party. Fiennes, a friend of her husband's, takes her to a film and dinner, and says he loves her. After a bad ten years of marriage, she takes Fiennes home and they make love. (Fiennes: *"As she learned to love me, she learned to deceive Henry."*) The affair ends in 1944, but later the two meet. (Fiennes: *"We're adults—we knew it had to end sometime."*) She cries and runs off. Meanwhile he is tormented by their intense moments. (*"I measure love by my jealous nature, and my jealousy is infinite."*) Moore still wants Fiennes, though her husband suspects him. Fiennes recalls the lovers' last meeting, when she thought a Nazi bomb had killed him, and agonized, began to pray. She then left him, but said, *"Love doesn't end because you don't see each other."*

His feelings were dead. (*"I lived and that was the end of the affair."*) Then a detective he hires steals her journal. As he reads it, the affair is shown from her point of view. When he seemed to be dead from the bomb, she prayed: *"Please, bring him back and I'll give him up forever. I promise I'll never see him again."* She planned to leave her husband until he said: *"I can't live without you, don't leave me."* Fiennes finds her, and she tells him: *"I've only made two promises in my life, one was to marry Henry and the other was to stop seeing you."* But she's always loved Fiennes, so they become lovers again, taking a holiday together. Then her husband appears, telling Fiennes he knows it all but will do nothing—she is dying and has only a few months to live. Fiennes moves into their home, Moore telling him, *"I never loved anyone as I loved you."* She dies, and he begins his own diary: *"I hate you, God, hate you as though you existed."* Later on he writes: *"Dear God. Forget about me. Take care of her. But leave me alone forever."*

Romance (1999, France) tells the story of beautiful young Caroline Ducey's odyssey towards sexual self-understanding while in a relationship, resulting in the relationship being destroyed. (Director Catherine Breillat: *"This character's goal is to follow the sexual urge wherever it leads."*) First Ducey's lover, model Sagamore Stévenin, will no longer make love. (*"It's always this way with a woman—a few months, then nothing."*) He's unfeeling; she's devastated. For her, a man who refuses to make love *"is a pit of misfortune, a gulf of misery."* (He won't even let her fellate him, or remove his shorts.) She finds a willing lover in a bar (*"I haven't had sex in four months!"*). They make out. She spends the next day demurely teaching elementary school, then has intense sex with the new guy. (Ducey: *"I'm just a hole to stuff!"*) She goes back to her old lover, who asks about this and later infidelities, but stays indifferent. Ducey next has bondage games with her chubby grade-school boss, who absurdly claims thousands of eager lovers in his past. She picks up another stranger, but that ends in a degrading rape. In a bizarre fantasy, she images several women lying on hospital beds, as husbands and boyfriends sit solicitously near. But the

women are nude, their beds and bodies projecting through the wall so the nude bottom halves of their bodies are in the next room, where roving anonymous men touch, lick, and penetrate the women, while their lovers show caring and support to their upper, non-sexual bodies. Now she and her lover begin making pub crawls of Paris nightspots. He is drunk and flirtatious; she now pregnant. When she goes into labor in their apartment, her lover stays asleep, so she turns on the gas, and her boss takes her to the maternity ward. Meanwhile their apartment and the lover explode into a giant fireball. Later the happy mom and her boy child follow the lover's hearse to the graveyard, Ducey remarking to God that she's taken one soul, and given him a new one.

Director Breillat commented that, "*What she's after is not sadomasochistic pleasure, it's what we call curing the ill by the ill, to take the road to hell in the quest for the grail.*"

Alternately, the film is a kind of feminist settling of accounts. Ducey's lover knows his rejection devastated her, making her turn to ever more ridiculous intimacies, the drunken pub crawl, deliberate public humiliation, and drunken refusal to take her to the maternity ward. In return, she turns on the gas and leaves his fate to the gods. The shocking scene of women getting sexless kindness from nice men above the waist, and sexual excitement from casual strangers below it, resembles how society and her lover treated her. In a world run by such absurd rules, she tells God her breakup was fair.

The breakup and self-sabotage films of the new century fall into the categories of the old one: analysis of breakup roots in *High Fidelity, Y Tu Mama Tambien, 2046, Two Days in Paris,* and *Blue Valentine*; breakup playfully treated in *Loving Jezebel, Crush, Love and Sex, Someone Like You,* and *The Baxter*; pain and possible danger in *Roger Dodger, Broken Flowers, Closer,* and *XX/YY*. Again several films resemble their predecessors, *Two Days in Paris* recalling *Annie Hall,* and *Broken Flowers* a past tense of *Five Easy Pieces*. In general, the films have a lighter tone, for example there are no deaths in the painful breakups, while in previous decades almost every such film had one.

High Fidelity (2000) begins with record store manager John Cusack arguing that romance songs confuse the meanings and connections of love, music, and commitment (as does he). His beautiful live-in girlfriend Iben Hjejle is moving out, tired of his vague, drifting personality, though she's reluctant to go. Cusack begins telling his love history. His junior high love, Sharon Stillo, betrayed him by kissing another guy. His tight-assed high school girl Joelle Carter, confident woman of the world Catherine Zeta-Jones, and friendly, insecure Lili Taylor appear. As he sees them, he rationalizes the splits: Stillo married the other guy, so he doesn't care; Carter loved him but refused him sex so he turned to another; Zeta-Jones he now evaluates as a babbling snob he's glad to be rid of. (Suggestively, Zeta-Jones said her new guy was "*more fun and less work*" than him.) When he sees Taylor again and finds her miserable and lonely, all he can do is walk away, smug at having avoided such a loser. He's still pursued by Hjejle—she is dissatisfied with her new guy, who treats her badly. But Cusack

evaluates his women like new song albums, and can't forgive their imperfections—he's a nice guy with a life sentence to adolescence.

Psychologically, Cusack's character is termed a hit-and-run, love-me-and-then-I'll-leave-you lover. As soon as a woman reciprocates his feelings, he's got his victory, so then he finds some flaw, and stops caring. His viewpoint wrecks his relationships, like his pointless rating and rerating of love songs.

Loving Jezebel (1999) deals with a rake who only falls for women who already have men (an ad for this movie: "He doesn't like every woman—just yours!"). Hill Harper is first shown running from an armed, revengeful husband. Flashback to his childhood, notable for its jezebels, defined as "a woman who engages in amorous activity with someone other than her mate." In kindergarten, he chooses another kid's sweetheart; in high school, he is involved in intimacies with teen Heather Gottlieb, but a pregnancy scare makes her return to her old beau. In college, he falls for a beautiful acting major, who plays innocent then turns out to be insatiable. But then her boyfriend appears, and Harper graduates on crutches. Later his roommate's girlfriend wants sex from him moments after they meet. Then he lives briefly with a beautiful actress, until the usual happens:

> Harper: *I felt the loss of my innocence, knowing for the first time that even a soul-touching love could not last.*

Women from his past reappear, and he falls for a bright poetess and a beautiful ballerina, finally running away with the poetess, chased by her husband with his gun, where the film began.

The hero's behavior is termed the juggler syndrome—an addiction to overlapping relationships, with very high turnover, women coming and going furiously. As the film suggests, the juggler is delighted with his prowess and driven by the fear of being left alone. So even if a woman leaves, there's always another waiting in the wings.

Love and Sex (2000) starts with adventurous beauty Famke Janssen writing for a women's magazine about her relationships. Episodes include a high school affair with a creepy French teacher and a run-in with an artist who tells her date: "*She and I are together now!*" Soon she and the artist, Jon Favreau, move in together. When he finally admits he loves her, she gets her video camera out and makes him say it again: "*I want to preserve it forever!*" But while living together, their sex life decreases, which scares him into moving out. They start seeing others, become jealous, and try to get over the big breakup.

Psychologically, the lover who moved out has been termed a just-so-far lover, willing to pursue a relationship up to a certain point, but no further. He won't take the plunge, and when there are problems he tends to evaporate, fearing his inadequacies will be revealed.

Y tu mamá también (2001, Mexico, aka *And Your Mama Too!*) has Mexican teen Diego Luna and pal Gael Garcia Bernal have sex with their girlfriends before the girls go to Europe. Next they meet an older woman, Maribel Verdú, and ask her to go on their road trip. She refuses, but when she learns her husband is unfaithful, changes her mind. She's pure at first, but eventually she has sex with each of them, forming an enthusiastic polyamorous relationship.

But when each boy learns that his girlfriend has also slept with other boy, they both violently vow eternal hatred. The sex continues, but while the woman is playing with some children one day, she becomes aware of her deeper feelings and adulthood, her differences from the sex-obsessed teens. She leaves them, and they return to their old lives.

Psychologically, the threesome is one of many types of kinky relationships, their numbers growing in real life today. The reasons it started (for the woman) include sexual dissatisfaction, and spicing up her sex life; (for the youths) the search for adventure, and escape from responsibility, as swinging bachelors satisfying a mature woman. The breakup is predictable, given the boys' jealousy of one other, their involvement with girls their own age with whom they have more in common, and the woman's fading interest.

Someone Like You... (2001) is a light comedy about a breakup. Ashley Judd is a talent booker for a talk show with two interesting men, womanizing writer/producer Hugh Jackman and charming executive producer Greg Kinnear. Kinnear romances Judd and both admit they're in love and plan to live together. Then he starts to back out, showing the "escape behavior" Judd has seen on nature TV. Needing a home, she moves into Jackman's two-bedroom pad, and learns more science while reading: "*Polygamy preferred by the male bovine*" means Kinnear won't return. In fact, he makes a New Year's date and then stands her up. She breaks down, then wakes up with Jackman, and goes on camera to say she now loves Jackman.

Psychologically, Kinnear is simply an unreliable lover, who seems committed but is actually ambivalent since being precise might lead to rejection. Judd likes to be literal and precise in romantic matters (note her tapping scientific findings), so she becomes blind to the chance of a breakup.

Crush (2001, England) is another breakup comedy, with fortyish Andie MacDowell, an American schoolteacher in England, making friends with a woman police chief and woman doctor. MacDowell notices the new church organist is twentyish former student Kenny Doughty. Soon the two are making love in the town cemetery. An intense romance follows. When the couple holds a dinner party for MacDowell's friends, Doughty can't relate and collapses drunk, but later recites sensitive love poetry to her. Her friends know enough to try to break them up, taking MacDowell to Paris and introducing her to handsome, sophisticated Frenchmen. But MacDowell can't forget Doughty, and flies home. The lady cop decides to show her friend the truth, so she seduces Doughty herself, while the doctor videotapes it. MacDowell is revolted, and it's her bond to her two friends that endures.

Doughty may simply be a vulnerable normal man, but letting himself be seduced by a best friend of the woman he is about to marry shows little respect, consideration, or likelihood he will satisfy and fulfill her, all basic to a good marriage.

Roger Dodger (2002) stars Campbell Scott as a young copywriter who when his beautiful boss Isabella Rossellini asks about sex, smirks that egg self-fertilization will soon make men unnecessary for procreation.

Rossellini: *But we have sex because we like it!*

Scott: *But the male is not necessary for you to feel pleasure.*

[The clitoris] *is the most efficient pleasure system. Now, why isn't it outside the vagina? Because intercourse and sexual fulfillment are not meant to be independent. Consequently, a woman's desire to please herself will increase exponentially (so men will be servants).*

Later he sneaks into the apartment of his boss/lover Rossellini and waits for her, but she says she wants an adult lover, not a game player. Yet they have a pleasant last night together. Later, in a bar, Scott tells a young woman he knows she has a crush on her supervisor, and that her personality is a construct of *Vanity Fair* articles. As she walks out, he laments: "*The heartbreaking predictability of it all.*" When he next approaches a blonde, she has the bartender throw him out. His teen nephew appears, wanting sex and love explained. On the street they find two beautiful women, but Scott's pickup lines fail. When one girl asks them why men like women to do intimate things, his nephew wisely replies, "To see what the woman's been hiding." The nephew says he's had no romantic experience, so one girl gives him a passionate kiss. Scott falsely claims that his nephew is actually married, and this makes the women leave in disgust. Now Scott crashes a party that Rossellini is holding, where his nephew helps a drunken woman into bed, but Scott is thrown out. Finally, they go to a whorehouse and Scott is shamed by being reduced to this after all his sophisticated talk.

Psychologically, the Scott character can be termed a vicious hit-and-run lover, dehumanizing the women he comes on to. His speech to his boss hints at this, and his treatment of the women he meets makes it clear. He enjoys deceiving and hurting them. Fortunately, such people reveal themselves very quickly, so encounters with them are usually brief.

XX/XY (2002) features a main character that creates love triangles to avoid real relationships. In 1993, Mark Ruffalo meets beauty Maya Stange. They are soon in bed. She invites her unconventional pal, Kathleen Robertson, to join them. Mark objects, but the couple stays together. Years later Mark cannot commit. When Stange asks him what he wants to be, he replies, "*I'm never growing up!*" Both cheat, but when Maya finds Mark in bed with Kathleen, that's the end of the relationship. Ten years later, Mark is living with a new girl, Petra Wright. Then Mark meets Maya again, and they still want each other. They reunite with Kathleen and the three start dating, Maya bringing her boyfriend and Kathleen her husband. Maya and Mark start making love again. Petra interrupts them, but nobody reacts strongly. Kathleen invites everyone to her new home, where Mark tells her he still loves Maya. Then Maya appears, and announces she's just married a man she was engaged to. Mark turns to Petra and pleads with her to marry him now. Instead, having known all about Maya, she scolds him for his adolescent nature.

Psychologically, Mark is a juggler of women, who can't commit, can't be honest about it, and lives in fear that his latest lover might leave him. So he keeps the different relationships as separate from each other as he can, telling

each woman he loves only them, delighting in his "harem" and its supposed love security.

Closer (2004) has four ravishing people stylishly forcing themselves in and out of relationships for the special pleasures this offers. In present-day London, strangers Natalie Portman, a stripper, and Jude Law, a journalist, notice each other on the street. Then a cab sideswipes her, and he takes her to the hospital. They're next shown living together, and she's inspired him to write a novel. The book jacket photo is taken by Julia Roberts, to whom Law is attracted. Later Law, pretending to be his lover Portman, has a seductive e-mail exchange with doctor Clive Owen, so Clive meets Portman. The two fall for each other. The doctor runs into Portman at a strip club, but no matter how much he pays her, she won't reveal her real name. Law meanwhile goes to an exhibit of Roberts' photographs, and comes on to her though she's clearly paired with Doctor Owen. Then Law tells Portman he's seeing Roberts, breaking up with her (Portman: *"Don't stop loving me, I can see it draining out of you."*) Doctor Owen, who has married Roberts, tells her he's slept with a prostitute, but Roberts doesn't care since she's decided to leave him for Law. The doctor goes wild, crying, striking her, asking for the details of her sex life, maneuvering her into sleeping with him, and winning her back. Law goes back to Portman, quarreling and wanting to know if she slept with Owen, finally being rejected. Portman reveals she's been using an alias, and goes off alone. Owen stays with Roberts, for the moment.

Psychologically, the characters in this film might be termed situational hit-and-run-lovers. Modern sexual liberation promotes their abrupt switches from partner to partner, women sharing what once were male prerogatives. All seem principally interested in demonstrating their desirability and manipulative skill to themselves, and each other. The vaguely moralistic ending of the film seems largely gratuitous.

2046 (2004, Japan), a sequel to *In the Mood for Love* (2001), has newsman Tony Chiu Wai Leung go to Hong Kong and become infatuated with Carina Lau in hotel room 2046. He is also attracted to one of its next occupants, prostitute Ziyi Zhang, who falls for him. Li Gong, a professional gambler, also falls for Tony. In each case, Tony cares for the woman but is too passive and self-centered to develop a real relationship, though the women are ready and willing. Sensuality is emphasized: different women's legs are displayed in slit skirts, and we hear the sounds of actual lovemaking.

A passive male like Tony always wants the woman to make the first move, in order to be dead sure he's not rejected. But most women are not sexually assertive, often because they are likewise afraid of rejection, or think it's unfeminine. This leads to not much of a sex life for such men. If the romance does get started, the passive male is at least usually sensitive, understanding, and caring, if sometimes later blocked in the physical expression of his love.

The Baxter (2005) is about Michael Showalter, what his grandmother calls a "Baxter"—the guy who doesn't get the girl. He finds a sweet, quiet girl, office temp Michele Williams (both love reading the dictionary), but at the same time

encounters blonde stunner Elizabeth Banks, and their engagement soon follows. However, her old swain Justin Theroux, a wealthy, world-roving scientist, soon begins chasing her again. Williams spends a night with the decent Showalter, but must hide the next morning when Banks appears to plan the wedding, getting mad when the groom has given it no thought. Afterwards he encourages Williams in her career as a singer, and she sees his troubles (Williams: *"You've got to be willing to take risks."*) Later, he, Banks, and Theroux go out, and he comes off a poor second to the scientist. At the wedding, Theroux appears before the vows to announce his love, and so Showalter immediately hurries away to win Williams' heart.

None of *The Baxter's* characters have psychological problems. It's a conventional romance; the lovers simply need to be linked up with their appropriate matches.

2 Days in Paris (2007) starts with French photographer Julie Delpy returning home to Paris with her American boyfriend, Adam Goldberg. Goldberg is increasingly upset as they meet her old boyfriends, Delpy constantly recalling their sexual relationships.

> Goldberg: *That guy was looking at you like you were a big*
> *leg of lamb. It's like he had the fork and the knife and the bib.*
> Delpy: *I am a big leg of lamb.*
> Goldberg: *I know, but you're my leg of lamb. How do you know him?*
> Delpy: *Well, we met many years ago, and we had a little thing. I think I gave...I gave him a blow job. No big deal.*
> Goldberg: *Really? A blow job is no big deal?*
> Delpy: *Oh, I'm sorry.*
> Goldberg: *I'm all right.*
> Delpy: *No, I mean, it's no big deal in comparison to what's going on in the world. You know, there's George Bush, the war in Iraq, there's Asian flu, and then there's a blow job. You know what I mean?*

More similar encounters occur to the point where Goldberg feels he doesn't understand her at all, and they break up. The breakup scene is shown without sound, the two characters gesturing at each other and looking upset, while on the sound track, Delpy reflects on the nature of love and romantic conflict.

> Delpy: *It always fascinated me how people go from loving you madly to nothing at all, nothing. It hurts so much. When I feel someone is going to leave me, I have a tendency to break up first before I get to hear the whole thing. Here it is. One more, one less. Another wasted love story. I really love this one. When I think that it's over and that I'll never see him again, like this...well yes, I'll bump into him, we'll meet our new boyfriend and girlfriend, act as if we had never been together, then we'll slowly think of each other less and less until we forget each other completely. Almost. Always the same for me. Break up, break down. Drunk up, fool around. Meet one guy, then another, fuck around. Forget the one and only. Then after a few months of total emptiness, start again to look for true love, desperately look everywhere and after*

two years of loneliness meet a new love and swear it is the one, until that one is gone as well. There's a moment in life when you can't recover any more from another breakup. And even if this person bugs you sixty percent of the time, well you still can't live without him. And even if he wakes you up every day by sneezing right in your face, well you love his sneezes more than anyone else's kisses.

The heroine could be said to have a mild impulse control problem, verbally assertive behavior that is out of proportion to any and all provocation. The "leg of lamb" exchange is typical "no problem" for Delpy, but quite insensitive to her boyfriend's feelings. (Note that she knows this should not be done, mentioning how to behave with old lovers in her monolog, but can't or won't hold it back.)

Blue Valentine (2010) shows how a couple moves in and out of love. Ryan Gosling, now a housepainter, and Michelle Williams, now a nurse, are embittered and quarreling in their modest home while their child looks on. Next it's six years earlier, and the two are trim and amorous, Gosling courting Williams. She wants to finish college and go to medical school; he only knows she's the great love of his life, and he will do anything to win her—play the ukulele, be bad-mouthed by her dad (for not being a high school grad), and marry her when she's pregnant. Insecure and impulsive, she does marry him. Cutting back and forth from cute first meeting to later irreconcilable differences, his devotion and decency are shown to no be longer enough. She needs him to be ambitious and purposeful; he just wants what he's got—his wife and child. He also drinks and babbles while she's working herself hard. (Grandma warned: *"You've got to be careful of the person you fall in love with!"*) He's got an answer: *"Pack your bags, babe, we're going to the future!"* They'll spend a night at a local resort's eerie blue-lit "future room": *"We're inside a robot's vagina!"* But he starts drinking, she locks herself in the bathroom, and soon he's pounding on the door...their future indeed.

These characters have no overwhelming psychological syndromes that sabotage relationships from the first, but do have needs and expectations that in time they won't or can't fulfill, which infatuation or affection make bearable, or don't. As Michelle Williams's character puts it, "feelings just disappear." Finally the filmmaker leaves it to the viewer—should the now wrongly partnered couple stay with each other, or break up to look for peace and happiness apart?

Breakups always lead to, if not precede, much personal, social, and economic pain, which frequently lasts a lifetime. As noted, breakup films tend to blame the breakups on the characters' clearly flawed, often self-sabotaging natures. While these can be the source of trouble or at least a contributing factor, it should be noted that the majority of real marriages and probably serious relationships fail due to social or economic stress. Over half of American marriages fail due to money problems of one sort or another, for example. Yet money troubles appear in almost none of the films discussed, or if they do are downplayed (e.g., *Blue Valentine, Forget Paris*). Hollywood long ago decided romance movie audiences don't wish to be reminded of the most common

objective problems—economic, sexual, class consciousness, or others, but to stick with the psychological. Why this is so is left as an exercise for the viewer. Part of the reason, of course, is that this fits the great American success myth that if you're not a winner, it's your own damned fault!

Another part of the reason is that parting is at its core an agonizing, tormenting, emotional scar that is never forgotten. As Emily Dickinson put it, "parting is all we need to know of hell."

Conclusion

Whatever their flaws, films about love, passion, and romance should never be taken lightly. Courtship and/or seduction have been enormously important in the human race's thousands of generations and hundreds of thousands of years of history. In general, it was the best masters of these skills who had the most offspring, our species breeding for them down the centuries. It's therefore no wonder that the romance film fascinates, since every person alive today—including you and I—is one of the lucky winners in the combined process of natural selection and sexual selection—we need to keep up the good work!

Today's Hollywood romance films of passion, romance, and love not only salute, honor, and explore this history, but surely provide the scaffolds and frameworks upon which real new love stories will arise, broad guides to human individual and species fulfillment. As Nicholas Lumen puts it in *Love and Passion:*

> *Taking a chance on love and the corresponding complicated, demanding re-organization of everyday life is only possible if one has cultural traditions, literary texts, convincingly evocative universal patterns and situational images.*

The romance film, for all its exaggerations and omissions, teaches many the negotiation of the subtle, many-staged, always imperfect love bond, presenting our continuously evolving courtship predispositions. At the same time, it reminds us of love's delights, *"the whirlwind, and the delirium of Eros,"* as Robert Lowell put it. For as Donald Yates noted, *"People who are sensible about love are incapable of it."*

Bibliography

Bernard, Jami. *The X List: The National Society of Film Critics' Guide to the Movies That Turn Us On*. Cambridge, Massachusetts: Da Capo Press, 2005.

Botwin, Carol, with Jerome L. Fine. *The Love Crisis: Hit-and-Run Lovers, Jugglers, Sexual Stingies, Unreliables, Kinkies, and Other Typical Men Today*. New York: Doubleday, 1979.

Doherty, Thomas. *Pre-Code Hollywood: Sex, Immorality, and Insurrection in American Cinema 1930-1934*. New York: Columbia University Press, 1999.

Evans, Peter William, and Celestino Deleyto, editor. *Terms of Endearment: Hollywood Romantic Comedy of the 1980s and 1990s*. Edinburgh, Scotland: Edinburgh University Press, 1998.

Everson, William. *Love in the Movies*. New York: Citadel Press, 1979.

Fisher, Helen R. *Anatomy of Love: A Natural History of Mating, Marriage, and Why We Stray*. New York: Ballantine Books, 1994.

Halpern, Leslie. *Reel Romance: The Lovers' Guide to the 100 Best Date Movies*. New York: Taylor Trade Publishing, 2003.

Harvey, James. *Romantic Comedy in Hollywood: From Lubitsch to Sturges*. New York: Da Capo Press, 1998.

Higashi, Sumiko. *Virgins, Vamps, and Flappers: The American Silent Movie Heroine*. Montreal: Eden Press Women's Publications, 1978.

Kael, Pauline. *5001 Nights at the Movies*. New York: Holt, Rinehart, & Winston, 1984.

Kendall, Elizabeth. *The Runaway Bride: Hollywood Romantic Comedy of the 30's*. New York: Alfred A. Knopf, 1990.

Landay, Lori. *Madcaps, Screwballs, and Con Women: The Female Trickster in American Culture*. Philadelphia: University of Pennsylvania Press, 1998.

LaSalle, Mick. Complicated Women: Sex and Power in Pre-Code Hollywood. New York: St. Martin's Press, 2001.

Lev, Peter. American Films of the 70s: Conflicting Visions. Austin: University of Texas Press, 2000.

Mainon, Dominique, and James Ursini. *Femme Fatale: Cinema's Most Unforgettable Lethal Ladies*. New York: Limelight Editions, 2009.

Mellon, Joan. *Big Bad Wolves: Masculinity in American Films*. New York: Pantheon, 1977.

Mellon, Joan. *Women and Their Sexuality in the New Film.* New York: Horizon Press, 1974.

Parish, James Robert. *The Hollywood Book of Love.* New York: McGraw-Hill, 2003.

Pennington, Jody W. *The History of Sex in American Film.* Connecticut: Praeger Books, 2007.

Pines, A.M. *Falling in Love: Why We Choose the Lovers We Choose.* New York: Routledge Books, 1999.

Robinson, David J., M.D. *Reel Psychiatry: Movie Portrayals of Psychiatric Conditions.* Port Huron, Michigan: Rapid Psychler Press, 2003.

Sennet, Ted. *Lunatics and Lovers: A Tribute to the Giddy and Glittering Era of the Screen's "Screwball" and Romantic Comedies.* New York: Arlington House, 1973.

Sternberg, R. J., and M.L. Barnes, editor. The Psychology of Love. New Haven, Connecticut: Yale University Press, 1989.

Taylor, Richard. *Love Affairs (Marriage and Infidelity).* Amherst, New York: Prometheus Books, 1990.

Tennov, Dorothy. *Love and Limerance: The Experience of Being in Love.* New York: Stein & Day, 1979.

Williams, Linda. *Screening Sex.* Durham and London: Duke University Press, 2008.

About the Author

Norman Kagan has published six previous books on film, and taught or teaches film, communications, composition, mass media, and related subjects at City University of New York, the College of New Rochelle, Yeshiva University, and elsewhere. He has been a contract research coordinator for Microsoft, Encarta, the Seattle Art Museum, John Wiley & Sons, Macmillan, and others. He has been a news writer-producer for Group W, Scholastic Productions, and the U.S. Information Agency's Science Report, a U.S. policy instrument on 600 television stations in 110 nations in ten languages. He has a B.A. and M.F.A from Columbia University. He is finishing several other books on film.